EDWIN ROMANZO ELMER

1850-1923

Betsy B. Jones

SMITH COLLEGE MUSEUM OF ART
Northampton, Massachusetts

Distributed by the University Press of New England
Hanover and London (1983)

Printed by The Pioneer Valley Printing Company, Easthampton, Massachusetts.

Distributed by the University Press of New England, 3 Lebanon Street, Hanover, New Hampshire 03755.

ISBN 0-87391-033-8

Library of Congress Catalog Card Number: 83-51554

Photographers: E. Irving Blomstrann, Helga Studios, Fred G. Hill, Marjorie DeWolf Laurent, Stephen Petegorsky, Robert Schlosser, David Stansbury, Wayne Thompson, Steven Tucker.

Cover: *A Lady of Baptist Corner, Ashfield, Massachusetts,* 1892 (detail, fig. 68).

Published with the aid of funds provided by The National Endowment for the Arts, Washington, D.C., a federal agency. Additional funds provided by Museum Members/ Smith College Museum of Art.

CONTENTS

FOREWORD

That the Smith College Museum of Art should be the publisher of this monograph on Edwin Romanzo Elmer is particularly appropriate, even though we cannot claim to be situated in his native Franklin County, but in its neighbor, Hampshire County. Nevertheless, the artist did venture to Northampton, taking views of local points of interest and showing at the town's Tri-County Fair in 1905. Two hundred fifty years before that his first American ancestor had been one of Northampton's original land-holders. It was an alumna of the College, Dorothy C. Miller ('25), who started the chain of events that led to the rediscovery of Elmer's work in 1950, and her initiative was followed up by another alumna, Elizabeth McCausland ('20). E. Porter Dickinson recalls that after he bought Elmer's *A Lady of Baptist Corner, Ashfield, Massachusetts* in 1939, he lent it to the Museum in the summer of 1940 for what was probably the first museum showing Elmer's work had ever had. Thanks to Mr. Dickinson this masterful work now hangs in the Museum, along with the *Mourning Picture* and three other works by Elmer.

In 1952 the Museum gave Elmer his first museum exhibition; thirty years later, in 1982, his second exhibition was held here. When his niece Maud Valona Elmer died in 1963, the executor of her estate sent the charming portrait of her father by Elmer which was her bequest to the Museum, together with a typescript of her memoir of her uncle. With the executor's approval, it was published under the Museum's copyright in the *Massachusetts Review*. As an offprint, it has been a best seller ever since.

Maud Elmer's article, "Edwin Romanzo Elmer as I Knew Him," with its personal recollections of the artist, is irreplaceable. Nevertheless, we were delighted when Betsy B. Jones, the Museum's Curator of Painting, became intrigued with the work of this still little-known artist who painted at least three masterpieces, and began to investigate his life and art. Although the pursuit of the very elusive facts of his life has not taken her to London, Paris or Rome, but to Ashtabula, Cleveland and Gloversville, among many other places, the pleasures of discovery have been her reward. She has unearthed much new information about the artist, his family, and the influences on and sources of his art, and has distilled these findings into the present volume.

The Museum has been the beneficiary throughout of the generous assistance of the National Endowment for the Arts, without whose support this publication could not have been realized.

Charles Chetham
Director
Smith College Museum of Art

ACKNOWLEDGMENTS

E. Porter Dickinson must come first in any list of individuals to be thanked for their contributions to our knowledge of Edwin Elmer not only because he was the agent for the rediscovery of the artist's work, but because he has gathered and retained so much lore about the artist.

Mrs. Robert Luce, a great-niece of the artist's wife, has never failed to respond generously to a request for information stored in her own clear memory or for permission to study her collection of works of art by the artist as well as family documents and other material in her collection. Her son, R. Russell Luce, has been her cordial assistant.

Florence Haeberle, who with the encouragement of Maud Elmer, located many works for the collection that Electra Havemeyer Webb formed at Shelburne, Vermont in the 1960s, has graciously lent me her records and letters on the subject.

Dennis A. Fiori has let me read his unpublished notes on Elmer gathered while he was a graduate student at the University of Vermont.

Mrs. Wayne Phillips, whose late husband was the grandson of the artist's sister, Emeline, has shared with me papers in her possession and given me the benefit of her own recollections.

Mrs. Evelyn E. Whiting and her daughter Mrs. Clifford H. Watkins have been especially generous (and patient) in permitting me to use material bequeathed by Maud Elmer.

Joseph Holland and Vincent Newton, owners of the largest private collection of Elmer's works, provided me with much interesting data based on their own researches, gave me many leads, and altogether acted with extraordinary generosity.

Help from Mrs. Kenneth L. Beals, Priscilla Barnes Bingham, and Mrs. Harold A. Lesure, all relations of the artist's wife, has been especially valuable.

Lois Buell, who grew up in Elmer's Buckland house, seen in his *Mourning Picture,* and Mr. and Mrs. Winthrop Anderson, who now live there, have been continuously interested helpers.

Correspondents who have conducted helpful research for me are Mrs. Edmund Berndt, Eleanor E. Burton and Sarah Ulen.

In addition to the many owners of Elmer's works who are named in the catalogue entries at the back, thanks are due to Marguerite Allen, Mrs. Francis R. Bray, Sarah Burns, Dee Edwards, Mrs. Edward S. Decker, Mrs. Walter Doneilo, Philip W. Elmer, William Bull Elmer, Steve Finer, Harry A. Frye, Mrs. L. H. Green, Norma Harris, John Hoyt, Phyllis Joyce, Mrs. Theodore Krueger, Mrs. Charles T. Litchfield, Priscilla March, Harold F. Maschin, Benjamin Mason, Thomas McDonald, Sally Mills, Dr. Jerrold N. Moore, Maria Naylor, Celia Oliver, Mrs. George W. Patch, Mary Ellen Earl Perry, Ernest Pike, Nancy Rexford, Elaine Trehub, Eleanor Tufts, Mrs. Hugh F. Ward, Linda Wendry, Dr. Keith Wilbur, and Ruth Wilbur.

My sharp-eyed editor has been Helen M. Franc, who was Editor of the *Magazine of Art* when it published Alfred Frankenstein's article on Elmer in October 1952, and who has done this work as a labor of love. Lapses still to be found are chargeable to the author. A second, questioning look and professional copy-editing have been provided by my colleagues Linda Muehlig and Ann H. Sievers. When an emergency arose, the latter generously put aside her own work and took over for me the tedious and difficult management of the final stages of publication, including the preparation of the index with the assistance of Michael Goodison. Drusilla Kuschka has typed the manuscript with her usual patience and accuracy. Others on the Museum staff to whom thanks are due are Kathryn Woo and David Dempsey, but most of all they are owed to Charles Chetham, the Director, who has supported and encouraged this publication from start to finish.

When a project spans a number of years and requires much original research, one accumulates debts to many people, and the chance that some will be overlooked when the time comes to thank them is very great. I offer my apologies to those whom I have inadvertently failed to acknowledge.

PREFACE

A magnifying glass, the focus of Edwin Romanzo Elmer's beautiful still life, *Magic Glasses,* could serve as a symbol for this investigation into his life and art. Largely an exercise in detective work, it has involved discovering clues and pursuing countless leads, most of them to dead ends.

The project began by chance a number of years ago when, at a lecture on John Ruskin and the camera, I saw a slide of one of his illustrations for the *Seven Lamps of Architecture*. Called "Tracery from Giotto's Campanile in Florence," it was a drawing Ruskin had made from one of his own daguerreotypes. I realized that this drawing was the source for the architectural details in the background of Elmer's *Portrait of My Brother* in the collection of the Smith College Museum of Art. Having often wondered where he had found this element, which did not appear to be imaginary, I was delighted to know at last.

Several months later, another question that had lingered at the back of my mind was answered when I discovered the identity of the painter of a fine panoramic view of the town of Northampton, also in the Museum's collection. The picture had been catalogued as "Anonymous American, 1850s" since its acquisition in 1953, but it had always seemed that so accomplished a work must have been painted by a recorded artist. Detective work turned up clear evidence that the artist was a young English student of Ruskin, Thomas Charles Farrer, who had spent the summer of 1865 in Northampton.

Since Ruskin's American friend and champion, Charles Eliot Norton, had chosen Ashfield, Massachusetts—Edwin Elmer's native village—as his summer home the year before, it seemed probable that Farrer had visited that town, too. All these clues hinted that Ruskin's teachings might be an important and previously unrecognized formative influence on the art of Edwin Elmer and might account in part for its contradictory nature. To discover the truth of this supposition and to add to the meagre biographical record of this curiously talented artist, this book was undertaken.

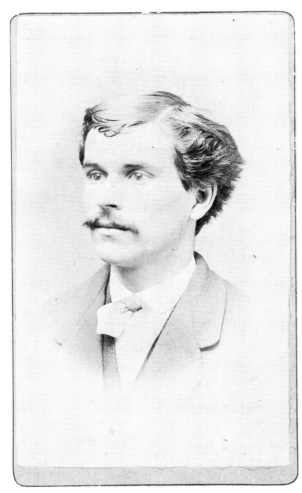

Fig. 1. Edwin Romanzo Elmer, ca. 1876. Photograph, 3¾ x 2⅛″, by J. K. Patch, Shelburne Falls, Massachusetts. Collection of Evelyn E. Whiting.

PART I. Biography

Ashfield has neither telegraph nor railroad, and but one mail a day,—and it is a good, patriotic, happy little village, that does not believe in being excited, but holds firm to its faith in the country and is quiet in the assurance that the rebels are soon to be on their knees. It is so pleasant a place that I hope you will come up to see it and us while we are here. The scenery all around us is delightful, with the mingled charms of fresh wild nature and the cultivation of cheerful farms. It is prettier than any other scenery I know in Massachusetts,—and is like the tamer parts of the English lake country. The village is as quiet as if every day were Sunday. The people are all well off. There are no poor in the town. The air is cool and fresh, the hills have a fine wind blowing across their tops, the little brooks run singing and leaping down their sides, the fields are gardens of wild fruit, the woods are thick and dark and beautiful as the forest of Brocéliande,[1] the glades look like the openings in a park,—one could write Massachusetts idylls or a New England 'Arcadia' in this happy, tranquil region of the world —Charles Eliot Norton to George William Curtis, July 14, 1864.[2]

The little village itself where we are has an air of rural comfort and pleasantness that is really delightful. It is embosomed in the hills, not crowded upon by them, but seeming to have a sweet natural sufficient shelter from them. We are within a stone's throw of the tavern, of the meeting houses, the three shops, and the post-office,—and on the other side we are as near two hills between which the road runs, and from either of which there is a wide and beautiful view. . . . Wherever you see a habitation you see what looks like a good home. There are but three town poor, and they are very old. There is but one Irish family, they say, in the township. The little village of Tin Pot, two miles away, does, however, look as if its name were characteristic. There is a good deal of loafing and drinking there, but the loafers and the drunkards are not permitted by public opinion to come up here. The line is one of positive separation between the two villages. —Charles Eliot Norton to James Russell Lowell, July 7, 1864.[3]

A family illness had brought Norton to western Massachusetts in 1863. Perhaps the first stop had been Northampton, which was famous at the time for its water cure, but in that summer the Nortons also discovered Ashfield and in 1864 bought their house there. A note in the Greenfield paper at the end of August 1864 reveals that Norton succeeded in luring his friends Curtis and Lowell to Ashfield that summer.[4] Lowell visited again the next summer and toyed with the idea of buying a house, but decided against it. Curtis, editor of *Harpers Weekly* magazine and author of its "Easy Chair" column, began to summer in Ashfield regularly in 1865, living first in a rented house and then in the Nortons' during the years 1868–1872, when the Nortons were abroad. He bought his own house in 1872.

1

While Norton was entertaining Lowell and Curtis up in Ashfield in August 1864, Henry James, a young man of twenty-one, was settling in for a few months' stay in Northampton to write and to try the water cure. He had just completed and sent off to Norton his first journalistic effort, a review for publication in the *North American Review,* of which Norton and Lowell had recently become co-editors.

Norton's condescending reference to the single Irish family reflected the widespread fear among the intelligentsia, as well as the middle class, of the changes in values and mores that the growing tide of immigrants was bringing to America.[5] He was apparently unaware of the fact that Ashfield's first settler in 1742, Richard Ellis, had been an immigrant from Ireland. Norton treasured this tiny town of 1,200 inhabitants buried in the eastern foothills of the Berkshires, because it had not been touched by "progress." It was not likely to be affected by industrialization in the future, either, because it had no water power, except for a couple of little streams that could just drive a small sawmill or grist mill. No local history mentions a village called Tin Pot. It may be that Norton was thinking of Buckland, the next town north, which had a number of mills on its Clesson's Brook, or Shelburne Falls, about six miles north, already a bustling factory town with plenty of power from the Deerfield River. On Ashfield's eastern border was the town of Conway which also boasted several mills. But probably he meant South Ashfield, about two miles away and a couple hundred feet lower in elevation, where there was a good deal more industry than in Ashfield Plain, as the center of town was then called.

Whether Norton counted Erastus Elmer among his "three town poor" we do not know, but the parents of Edwin Romanzo Elmer had lived on the edge of poverty most of their lives. They had returned to the Baptist Corner district of Ashfield in 1847, after an absence of more than twenty years, during which they had attempted to extract a living from the soil of Chautauqua County, New York and Clark County, Illinois. They might have followed the example of so many thousands of others and pressed still further westward, but they chose instead to return to Ashfield, where the Elmer family had lived for three generations.[6] Besides the incredible hardships of farming land as yet uncleared and uncultivated,[7] the Elmers had suffered the loss of many children. Of the ten born to them between their presumed departure from Ashfield about 1825 and their return in 1847, five had died within a five-year period.

On October 12, 1850, thirteen years before Norton discovered Ashfield, Edwin Romanzo Elmer had been born there, the twelfth and last child of Erastus Elmer (1797–1890) and Susan (Smith) Elmer (1807–1878). He was the second of their children to be named Edwin, the first having died at the age of eight in 1843. It may have been to this circumstance that he owed his exotic middle name. Names of Spanish and Italian origin—Alfonso, Lorenzo, Alonzo, Ozro, etc.—had been commonplace in New England for many decades, inspired by the Gothic novels and romances which had long been popular. The artist's wife had a first cousin named Ormanzo. Romanzo may be a variant of this name (on the model of the transposable first letters in the French and Italian forms Roland and Orlando).[8] Exactly where in Ashfield Elmer was born is not clear. His sister,

Emeline, said that when the family returned from the West they lived for a time "in the old home."[9] In the Census of 1850, taken the summer before the artist's birth, the family is found divided among three different households. Whether this accurately reflected their living arrangements or simply recorded their whereabouts on the day the census taker arrived is not known. In any case, Erastus is counted in the household of his brother Watson, while his wife, then pregnant with Edwin, is listed as living in another, nearby household with her daughter Clarissa Totman; indeed she and all her children, including Emeline, who is listed in the household of an uncle, are assigned the surname Totman.[10]

The artist's father appears to have been a farmer most of his life, though at various times he is said to have earned money weaving baskets and hats, making brooms and pails, and carving ax helves. Following an accident in which he lost his left eye, it is said that he peddled eyeglasses for a time. Although he lived a very long life, little else is recorded about him.[11]

Elmer's mother, Susan, was the daughter of Israel Smith, born in Guilford, Vermont about 1786, and Esther Cook, of Buckland, Massachusetts, where they were married in 1804.[12] Susan, or Susannah as she is sometimes called in early records, was born in Worcester, Otsego County, New York on November 7, 1807, probably while her parents were en route west. In March 1810, Israel is listed as one of the first purchasers of land in the town of Ellery in Chautauqua County, New York. Perhaps because of the death of Susan's mother, he apparently returned to Ashfield sometime around 1815. How long he remained is not certain. In the years 1815–1819, perhaps on the strength of his report, a dozen or more Ashfield and Buckland families moved out to Chautauqua County. Israel is listed among these migrants, and in January 1819 he and his second wife, Elizabeth Phillips, joined the Baptist Church in the Chautauqua County town of Stockton.[13] His wife's father, Philip Phillips, was one of those who migrated from Ashfield and settled in the adjoining town of Cassadaga. Others were the locally famous Baptist preachers Ebenezer Smith, father and son, and Aaron Lyon, whose sister Mary was to found Mount Holyoke Female Seminary in 1837. Aaron had purchased his plot two years before. Mary's sister Rosina went to Chautauqua County a few years later.

Elizabeth Smith apparently died shortly after her admission to the church, because the 1820 Stockton Census lists Israel Smith with a household consisting of just one female between the ages of ten and sixteen, and a resolution of January 12, 1821 in the church records recommending him to another Baptist church wherever he may go, suggests that he may once again have returned to Ashfield with his young daughter.[14] It is an Elmer family tradition that Susan was a student and assistant to Mary Lyon in her early years as a teacher in the district and the "select" or private school in Buckland. Emeline Elmer stated that this was during two summers when Susan was "twelve and thirteen," that is, in 1820–21.[15] No existing records appear to support this belief. The one cited by Emeline was apparently a reprint in the Greenfield paper of a prospectus of Mary Lyon's classes in Buckland for the year 1830,[16] in which a student assistant named Susan N. Smith is listed, but she was a native of Hatfield; and by 1830 the artist's mother had been married for six years, was the mother of three children and was living in Stockton.[17]

Whatever the truth of this tradition, it seems clear that the artist's mother did receive more education than his father. She apparently possessed considerable force of character, and this, coupled with an artistic bent, which in her case was expressed through poetry, seems to have been the principal formative element of the artist's early years. In her memoir, the artist's niece, Maud Elmer, quotes the following eulogy to their mother written by the artist and his next older brother, Samuel, Maud's father.

> The genius of Susan Elmer has been known to the public for many years. The beating of her Christian heart, in the soft melody of her nature, has caused the hearts of thousands to throb in unison with its music. Not alone, now, among the hills of New England, her native land, nor upon the lives of her acquaintances does the sympathy of the poet vibrate; but wherever a warm heart feels the glow of friendship, wherever a sad spirit droops under misfortune, or a proud soul rises against a sea of adversity, there, the truthful, the earnest, the ennobling thoughts of Susan Elmer find an eternal response. [18]

Her poetry apparently appeared from time to time in the local newspapers. All sources seem to confirm that she was a deeply religious woman. Probably by the time Edwin was born, the teaching she espoused was not, however, the Baptist

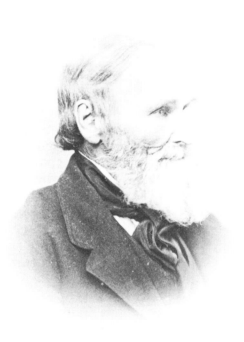

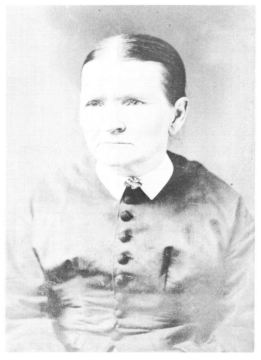

Fig. 2. Erastus Elmer, ca. 1885. Photograph. 3¾ x 2⅛", by J. K. Patch, Shelburne Falls, Massachusetts. Collection of Mrs. Robert Luce.

Fig. 3. Susan Smith Elmer, ca. 1875. Photograph, 3¾ x 2¼". Collection of Mrs. Robert Luce.

4

faith of her father but that of a newer and much more controversial sect, the Second Adventists, often called at the time Millerites.

William Miller (1782–1849) was born into a Pittsfield, Massachusetts family of Baptist persuasion. He became a minister and in 1831 announced that a close study of the Scriptures had led him to the conclusion that Judgment Day was scheduled for sometime in August 1843 (or October 22, 1844, if his calculations were given a slightly different reading). He and his ministers made many converts, particularly among the Baptists. Needless to say they were subjected to much ridicule when the appointed dates came and went without incident. Stories abounded of the gatherings of the believers on the heights clothed in their "going-up robes" waiting to be brought to heaven. Later researchers have failed to find any reliable documentation of events of this kind, but the sect continued to be the object of suspicion and superstitious accusation, and it no doubt took considerable strength of will to persist in the tenets of the Adventist faith in the face of such attitudes. Apparently Susan Elmer was one who did and who attempted to raise her family in the religion. In its heyday and in later years, it was not uncommon to find newspaper accounts of suicides and other violent acts in which the deed is ascribed to the deranging effects of Millerism. In fact, it was only in the newspaper stories about the suicide of the artist's brother, Darwin, in Cleveland in December 1859 that Susan Elmer's connection to this sect was discovered.[19] The *Cleveland Plain Dealer's* lengthy account[20] asserts that "his shocking death was undoubtedly caused by brooding over the awful day which he believed was rapidly approaching." It goes on to report that a letter from his mother was found in his effects in which she reproves him for losing interest in "the religion of the family." The reporter further observes that "some Second Advent tracts were found in the store. One of them, several passages in which had been pencil-marked, lay on the floor near the dead man's feet. He had probably read it just before committing the fearful act." The reporter for the *Cleveland Daily Herald* closes his long account with the statement that "there is scarcely a doubt that the mind of the deceased was unsettled by the Second Advent fanaticism as there are no indications of pecuniary desires sufficient to cause such a determined suicide."[21] The *Plain Dealer* reporter quotes a passage from another of Susan Elmer's letters, "O Darwin, did ye but know what the Lord is doing for those who are in the present truth, even the third angel's message," and goes on to remark "What is meant by 'the third angel's message' is not clear, and the letters of other members of the family, relative to the Second Advent, are equally foggy."[22] She is quoted as closing one letter by saying "I am tired of writing, having been writing pieces for the Review and Instructor" (perhaps a confusion for the *Advent Review and Sabbath Herald,* a Millerite weekly).

Susan and Erastus Elmer were married in 1824, according to their daughter Emeline,[23] probably in Ashfield, but possibly in Stockton, New York, where their first child was born in May 1826. They remained there for the next ten years or longer. On the evidence of the 1835 Census taken in Stockton, this decade was one of severe hardship for them.[24] Whereas Susan's father, a Stockton neighbor with a household of eight persons (he had married as his

third wife a widow with eight children), had forty acres of land, ten head of cattle, sixteen sheep, four horses, and four hogs, Erastus and Susan, with a household almost as large, had only two acres with stock consisting of five head of cattle, four hogs, and no horses or sheep. Compared to other Ashfield families living nearby, they were the poorest in material possessions.

Sometime after 1835 they moved further west, arriving at the town of Marshall, Illinois, near the Wabash River, where on March 1, 1844 their ninth child, Emeline, was born. She recalled that they lived in a log cabin, according to Maud Elmer. At least three, perhaps five, of her siblings died there before the family determined to return to Ashfield in 1847.

Emeline stated that they returned to "the old home," and Maud Elmer mentioned that they had leased their house on "The Four Mile Square Road" before going west (but she mistakenly places their western stay in the years after the artist's birth). The Franklin County Registry of Deeds does not show Erastus Elmer as the owner of any land until April 1851, when he bought a 25-acre plot of land just over the Ashfield border in the town of Buckland for $325. This had been the farm of Reverend Aaron Lyon many years before and was the birthplace, in 1797, of Mary Lyon, founder in 1837 of Mount Holyoke Female Seminary.

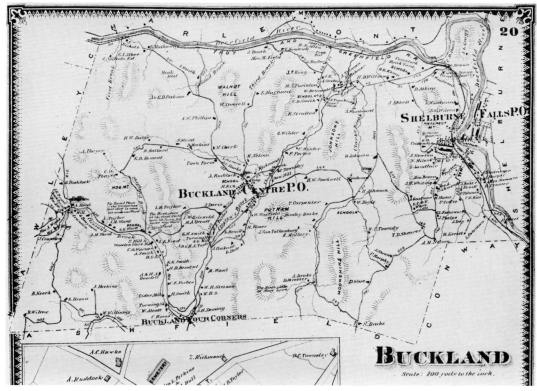

Fig. 4. Map of Buckland, Massachusetts, 1871. From the *Atlas of Franklin County, Massachusetts*, F. W. Beers & Co., New York, publisher.

Mary Lyon had died in 1849, just two years before Erastus bought the farm, but her fame was already growing nationally. The year of her death, the New York firm of Sarony and Major issued a lithograph of the birthplace, and it was not long before Mount Holyoke students would begin to make the more than thirty-mile pilgrimage from South Hadley to Buckland a regular ritual.

The northeastern corner of the town of Buckland is formed by a big oxbow turn in the Deerfield River. On the east side of the river, at the site of large and dramatic falls, lies the town of Shelburne.[25] By the fifties, the power of the river had already been harnessed to establish the beginnings of what would become a flourishing cutlery industry, and the river already sustained a number of other mills as well. But the Elmer farm was on the west, or Buckland, side of the river up in the hills, several miles away from the town and its bustling life. Writing of her own youth there half a century earlier, Mary Lyon called it her "mountain home," a "wild, romantic farm, made, one would think, more to feast the soul than to feed the body."[26] Nevertheless, there was food for the body there, too. "Nowhere else have I ever seen wild strawberries in such profusion and richness as were gathered nearby. Never were rareripes so large and so yellow, and never were peaches so delicious and so fair, as grew on the trees of that favored farm."[27]

The house was a tiny one. In Mary Lyon's day, it embraced a family of eight in its living room and kitchen on the first floor and one bedroom and "open space" on the second. For at least a few of the years between 1851 and 1863 when Edwin Elmer lived there, it probably had to accommodate ten Elmers, including his oldest sister, Clarissa Totman, and her daughter, born the same year as Edwin. Emeline Elmer recalled that her father had partitioned the living room and had the large old chimney replaced with a smaller one to create two additional bedrooms.[28]

Throughout his life the artist returned to this site. He made many views of the house, torn down about 1864, from memory (see cat. nos. 11, 28, 29, & 37), and it appears that the remote beauty of the site and its association with a great woman, the most distinguished citizen produced by the towns of Ashfield and Buckland, affected him strongly.[29] He and his wife often camped on the site in the summertime and on at least one occasion, in 1899, an Elmer family reunion was held there.[30]

In the memoir that the artist's niece, Maud Elmer, wrote more than a hundred years after his birth, she envisioned an idyllic farm boyhood for her father, Samuel, and her uncle. But the years in this house brought more tragedy for the family. In August 1859, their oldest daughter, Clarissa Totman, probably already a widow at 33 years old, died, leaving a young daughter to be cared for. The death of Darwin that December meant that of the twelve children born to Erastus and Susan Elmer, there remained by the end of 1859 only five. Of these, the two oldest, Delilah and Ansel, were probably away from home working much of the time.[31]

Ansel had already worked for a few months in Ohio, as Darwin's traveling agent in the silk-thread trade, before he had brought his brother's body home for burial in December 1859. Evidently he returned west quite soon after that,

settling in Ashtabula County, Ohio, where, according to Maud Elmer, he managed the farm of a former Ashfield resident, possibly Otis Edson.[32]

Maud Elmer recorded that both Edwin and her father, Samuel, exhibited an interest in art from an early age. There are preserved two tiny homemade illustrated books (figs. 5 & 6), handstitched with thread, one bearing the name Edwin and the other Samuel on the cover pages. They both contain sixteen pages of pen and ink drawings, the subjects of which are sometimes exotic—Eskimos and reindeer, or bareback riders with boomerangs hunting ostriches. The same scenes in nearly identical composition are found in each booklet. Maud Elmer believed they were the work of the two brothers, but an equally likely possibility is that they were made as gifts for them by someone else. Whatever the case, it is clear that they were copies in part, at least, from a common source, perhaps one of the tiny childrens' books that were widely popular in the first half of the nineteenth century.

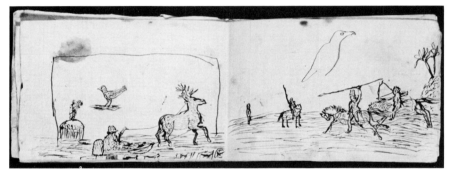

Fig. 5. above. Pages 6 & 7 from a booklet of pictures. Ink, each page approx. 2¾ x 3½". (cat. 1.)

Fig. 6. below. Samuel Elmer. Pages 4 & 5 from a booklet of pictures. Ink, each page approx. 2¾ x 3½". Collection of Evelyn E. Whiting.

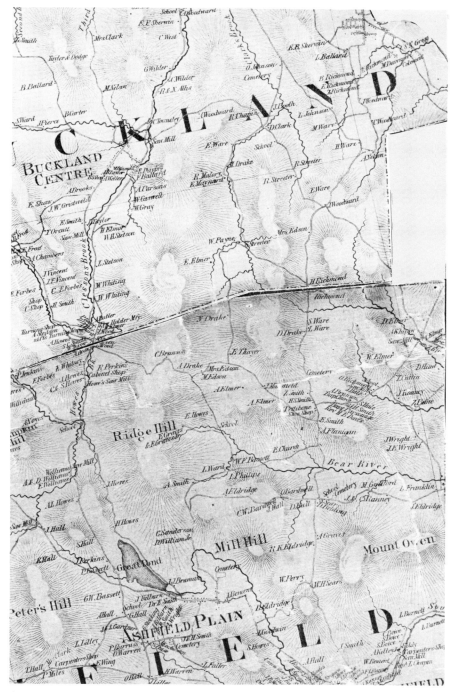

Fig. 7. Map showing parts of Buckland and Ashfield, Franklin County, Massachusetts, 1858. Henry F. Walling, publisher.

In April 1863, Erastus Elmer bought sixty acres of land in the northern part of Ashfield, and in July of the same year he sold "a certain parcel of land situate in the southerly part of said Buckland, being the birthplace of Mary Lyon. . . . Reserving to myself and my heirs and assigns all the maple trees now standing on said land excepting four, and the right to enter upon said land at any time to remove."[33] The move from Buckland back to Ashfield was a distance of about a mile. By the summer of 1865, when the Massachusetts Census of that year was taken, the family had split into two households, one consisting of the parents and Delilah Elmer, and the other headed by Emeline, a young woman of twenty-one, and including Samuel, Edwin, their orphaned niece, Mary Totman, and their grandfather, Israel Smith, now a widower of seventy-nine years. The reasons for this division of the household can only be guessed at; it may have been necessitated by the onset of Erastus Elmer's mental illness (see n. 11).

It seems likely that the move back to Ashfield marked the end of the artist's formal education, which was probably limited to that offered in the local district or common school near the Buckland farm. Ashfield's secondary school, Sanderson Academy (where Mary Lyon had been both a pupil and teacher some forty years earlier), was then in a state of disarray. It was offering one, sometimes two, sessions a year, but it was not then a free academy, and it seems unlikely that the Elmers could have found the money to pay for schooling for their children. Besides helping with the farm work, both Edwin and Samuel also worked for other farmers, cutting wood, among other chores.[34]

In October 1867, Emeline Elmer married her first cousin, Ansel Chapin Elmer, the son of her uncle Ansel Elmer. Probably about this time, the artist and his brother Samuel left Ashfield to go out to Ashtabula County, Ohio to help their oldest and only surviving brother, Ansel, on the farm he was managing.

Ansel, who was twenty years older than Edwin, had lost his first wife sometime after the birth of their second son in 1866, and in January 1870 he married a second time in the town of Ashtabula.[35] If the farm where the brothers were working was indeed that of Otis Edson, it may be that the death of Otis in February 1869[36] was the occasion for them to move into the town of Ashtabula and to begin to organize themselves as dealers in silk thread.[37] Beginning as early as April 1870, Samuel Elmer made regular visits to Cleveland from Ashtabula, no doubt to make business contacts and prepare for the move to Cleveland, which probably took place in the latter half of 1871.[38] In any case, the Cleveland directory for 1872–73 recorded that the Elmer Brothers, dealers in Sewing Silks and Machine Twist, were located at 40 Public Square, and that all three brothers resided at 186 Dodge Street.[39]

In 1870 Cleveland's population stood at 93,000, having doubled during the previous decade. In the seventies it was a very busy commercial town, where many fortunes, not the least of them that of John D. Rockefeller, were being made. The Elmer Brothers' offices on the south side of the Public Square were not only in the heart of the town but at the center of a bustling sewing machine business. Six agencies, representing Singer and Howe, among others, were clustered in this row of buildings, and as early as May 1871 they advertised under the heading "Sewing Machine Place." No advertisements placed by the

Elmer Brothers have been located, but a photograph of 40 Public Square, taken between about March 1872 and September 1873, has been preserved (fig. 8).[40] Legible with a magnifying glass is the firm's name, "Elmer Brothers," above the second floor windows. The large sign "Sewing Silks" on the roof was no doubt their addition as well, as theirs was the only firm in the block to offer sewing threads.

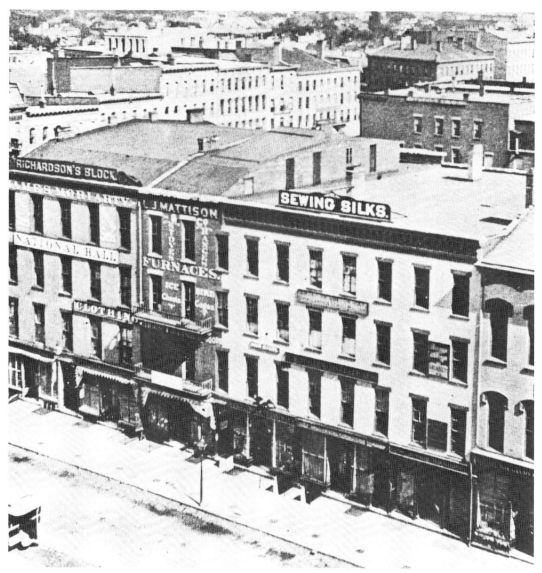

Fig. 8. Cleveland, Ohio, ca. 1872–73. View of the southwest end of Public Square showing the Elmer Brothers' Sewing Silks offices, 40 Public Square, second floor. Courtesy of the Cleveland Public Library, Cleveland, Ohio.

Cleveland was a lively town in these years, but it could not rival the much older Ohio town of Cincinnati in cultural matters. There was an Academy of Music, which occasionally offered some Shakespeare, but more typical of its offerings was "Bertha the Sewing Machine Girl, or Death at the Wheel," which it put on in October 1871, not long after the story on which it was based had been published in the *New York Weekly*. The ad describes the melodrama as "the most successful drama of the present day, illustrating in a vivid manner the trials and triumphs of the working girls of New York."[41]

There was, of course, no art museum in Cleveland at this time, and only in 1876 were there enough artists to warrant the formation of an artists' club.[42] Nevertheless, during the four or so years—from about 1871 to 1875—that Elmer lived in Cleveland, there were a number of galleries where original works of art as well as reproductions of old masters could readily be seen. James Moriarty, whose auction rooms were located two doors away from the Elmer Brothers' offices from about March 1872 to September 1873, and at no time far away, brought collections of paintings from Philadelphia and Brooklyn for auction. Among the artists whose work Elmer might have seen there were Albert Bierstadt, Asher B. Durand (described in one of Moriarty's ads as "the champion artist of the country"), John F. Kensett, A. F. Tait, George Loring Brown, Regis Gignoux, Ralph Blakelock, Aaron Draper Shattuck, M. F. de Haas, Morston C. Ream, George Cochran Lambdin, and others. The picture and frame dealer J. W. Sargeant frequently stocked large quantities of Braun's autotypes of masterworks from all the major European collections. The photographer James F. Ryder often showed original works of art, as well as imported engravings and reproductions, in his photograph gallery and studio. Indeed, he was responsible for starting Archibald Willard (1836–1918), the genre painter most famous for his *Spirit of '76*, on his road to his modest success, first by publishing a couple of anecdotal pictures called *Pluck, No. 1* and *Pluck, No. 2,* about 1872. In 1874, he got the poet, Bret Harte, to sit for a photograph and during the session persuaded him to write a poem to go with a painting that Willard had just sent him called *Deacon Jones's Experience*. Still later he gave *The Spirit of '76* its first showing.[43]

The most famous artist in Cleveland during the years Elmer was there was probably Caroline Ransom (1838-1910), a portrait and landscape painter who had gained national attention in 1871 because of a commission she received from the U.S. Congress to paint a full-length portrait of the Civil War hero Major General George A. Thomas for the Capitol. A graduate of Oberlin, she had studied with Asher B. Durand, Thomas Hicks, and Daniel Huntington in New York.

In her memoir Maud Elmer stated that Elmer and his brother "made friends with artists and in their spare time painted and sketched" during their Cleveland years. While they probably did not make friends with Miss Ransom or Archibald Willard, they may have known De Scott Evans (1847–1898), a portrait and genre painter who came to Cleveland about 1874 (he is listed in the city directory of 1875–76), or possibly an artist named Leonora L. Fox who gave private lessons in "drawing and painting from the cast, life and nature."[44] Miss Fox had at-

tended the Cooper Union School of Design for Women in New York in the years 1863–65. In 1866 she joined the faculty of the Cleveland Academy, run by Linda T. Guilford, an 1847 graduate of Mount Holyoke Female Seminary, who had been a student of Mary Lyon. Miss Guilford notes that in Leonora Fox's classes "began the first systematic teaching in art in this vicinity."[45] Miss Fox had begun giving private lessons before her departure from the Cleveland Academy in 1872 and her ads continued as late as the spring of 1874.

Fig. 9. De Scott Evans (American, 1847–1910). *Teaching the Bird Her Song.* 1891. Oil on canvas, 27 x 18½. Courtesy of the Berry-Hill Galleries, New York.

Elmer may also have enrolled in the Free Drawing School, which opened in February 1873 at the Central High School, offering evening classes in mechanical and freehand drawing.[46]

While they were participating in the artist's life of Cleveland, the Elmer Brothers silk thread business may have been faltering a bit. In any case, by 1874 they had added cigar manufacturing to their enterprises and probably by the end of 1874 Ansel had separated himself from the firm and become an independent silk merchant.[47]

Sometime in late 1874 or early 1875 Edwin and Samuel returned to Massachusetts[48] and took up residence with their parents, who at this time were living on a five-acre plot on the Buckland side of the Deerfield River, about a mile from the town of Shelburne Falls.[49] Evidently the brothers' years in Cleveland had been at least moderately prosperous for not long after their return they began to build for their parents a mansion such as they had never before lived in. Maud Elmer said the house (fig. 10) was modeled after one or more that the brothers had seen in Cleveland. Certainly there were many similar houses in Cleveland in the 1860s and 1870s, and houses of this general plan and style—bracketed Italianate—were being built in towns all over the northeast and middle west at the time.

Many details of the Elmers' house were not, however, run of the mill—for instance, the subtly rounded windows, or the caps and keystones over the win-

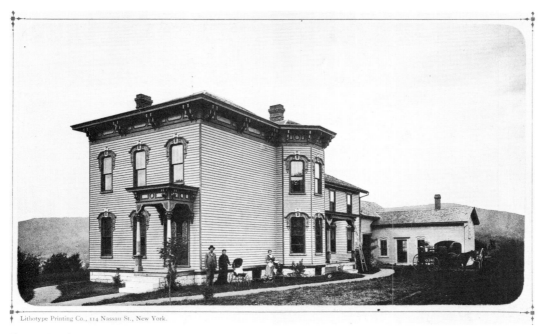

Lithotype Printing Co., 114 Nassau St., New York.

Fig. 10. Elmer House, Buckland, Massachusetts, ca. 1880–81. Photograph, 4 x 7", by Lithotype Printing Co., New York. Collection of Mrs. Robert Luce.

14

dows which appear to be homemade, nor indeed the marbleized porch columns with their Corinthian-style capitals.[50] There is no record to show where or when the brothers learned carpentry skills and some sources say that they received a good deal of help from their cousin, John H. Elmer.

If the house reflected a degree of financial success during the past years in Cleveland, it symbolized even more a determination to extricate the family from

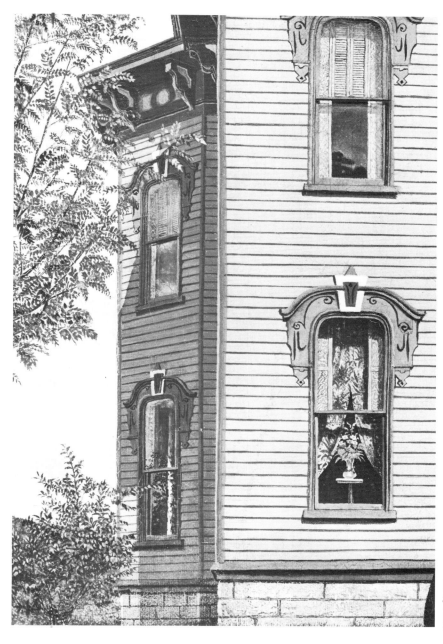

Fig. 11. *Mourning Picture.* 1890 (detail, fig. 55).

the decades of poverty and subsistence farming that it had experienced. Certainly it was clear that the brothers did not intend to return to farming, nor did they want to give up the big-city pleasures to which they had become accustomed. On the second floor of their house they provided themselves with a billiards room, since the nearby town of Shelburne Falls lacked any such facility—an oversight they were soon to correct.

The July 31, 1876 issue of the *Greenfield Gazette and Courier* notes that "The Elmer brothers are building a very fine house and barn in a conspicuous place on the Buckland side [of the Deerfield River]." That the house was completed in 1876 is recorded on a painted keystone in the front hall (fig. 14), which is also decorated with painted *trompe l'oeil* columns, whose shadows lengthen the farther they are from the front door (fig. 12). In her memoir Maud Elmer recalled "Uncle Edwin's drawing books in which were beautiful pencil work and especially, studies in perspective, accurately figured out by the length of the shadows cast from a half-opened door." Elmer also decorated the walls of the billiards room. A taste for frescoed walls was also a legacy of the big city. There were several fresco establishments in Cleveland in the seventies that were kept busy filling commissions in houses and offices, such was the popularity of this type of decoration.

In September 1876, the brothers had opened a billiards parlor with two tables in a room above a restaurant in Shelburne Falls.[51] Billiards was not regarded with the same suspicion as pool, but there were occasional complaints in the local paper that it caused young men to waste their time and money. Perhaps

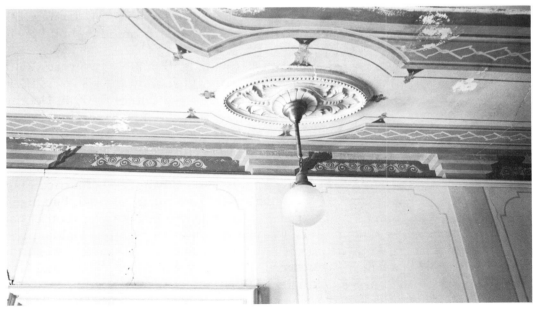

Fig. 12. Elmer House, Buckland, Massachusetts. Front hall.

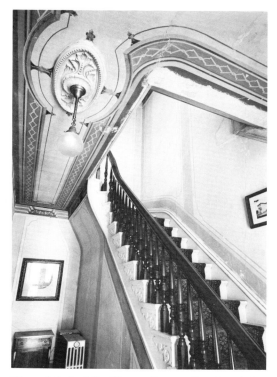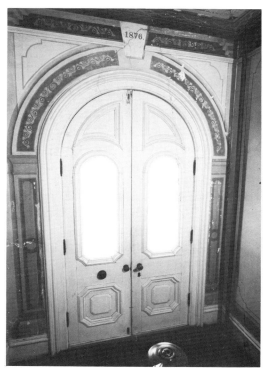

Figs. 13 & 14. Elmer House, Buckland, Massachusetts. Front hall.

some kind of local disapproval manifested itself because the business did not last long. The next notice of the brothers is a newspaper report of January 28, 1878 that they were the proprietors of oyster rooms in another building in Shelburne Falls.[52]

The brothers shared the house with their parents for almost two years, until March 1878, when their mother died. The father then moved back to Ashfield having sold his sons the land on which the house was built for $700 in December 1877.

In June 1878 Samuel married Alma Whiting, the daughter of their neighbor across the road, Joseph W. Whiting, a farmer and citizen of some standing in the town. Their daughter, Maud, was born in 1879.

On November 2, 1879, at the age of twenty-nine, Edwin Elmer married Mary Jane Ware, an Ashfield girl ten years his junior. Her father, Samuel, had died a prisoner of war at Andersonville prison in Georgia and in 1866 her mother had married Edwin's first cousin, John. Edwin and Mary went off to Halifax, just across the border in Vermont, to get married, perhaps because there was little money in the bride's family for a formal wedding. John Elmer had a small farm and was a hunter of sufficient skill to enable him to earn some income by it, but he does not seem to have had a great deal of money at any time. The following June 29, the artist's daughter and only child, Effie Lillian, was born.

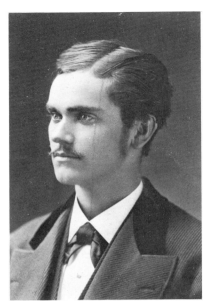

Fig. 15. Samuel Elmer, ca. 1873? Photograph, 3¾ x 2¼″, by J. F. Ryder, Cleveland, Ohio. Collection of Evelyn E. Whiting.

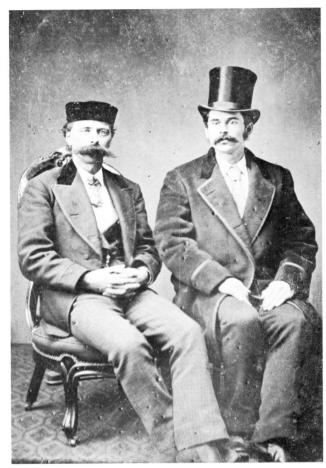

Fig. 16. John H. Elmer and Edwin R. Elmer, ca. 1880? Tintype, 3⅞ x 2½″. Collection of Mrs. Robert Luce.

Apparently the oyster rooms did no better than the billiards parlor, because by September 1879 the brothers had become manufacturers of churns, washing machines, and clothes wringers for which they won premiums at the Old Society's Cattle Show at Greenfield, Massachusetts.[53] The washing machine (fig. 108) and the clothes wringer had been invented by others, but the churn, Elmer's Double-Acting Churn (figs. 112 & 113), was the invention of the artist and his cousin, John H. Elmer, in 1880.[54] In a promotional handbill (fig. 114) the artist explains the "double" action: "In churning when the cream is thin, place the large wheel on the first gear until the cream begins to thicken, then change to a slower and easier motion, in order the better to separate and work over the

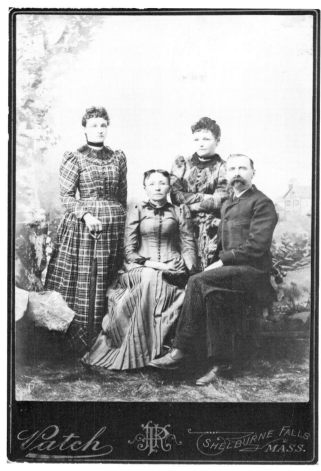

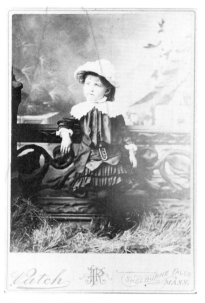

Fig. 18. Effie Lillian Elmer, ca. 1889. Photograph, 5⅜ x 4″, by J. K. Patch, Shelburne Falls, Massachusetts. Collection of Mrs. Kenneth L. Beals.

Fig. 17. The John H. Elmer family, ca. 1889. Standing left: Mary (Ware) Elmer, wife of the artist; right: Lucy (Ware) Barnes, her sister. Seated left: Jane (Payne) Ware Elmer, their mother; right: John H. Elmer, her second husband, Photograph, 6⁷/₁₆ x 4½″, by J. K. Patch, Shelburne Falls, Massachusetts. Collection of Mrs. Charles T. Bingham.

butter." The churn was manufactured in five different sizes and the largest size, with a capacity of four to twelve gallons, could be bought with a crank on each end. By October 1880 the newspaper reported that "The Elmer Bros. now contract for their churns in 500 lots. Nearly all competition with them has ceased, and every good housewife thinks she must have one of their churns."[55] It is hard to know how accurate such reports were or, indeed, how long the business continued. The artist did not sell his interest in the churn until 1903, but reports of the progress of the business cease after the promotional handbill, probably put out in the spring of 1881.

By June 1880, when their daughter Effie was born, the artist and his wife had

become the sole occupants of the big house. Samuel, following his marriage, had resumed what must be regarded as a family occupation—the selling of silk thread—and was a traveling agent for a New Haven firm. His wife and daughter, Maud, had moved in with her parents across the road.

Mary Elmer was known not only for her beauty and quick wit, but also for her cooking, and to help fill the large house and, no doubt, their coffers, the Elmers began in 1883 to take in summer visitors.[56] Maud Elmer said they continued to do so "for a few summers, but when it became too exhausting for his wife, Edwin was glad to give up the project."

Evidence that the artist was in some financial straits comes also from the fact that in a deed dated June 18, 1884 he sold back to his brother Samuel his half interest in the Buckland house and land for $4,000. Samuel was at that time living in Boston and the artist remained in the house.

In August 1885, Elmer applied for another patent, this time for what he described as a shingle or roof bracket (fig. 116). Used in pairs, it was meant to be clamped to a roof to serve as a support for the plank on which the shingler stood. It was designed to adjust to the cant of any roof.[57]

Maud Elmer recalled that "Edwin's knowledge of mathematics was remarkable and his skill was further trained by doing advanced and difficult problems given in the 'Boston Post.' He was often the only one sending in the correct answer."

His final known effort at inventing has been memorialized in the painting of his wife done in 1892 (fig. 68). This machine was a device for making whipsnaps—the ends of horse whips—by means of a crank and gear system that twisted and braided the silk thread (fig. 109).

He did not patent the invention, but it was probably devised during the first part of 1886, and produced in rather small quantity by June 1887.[58] In October 1887 the Greenfield paper took note of the fact that Samuel Elmer had introduced the whipsnap industry to the locale,[59] and in November of that year Samuel brought suit against George H. Fessenden, Ashfield's doctor, claiming that he had injured Samuel's business by telling one of his employees in this cottage industry that the thread she was working contained arsenic. In the court records Samuel states that he has "for a year and more past been engaged in the business of manufacturing whipsnaps from silk threads of various colors and has during said period, employed in said manufacture divers persons resident in the towns of Ashfield and Buckland or Conway. . . ."[60] After losing the first round, Samuel won on appeal. His victory hinged in part on whether one of the employees who had testified originally said the doctor told her about the arsenic before or after "a certain machine for working the silk had been taken away from the house." The earlier court records were admitted under protest and they showed that she had said before, thus establishing that she stopped doing the whipsnaps for Samuel only after the doctor mentioned the arsenic to her. He never produced any proof of the presence of arsenic in the thread. The court papers also reveal that Edwin Elmer served as his brother's agent in the managing of this little industry, since Samuel was then living in Boston.

On his marriage license in 1879 and in city directories as late as 1888 he

listed his occupation as mechanic or manufacturer of churns and washing machines.[61] Although it seems quite clear that he was making pictures during the 1870s and 1880s, art was evidently still a pastime to him. In August 1888, he sold his interest in the shingle-bracket invention, and it may be then that he began to think about becoming a full-time artist. It is doubtful that the manufacture of the churns and washing machines was occupying much of his time.

An event that may have had much to do with his decision to try a new career as a full-time artist was the death from pericarditis of his daughter, Effie, on January 3, 1890. According to Maud Elmer, who was living in New York City with her father and his new wife at this time,[62] Mary Elmer was so overcome with grief that she could not bear to look at other little children and did not wish to remain in the big house any longer. Maud goes on to say that "They stayed long enough for Edwin to paint a portrait of Effie, now called 'The Mourning Picture,' owned by Smith College (fig. 55). When this was finished Edwin gave away the pet lamb, kittens, and the hen 'Dody' to me. Edwin made a box in which they stored Effie's clothing, books, and playthings. They took this with their furniture and went to live with Mary's mother and stepfather John Elmer in 'Baptist Corner.'"

The stay in Baptist Corner was probably very brief, because by May 1890 the Shelburne Falls reporter for the Greenfield paper noted that "E. R. Elmer of this village" was exhibiting a crayon portrait of Joseph Wilder, the late Shelburne Falls postmaster, in the post office. This, the first mention of a work of art by Elmer, was certainly not an original work: it was, rather, an enlarged photograph worked up with crayon and perhaps airbrush.[63] The Elmers were probably already living in an apartment in the Gilbert Mitchell house on Pleasant Street in Shelburne Falls.

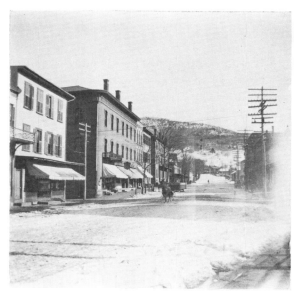

Fig. 19. Bridge Street, Shelburne Falls, Massachusetts, ca. 1895? Photograph, 3¼ x 3¼", probably taken by Elmer. Collection of Mrs. Robert Luce.

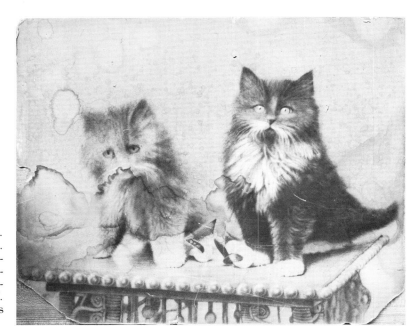

Fig. 20. Elmer. *Two Kittens,* ca. 1892. Enlarged photograph with airbrush and watercolor, 15⅞ x 20″. Collection of Phyllis Joyce.

Although Elmer appears to have begun to try to earn money from crayon portraits at this time, he had not given up other business ventures. In the fall of 1890, he built a shingle mill on the Buckland side of the river.[64] The destruction of this mill by fire in August 1892 may have ended his attempts to be an ordinary businessman.[65]

The artist's reaction to the death of his daughter was not recorded by Maud, but Effie was memorialized by him in the painting she mentioned. Whatever his feelings, he was evidently proud of the picture and did not regard it as a private family document, because he showed it at the Shelburne Falls post office in November 1890. The Greenfield paper's laconic description reads, "In the post office hangs a very fine oil painting of Edwin Elmer, wife, daughter, pet lamb, house and mountains, executed by Mr. Elmer, who is quite an artist."[66] The correspondent, who had touchingly reported Effie's death ten months before, apparently felt it would be indelicate to mention the memorial nature of the picture or call attention to the mourning dress of the artist and his wife.

Beginning in the second half of the nineteenth century and continuing into our own day, many cities and larger towns of New England, the Northeast, and the Middle West held annual fairs, usually called agricultural fairs since the judging of livestock was the main feature. But almost always there was, in addition, horse racing, oxen or horse pulls, and competition in other fields such as mechanical arts, baking, sewing, and art. Two such fairs were held near enough to Shelburne Falls to permit Elmer to try his chances at them on a regular basis.

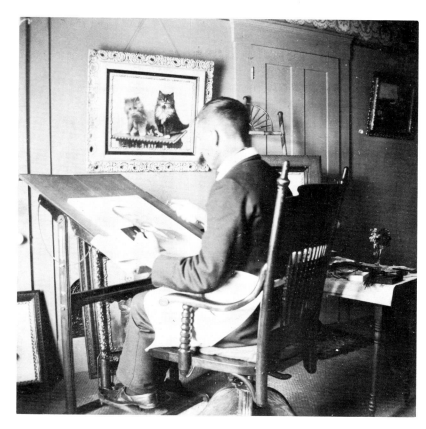

Fig. 21. Elmer using a pedal-operated airbrush, at his apartment in the Gilbert Mitchell house, Shelburne Falls, Massachusetts, ca. 1893. Photograph, 3⅜ x 3¼". Collection of Evelyn E. Whiting.

One was the Deerfield Valley Fair held in Charlemont and the other, in Greenfield, was the Old Society or Franklin County fair. Premiums were awarded to winners in various divisions, ranging from twenty-five cents to as much as three dollars in the fine arts section. Elmer appears in newspaper reports as a premium winner—for an oil painting and crayon portraits—at the Deerfield Valley Fair in 1891.[67] During the next decade he showed frequently at both fairs and often, but by no means always, won the highest premium. Almost all his competitors appear to have been amateur women artists.

Another way by which Elmer brought his work to public attention was to exhibit it in shop windows and he seems quite often to have persuaded local businessmen to show a painting or two. A newspaper report of such a showing is the only record of the fact that he also had a brief career as a teacher of art.[68]

By May 1892 he had intensified his efforts to make a living doing crayon portraits.[69] A photograph of the period shows him seated at a drafting table at work with his airbrush on one of these touched-up photographs (fig. 21). Enlarging daguerreotypes and tintypes or paper prints and then painting or drawing over them to conceal the photographic image was widely practiced in the last quarter of the nineteenth century. The product was immensely popular among

those who wanted a portrait of a family member—often one who had died—but could not afford to commission a painted image. Though evidence of hand work was expected, obviously no deception was intended by it, since the purchaser had provided the original photograph. At the time, everyone recognized the type and knew how it had been made.[70] Elmer could have learned something about the technique while he was still in Cleveland, where the photographer James F. Ryder advertised crayon portraits of this kind regularly—especially at Christmas time. There were books and articles available to instruct the novice.[71] The local Shelburne Falls photographer, J. K. Patch, had several people making crayon portraits for him in the nineties, at the same time Elmer was beginning to make a business of them himself. Most of Elmer's portraits are undated, but the existence of several dated as late as 1919 shows that he continued making them almost to the end of his life. The memorial portrait, such as that of the postmaster, his first publicly noticed work, seems to have been his specialty. Many of the extant examples have ornate black or silver frames of a distinctly funereal character.

Fig. 23. Elmer. *Portrait of Harriet Landon Beals.* Enlarged photograph with airbrush and charcoal, 16⅞ x 14". Collection of Mr. and Mrs. Kenneth L. Beals.

Fig. 22. Harriet Landon Beals. Photograph, 5½ x 4", by Silver, Ludington, Michigan. Collection of Mr. and Mrs. Kenneth L. Beals.

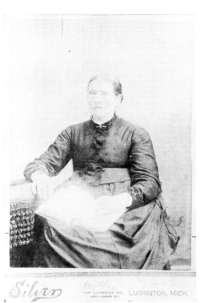

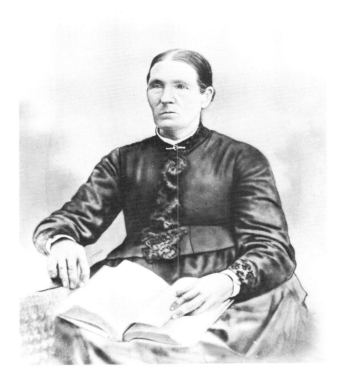

The business of crayon portraits and frames evidently prospered for a few years because in June 1896 he bought a wagon (fig. 24) to enable his agent, his wife's nephew, to get around the countryside securing new orders and delivering finished ones.[72] At the same time he had also started a sideline in frames and mats.

Like so many of his enterprises, however, this one too did not last. In January 1898, about a year and a half after he had bought his fine wagon, he sold his picture frame stock to a local businessman with the intention, according to the paper, of going to Alaska.[73] Reports of "Klondike fever" appeared often in the papers in the spring of 1898, but by April Elmer had changed his mind.[74]

Whatever his earlier training in art may have been, he apparently felt he needed more, and in the fall of 1899 he and his wife went to New York, where he had enrolled himself as a private student of the genre painter Walter Satterlee (1844–1908). How he came to select Satterlee as his master can only be surmised. From 1879 onwards he could have seen original works by him in the widely praised collection of contemporary American paintings being formed at

Fig. 24. Elmer's wagon, ca. 1896. Photograph, $3^{3}/_{16}$ x $3^{5}/_{16}''$, probably taken at the Deerfield Valley Fair, Charlemont, Massachusetts, or the Franklin County Fair, Greenfield, Massachusetts. Collection of Mr. and Mrs. R. Russell Luce.

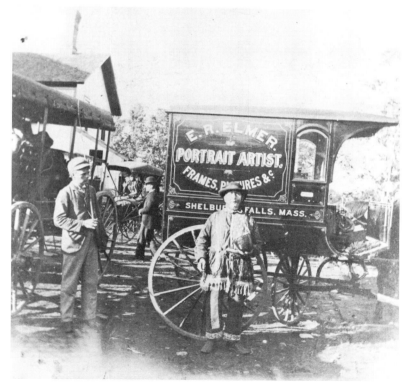

E. R. ELMER.

Portrait, Landscape, and Composition

:o: ARTIST :o:

BOTH IN OIL AND CRAYON.

SHELBURNE FALLS. - - MASS.

Fig. 25. Business card, ca. 1895?
Connecticut Historical Society,
Hartford, Connecticut.

Fig. 26. Business invoice,
1890s. Smith College Museum of
Art.

Smith College in nearby Northampton. The College's first president, L. Clark Seelye, frequently bought works direct from the artists, and in 1879 he had acquired a painting from Satterlee.[75] Between 1880 and 1895 Satterlee, who was a popular artist in his day, was also an annual contributor to the ambitious exhibitions of contemporary American art organized by the enterprising Springfield art dealer, James D. Gill.[76] Finally, Satterlee had been a student of Edwin White (1817–1877), a native of South Hadley, Massachusetts (the home of Mount Holyoke College) and a very successful history and genre painter, whose work Elmer might have learned about.

Satterlee, an Associate of the National Academy of Design, showed there almost every year from 1886 to 1900. In addition, he evidently did illustrations for publishers like Prang. In a Letter to the Editor of the Shelburne Falls paper, the *Deerfield Valley Echo,* published in the November 20, 1899 issue (see Appendix A). Elmer reports from New York that he has "just received the unexpected compliment of being commissioned to make reproductions in colors from his [Satterlee's] original paintings for the holiday trade at a good price, which with my portraits that I have to make will be all I can possibly do this winter outside my studies." Prang catalogues include works by Satterlee with titles such as *Christmas Design, Christmas Eve, Santa Claus,* and perhaps Elmer was taken on to help produce renderings from which the chromolithographs could be made.[77]

In his letter Elmer went on to report that he had "also recently had the honor of being admitted to the National Academy of Designs [sic] of New York City,

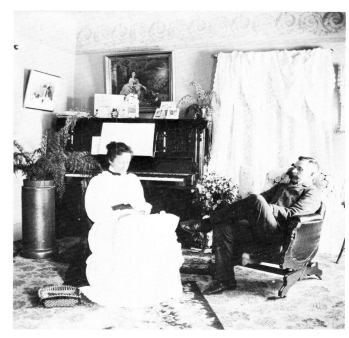

Fig. 27. Edwin and Mary Elmer in their apartment in the Gilbert Mitchell House, Shelburne Falls, Massachusetts, ca. 1893. Photograph, 8⅜ x 8⅜". Collection of Evelyn E. Whiting.

being one of a few selected by the committee after one weeks [sic] competition with over 300 art students." He observes that the Academy admits only "artists of recognized merit, and many of these are placed on probation. I am permanently admitted for the season. . . ." He was admitted to classes in painting, sketching and drawing from the antique, but not to the life classes. He writes that "these are the highest classes in the Academy, and I hope to be advanced to that class in February."[78] The program of study was quite time-consuming, and for a man in his fiftieth year to study both at the Academy and privately, and at the same time continue to turn out crayon portraits, the year in New York must have been a demanding one.

Further accounts of his stay in New York are lacking. He returned to Shelburne Falls in May 1900 and rented a studio on Main Street. Styling himself E.R. Elmer, N.A.D., Portrait Artist, he advertised in the local paper.[79] This new phase of his career began with a small flurry of activity. In early July he received a commission to "paint" a portrait of a recently deceased benefactor of the library, George Mirick.[80] In September the ladies of the Baptist Church hired him to do a crayon portrait of their pastor[81] and he also got the job of designing the frontispiece for the local opera house program.[82]

About this time he and his wife began to take long trips into the countryside in his wagon, drumming up crayon portrait business and taking photographs on which he could base his pastel landscapes. According to Maud Elmer, he had acquired and mastered the technique of pastel during his New York stay, and it became from this time forward his preferred medium.

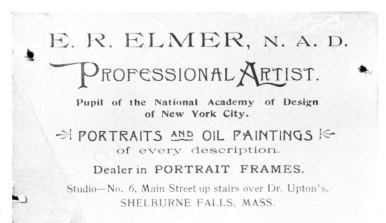

E. R. ELMER, N. A. D.
PROFESSIONAL ARTIST.

Pupil of the National Academy of Design
of New York City.

⇥ PORTRAITS AND OIL PAINTINGS ⇤
of every description.

Dealer in PORTRAIT FRAMES.

Studio—No. 6, Main Street up stairs over Dr. Upton's.
SHELBURNE FALLS, MASS.

Fig. 28. Business card, ca. 1900–1908. Collection of Ernest Pike.

In January 1902, his brother Samuel died in Gloversville, New York where he had moved in 1897. He had exchanged the big Elmer house in Buckland for real estate in Gloversville, and the house was owned very briefly thereafter by two different Gloversville businessmen. Edwin was the executor of the estate, but his duties were tragically lightened the following July 4 by an accident on a short railroad line recently completed by the company of which Samuel was president. It went from Gloversville up to Mountain Lake, where he owned resort property and where the local citizens liked to go on day trips. Fourteen people died in the accident and the resulting settlement eradicated Samuel's estate.[83]

Up until 1904 Elmer seems not to have shown a large number of his works in any one exhibition, but in September of that year he arranged to show a large group at the Brattleboro, Vermont agricultural fair.[84] Perhaps encouraged by its success, he decided to have a show in Shelburne Falls. This first of a series of four annual shows was held in a room over the local savings bank in November. A newspaper account stated that there were "over 40 oil paintings, pastels, charcoals and crayons, all hand work, painted by himself."[85] After the show closed the *Deerfield Valley Echo* reported that he had sold twenty pictures[86] and the *Greenfield Recorder,* which published two paragraphs on the show (see Appendix A), named several works, among them a townscape including Arms Academy, the local high school, and a picture called *Violin and Music,* which are unlocated.

A second annual show was held in November 1905 at C. W. Ward's Ice Cream Parlors at 10 Bridge Street, the principal street of Shelburne Falls. Newspaper accounts, which are the only records of the show, state that about 100 oil paintings, pastels, and crayons were exhibited, of which a third were sold.[87] The show was thus about twice the size of the previous year's presentation. It probably included some landscapes done in and around Northampton, including views of Mount Holyoke, because Elmer had spent a week in the town that October and had shown at Northampton's Tri-County Fair.[88]

STUDIO OF

E. R. ELMER,
ARTIST.
INK, CRAYON, SEPIA, WATER COLOR
AND OIL PORTRAITS.

PORTRAIT FRAMES OF EVERY DESCRIPTION.

Shelburne Falls, Mass., 190

Fig. 29. Business invoice, ca. 1900–1908. Collection of Mrs. Robert Luce.

The Elmers spent the summer of 1906 in Ashfield because, the newspaper reported, Elmer was in "poor health caused by a too close application to his business as an artist for the past 15 years."[89] The notice mentioned that he intended to devote only half his time to business, the balance to "outings." Besides making pictures, Elmer's professional cards and letterheads of the period (figs. 28, 29 & 105) show that he was carrying on Samuel's silk thread and machine twist trade as well as selling "portrait frames."

On his return to Shelburne Falls in the fall he put on several exhibitions at local functions[90] and prepared for his third annual exhibition to be held again at Clarence Ward's Ice Cream Parlors in December. It is the only one of his shows for which a checklist has been found (figs. 106 & 107). About a third of the ninety-three works in this exhibition can be identified with reasonable certainty with extant works. The newspapers are silent about the success of the show as they are, indeed, about all Elmer's activities for the next year.

His fourth, and last, annual exhibition was held in a new addition to Simon Schmidt's variety store. The show opened on December 14, 1907 and continued through the holidays.[91] No other information about it has been found.

Whether from reticence or disinterest, Elmer rarely participated in civic activities. He was, for a time at least, a member of the local businessmen's club and, as the town's artist, was made chairman of their committee to organize a town beautification competition one year.[92] He played once or twice in billiards tournaments, but otherwise he seems to have taken no active part in the town's life.

Since their return from New York, the Elmers had lived at 6 Main Street, known as the Briggs Block. In July 1907, Mrs. Briggs, who ran a boarding house at that address, decided to retire and, if the Elmers were boarders and not renters, this may have led to their decision to return to Ashfield. In any case, by the summer of 1908 they were settled in the Baptist Corner district of Ashfield, very near where the artist had been born and close to the houses of his sister,

29

Emeline, his wife's sister, Lucy Barnes, and the John Elmer farm.[93] Probably at the death of Jane Elmer, the artist's mother-in-law, in 1909, they moved to the John Elmer farm, which they bought in 1911.

Edwin Elmer, now sixty-one years old, from this time forward apparently devoted much of his time to farming, particularly his apple orchard.[94] Nevertheless, he continued to paint and make his crayon portraits in an enclosed shed that he fitted out as a studio, with green baize on the walls.

On January 25, 1923, at the age of seventy-two Edwin Elmer committed suicide with a shotgun. He had been suffering for some time with abdominal cancer, which, the doctor noted on the death certificate, had been diagnosed as incurable. He had already been confined to the Franklin County Public Hospital and at his death owed $113 in hospital, doctors', and nurses' bills. By one account, he decided to end his life, knowing his illness was fatal, so as not to dissipate further the small estate that would have to sustain his wife. It amounted to $2,519.10, including $800 worth of "furniture and pictures."[95]

So little of a personal nature has been recorded about the artist that it is difficult to imagine what kind of man he was. As compared to Samuel, who was known as an energetic and enterprising businessman, Edwin was certainly the more reserved. Nevertheless, those few alive now who can remember him as an old man agree that he was not shy. Indeed, people who knew Edwin and Mary Elmer in the early years of the century recall that they were a gay and lively couple. There is even a certain flamboyance in the decision of the brothers, on their return from the West, to build a mansion to catch all eyes, with a billiards room on the second floor—probably the only room of this kind in any Shelburne Falls or Buckland house. There was a black marble fireplace and frescoed walls. Recollections from later times reveal that they evidently flouted conventional manners by serving spirits and they remained outside any organized sect. Given the fact that two violent tragedies in their family history were linked to religion, it is not surprising that they might have determined not to associate themselves with the church (see n. 11). Elmer was said to be a meticulous dresser throughout his life; in later years, as a farmer, he always changed his clothes for the midday meal. Many people recall seeing him about the town and countryside in a white suit with his easel and umbrella, and he was obviously regarded as a mild eccentric.

Elmer does not, however, seem to have been a colorful town character about whom stories were told. Rather, he appears to have been the object of gentle condescension. People just didn't regard him as someone of importance. His origins in poverty and his limited education would have been known to all, but it was probably his lack of success at business that really determined the contemporary view of him. His art was interesting and unusual, but despite the frequent newspaper references it really didn't count, and in the eyes of his fellow townspeople he really didn't count, either.

After Mary Elmer's death in September 1927, members of her family arranged an auction of her effects, which included many of Elmer's pictures, though certain ones were retained by family members. At the end of the day there was still a wagonload of pictures and these were put under a shed near the barn.

Years later, when the property was sold, family members looked for the pictures, but none were found. Three paintings in an Ashfield private collection which are noticeably water stained may have originally come from this cache.

The artist's older sister Emeline did not die until 1939, at the age of ninety-five. Besides the *Lady of Baptist Corner* (fig. 68), she owned a number of works by her brother (including figs. 39, 49, 50 & 71), which were sold at the auction of her estate in 1940. The list of her effects includes twenty-six "paintings" and "pictures," but there is no way of telling how many were his. Her heirs had little interest in his paintings. Whatever small acclaim he may have won among the people of Shelburne Falls, Ashfield, and Buckland was by 1940 long forgotten.

Maud Elmer had accepted a teaching position in the Seattle public schools in 1908, and she remained in the West, with frequent visits to her home, until her retirement in 1945. She had become in the meantime the supervisor of art for the public schools. When she returned to Massachusetts in 1945 she set about trying to gain some recognition for her uncle's art. His work was seen on several occasions in Shelburne Falls,[96] and she devoted considerable effort to locating works in private collections. In March 1950, she visited the Smith College Museum of Art to see an exhibition of the work of John F. Peto, the *trompe l'oeil* still-life painter. Alfred Frankenstein, critic of the *San Francisco Chronicle* and an authority on American still-life painting, had selected the show and written the catalogue.[97] On March 20, he came to Northampton to deliver a lecture on Peto. It was perhaps on this occasion that Maud brought Elmer's work to his attention and to that of the Museum's Director, Henry-Russell Hitchcock, and its Assistant Director, Mary Bartlett Cowdrey, an authority on American nineteenth-century painting. In any case, that spring she showed them photographs of the *Mourning Picture* (fig. 55), the *Lady of Baptist Corner* (fig. 68), and the *North River* (fig. 76). Later in the summer she brought in *Magic Glasses* (fig. 64) and placed it and *Mourning Picture* on loan at the Museum. Miss Cowdrey and Mr. Hitchcock began then to plan the exhibition of his work which was held at Smith two years later. They asked Mr. Frankenstein to write the catalogue essay which was also the text of his article "Edwin Romanzo Elmer," written for the October 1952 issue of the *Magazine of Art*—the first published study his work had ever received.

In July 1950 Elmer's work had already attracted the attention of the national press[98] when *A Lady of Baptist Corner* was shown in the exhibition, *American Processional, 1492–1900,* at the Corcoran Gallery in Washington.[99] Its presence in that show was the result of the professional instincts of its owner, E. Porter Dickinson, a librarian at Amherst College. He had bought the picture from the estate of Emeline Elmer shortly after her death in 1939. He very soon had it photographed and sent a print to a former colleague then on the staff of the Frick Art Reference Library in New York, well known for its extensive picture collection. Elizabeth McCausland, former art critic of the *Springfield Republican* and author of monographs on several American nineteenth-century artists, was engaged as a researcher for the Corcoran show. In the words of the catalogue's Acknowledgments, she and an assistant

"Dorothy P. Miller, searched the entire American files of the Frick . . ." where they found the Elmer photograph.[100]

A hundred years after his birth, through the efforts of a devoted niece and because of a librarian's desire to add to the record, Elmer's work was brought out of obscurity.

Notes to Part I

1. Brocéliande (now called Paimpont), was a forest in Brittany which was the setting of many medieval romances and, in Arthurian legend, the home of Merlin the Enchanter. (See *Oxford Companion to French Literature.* Sir Paul Harvey & J. E. Heseltine, eds., Oxford, 1959.)
2. Norton and Howe, *Letters of Charles Eliot Norton.* vol. 1, pp. 273–74.
3. *Ibid.,* vol. 1, pp. 270–71.
4. *Greenfield Gazette and Courier.* August 21, 1864.
5. The stereotyping of the more recently arrived immigrants was widespread in the press of the day. Local Franklin County newspaper stories about the factory workers, most of them foreign-born, usually mentioned the Irish (or "Celtics" as they were sometimes archly called) when there was a drunken brawl to report. Italians made the news for their crimes of passion, while the Germans were usually praised for their sober, law-abiding industriousness.
6. The first American Elmer, Edward, arrived in Boston in 1632 aboard the ship *Lion*, out of London. In William W. Johnson's genealogy of the Elmer-Elmore family in America, the name is derived from Aylmer, and the line traced to the Bishop of London of that name, an advisor to the first Queen Elizabeth. In 1636 Edward Elmer joined the party of Rev. Thomas Hooker, which traversed the wilderness between Boston and the Connecticut River and established the town of Hartford, of which Elmer was one of the first proprietors. He moved up the river to Northampton, Massachusetts, where he appears as a landholder at the time of that town's founding in 1654. He returned to Hartford, but succeeding generations moved north again, among them Edwin Romanzo Elmer's great-grandfather Samuel, who in 1773 bought lands in Ashfield, in Franklin County, Massachusetts, in the Berkshire foothills to the west of the Connecticut River. His descendants lived on or very near these lands in the Baptist Corner district of Ashfield until 1939 when the artist's sister Emeline (Elmer) Elmer died. Her descendants still live in other parts of the town, the only blood relatives of the artist remaining.
7. A letter of April 28, 1850 written from Stockton, New York by Ebenezer Smith, Jr. (a great-uncle of the artist) to his nephew, Rev. Preserved Smith of Deerfield, is preserved in the College History Archives of Mount Holyoke College. It describes the look of the place in about 1817, and reads in part as follows: "When we come [sic] to this town 33 years ago their [sic] was not a fraim [sic] house in town and but one fraim barn. My father's was the second frame barne [sic] raised in Ashfield, and mine the second in Stockton/now their [sic] is [sic] five Meeting houses in town, four with belfreys, and one with a good toned bell."
8. The writer has discovered another person with the middle name Romanzo. He was Joseph Romanzo Edson, born 1847 in Jefferson township, Ashtabula County, Ohio. There were three Edson families in Ashfield who were immediate neighbors of the Elmers there and very distant relations of Joseph Edson. Coincidentally, Edwin Elmer lived in Ashtabula township, and probably also in Jefferson township, from about 1867 to 1872. In all likelihood he was employed on the farm of one of the Ashfield Edsons who had migrated west and to whom the Elmers were connected by marriage (see n. 32).

9. Hyde and Brainard, "Mrs. Elmer and the Mary Lyon Birthplace in Buckland," p. 202. A report in the *Greenfield Gazette and Courier,* March 30, 1885, of the suicide of the artist's uncle, Wilson Elmer (mistakenly identified in the paper as his twin, Watson Elmer), states that the deceased's farm was "one on which his grandfather, Samuel Elmer, settled more than a century ago, and on which his father and himself were born." On the basis of maps and other evidence, it seems likely that the farm meant was actually that of Watson Elmer, and this was probably the "old home" Emeline referred to. It may also have been the birthplace of Edwin Elmer.

10. Johnson, in his genealogy of the Elmer-Elmore family, says that Clarissa Elmer married Harvey Tolman. The name was in fact Totman, and Harvey may already have been connected to her by marriage. The Totman family records reveal that Abijah Totman (1804–1882), from the Franklin County town of Colrain, went out to Chautauqua County, New York, where his parents were admitted to the same Baptist Church in Stockton that Israel Smith, Clarissa's grandfather, had also joined. In Stockton Abijah married one Betsey Smith, who had been born in Vermont in 1793. It seems probable that she was a sister of Israel Smith. Abijah and Betsey named one of their sons Levi S. Totman, possibly after his wife's father, Levi Smith. A Stockton map of 1854 shows Abijah and Israel to be owners of adjoining lands. In the 1860 Stockton Census, Israel Smith is counted in the household of another son of Abijah, Edsel Totman, adding to the likelihood that Israel and Betsey were brother and sister. Although there were a number of Harvey Totmans, including Abijah's brother, a famous preacher, it is not clear which one was Clarissa's husband.

11. There was a strain of emotional instability in the Elmer family. Erastus is classified as "insane" in the Census of 1870 and denied on this account the right to vote. It does not seem to have been a continuing condition. Much earlier, in 1829, while Erastus and his family were out west, one of his younger brothers, Alfred, had shocked the village of Ashfield by murdering the infant son of his neighbor Timothy Catlin and attempting to kill his own grandfather with an ax. In the words of the newspaper account of the time, "he fancied himself commissioned from Heaven to kill three persons and derived his warrant, as he says, from the 11th chapter of Revelation" (*Greenfield Courier,* July 14, 1829). He was judged insane and not brought to trial. Instead he was delivered to the custody of four fellow townsmen of Ashfield, who first took him down to McLean's Asylum in Charlestown for observation. After six months he was brought back to Ashfield, where the records show, he was confined in a cage, probably at his mother's house (she was reimbursed for some of his meals). Bills submitted by his wardens include the cost of handcuffs, hasps and hinges for the cage. It is one of the ironies of the case that the father of the child Alfred murdered was hired to build his cage. He ended his days at the Northampton Lunatic Hospital in 1868. Wilson, another younger brother of Erastus, committed suicide.

12. Efforts to trace the maternal background of Susan Smith Elmer have been without result. Aside from the publishing of her marriage intentions, no record of Esther Cook has been located in Buckland or any nearby towns. Susan Elmer's paternal heritage has also been difficult to establish owing to the fact that an enormous number of families named Smith settled along the Connecticut River both in Connecticut and Massachusetts in the eighteenth century. Many members of these families later migrated to Vermont. A large number of Smiths settled in Hadley, Massachusetts (including the forebears of both Sophia Smith, the founder of Smith College and of Mary Lyon, the founder of Mt. Holyoke College, who were in fact distantly related through their Smith connections). Some of these Smiths, led by the Baptist preachers Preserved and Chileab Smith, moved to Ashfield, and around 1819 some of their descendants were among those Ashfield farmers who went out to Chautauqua County, New York along with Susan's father Israel. No connection between Israel and these Smiths has yet been found. Erastus Elmer, however, was connected to these Smiths several times over. His grandfather, Samuel, had married a daughter of Chileab Smith, as his second wife. His aunt Keziah Elmer married Chileab's grandson, Ebenezer, Jr., and his uncle Nathan married a granddaughter of Chileab, Julia Smith. Other Hadley Smiths settled in Brattleboro, Vermont (the town adjoining Guilford where Israel was born). Among these was one named Israel Smith, but again, no connection has been established between the two families. Many residents of Brattleboro and Guilford who sympathized with New York in its dispute with Vermont over the latter's independence in the 1780s were forced to flee either to New York state (where they were known as "Vermont sufferers" and given large tracts of land) or over the border into Massachusetts. On the evidence of deeds on file at the Town Hall in Guilford, it appears that Israel Smith's father was named Levi. A deed dated February

17, 1807 records that Israel Smith sold land in Guilford inherited from his deceased father, Levi. A deed dated October 16, 1787, is signed by Levi and Phebe Smith, and it seems likely that these were the artist's maternal great-grandparents. Another Israel Smith, from Suffield, Connecticut was the governor of Vermont from 1804 to 1811.

13. These records of the Baptist Church in Stockton are in the possession of the Stockton Library. In the genealogy of the Phillips family (Albert M. Phillips, compiler, *Phillips Genealogies,* Auburn, Massachusetts, 1885) and in the Ellis family genealogy (Ellis, *Biographical Sketches*), Israel Smith's second wife is identified as Esther Phillips, the sister of Elizabeth Phillips, who is listed as having married a man named John Robinson. Esther is recorded as having died "about 1830," and Elizabeth, "about 1828." On the evidence of the Stockton Church records, it would appear that the authors had confused Elizabeth and Esther, possibly because Israel Smith's first wife's name had also been Esther. It would seem likely that the estimate of her death date was mistaken as well. Israel Smith's third wife was Anna Smith (née Ellis), the widow of George Smith of Poughkeepsie, to whom he was apparently not related. The marriage probably took place in 1825, the year after George's death in 1824. In 1826, a son, Edwin, was born of this union. By her previous marriage, Anna had five daughters and three sons.

14. The Stockton Baptist Church records also refer to a rather recalcitrant Susannah Smith who may be the artist's mother. In November 1822 "Sister Serepta Grovener brought a complaint against Sister Susannah Smith for using profane language, visiting on the Sabbath, and justifying the universal sistem [sic]." The following January "Brother McNitt who was chosen to visit Sister Susannah Smith reported that Sister Smith remains in a measure obstinate, that he has little or no hopes of her returning to the Church. After taking the matter into consideration, voted to withdraw the hand of fellowship from her until she returns to the Church." In May 1823 it was voted to visit Israel Smith to find out why he, too, wasn't attending service.

15. Hyde and Brainard, "Mrs. Elmer and the Mary Lyon Birthplace in Buckland," p. 202.

16. *Greenfield Gazette and Courier,* May 14, 1894.

17. Erastus Elmer's sister Clarissa is listed as one of Mary Lyon's students at her Buckland school in 1828.

18. It is interesting that the children thought their mother was a native of New England. The Massachusetts State Census of 1865 is the earliest located document in which her birthplace is correctly given, although Samuel Elmore's manuscript notes for the Elmer-Elmore Genealogy, at the Connecticut Historical Society in Hartford, also give the correct birthplace. It was not included in Johnson's published version.

19. Darwin Elmer (1833–1859) was the fourth child of Erastus and Susan Elmer and seems to have had an independent and enterprising streak in him. In her interview with Mary Elisabeth Hyde and Faith Sanborn Brainard, Emeline Elmer said that he returned from the West later than the rest of the family, walking the distance from Troy to Ashfield (about seventy-five miles). He was probably not more than fifteen at the time. In the 1850s he returned West and became an agent for a silk thread firm, possibly in association with his former Ashfield neighbors, the Belding brothers, Milo, Hiram, and Alvah, who were later to have one of the largest silk thread businesses in the United States. A number of the Ashfield Beldings had already settled in Otisco, Michigan (later called Belding) and the artist's aunt Mary (Elmer) Flower had also moved there with her husband and family. The Beldings did not organize their firm until 1863, but they were already traveling widely in the West in the late fifties selling silk wholesale and retail, and they may very well have employed an old Ashfield neighbor to help them. In any case, by the fall of 1859 Darwin had opened a small store in Cleveland, and had persuaded his older brother, Ansel, to come out from Ashfield and be his traveling agent in Ohio.

20. *Cleveland Plain Dealer,* December 22, 1859.

21. *Cleveland Daily Herald,* December 21, 1859. A letter to Darwin written from southern Ohio by Ansel is quoted in part: "If I were to be hanged I could not work more diligently than I do now. I do the best I can for you." In spite of this suggestion that Darwin was worried about money, the newspapers noted that he left almost $250 in cash and some promissory notes. The reporter called his suicide "determined" because "He had fastened a new cord to the drawer knob, three feet from the floor, then lay down and put his head in the noose, and strangled himself—when found his head was only 18 inches from the floor, and his elbow was but an inch or two from the floor. He had evidently been dead for hours. Nothing but the

strongest determination could have enabled him to persist on committing the deed, as he could have released himself easily in case he repented during the first few minutes."

22. In Miller's teaching, after His death Jesus sent an angel from heaven with a third message to the world. In the words of Ellen G. White, in her *Early Writings of Mrs. White,* Washington, D.C., 1907: "This message was designed to put the children of God upon their guard by showing them the hour of temptation and anguish that was before them," and the angel calls attention to the example of the saints: "Here is the patience of the saints; here are they that keep the commandments of God, and the faith of Jesus."

23. Hyde and Brainard, "Mrs. Elmer and the Mary Lyon Birthplace in Buckland," p. 202.

24. The only copy of this census is the property of the Stockton Library, Stockton, New York.

25. The town itself, which encompasses many square miles and includes Shelburne Center, is known as Shelburne. The post office is called Shelburne Falls, and this has come to be the name of the settlement which was established by the river side.

26. Quoted in Hitchcock, *The Power of Christian Benevolence Illustrated in the Life and Labors of Mary Lyon,* p. 16.

27. *Ibid.,* p. 17.

28. Hyde and Brainard, "Mrs. Elmer and the Mary Lyon Birthplace in Buckland," p. 202.

29. The artist and his family were also, perhaps, proud to claim a connection to Mary Lyon's family through the marriage of Erastus Elmer's aunt, Elizabeth Elmer, to Mary Lyon's uncle, Nathan Lyon.

30. *Deerfield Valley Echo,* July 24, 1899.

31. For instance, in the 1860 Conway Census, Delilah is counted in the household of a newly widowed Conway father of several children, where she was probably working as hired help.

32. Possibly the farm in question was that of Otis Edson, a son of one of the Elmers' Baptist Corner neighbors, John Edson, who had gone West in the early part of the century. John Edson had settled in Jefferson Township, Ashtabula County, Ohio after a peripatetic life which had included a period in Phelps, New York (the birthplace of his son Otis and a daughter Anna), and a return to Ashfield. His daughter Anna had remained in Ashfield, where she married Francis Phillips. They named their first son Ansel Elmer Phillips after the husband of Francis's sister, Rachel, who had married the artist's uncle, Ansel Elmer. On an Ashfield map of 1871 Francis Phillips and Erastus Elmer are shown as occupying the same house. Otis Edson and his son, Royal, were farmers and real estate operators in Ashtabula County. Ansel Elmer, the artist's brother, married a Helen M. Hickok in Ashtabula in 1862. Royal Edson's wife was named Clarissa V. Hickok. A relationship between the two wives has not been established, but it seems likely that they were related in some way.

33. Deed on file at Franklin County Courthouse, Greenfield, Massachusetts.

34. In the *Greenfield Gazette and Courier* for November 20, 1865, Samuel Elmer is credited with bagging four partridges with one shot, and it may be that the brothers also did some commercial hunting to eke out the family's meagre resources.

35. Ashtabula County Courthouse records, Jefferson, Ohio.

36. Carroll Andrew Edson, *Edson Family History and Genealogy.* Tuscon, Arizona, 1969, 2 vols.

37. Although Samuel and Edwin do not appear in the 1870 Ohio Census, Ansel is recorded as a "silk dealer" in Ashtabula with a wife and two sons. In addition, he has a female domestic servant in his employ.

38. In 1870 and the first months of 1871, the Cleveland papers made a practice of publishing on a regular basis the names of all registrants at the city's two principal commercial hotels, the Weddell House and the Kennard House. S. Elmer of Ashtabula, Ohio is listed as a patron of Weddell House on at least ten occasions between April 20, 1870 and February 14, 1871.

39. The Cleveland directory for 1871–72 had been published in July 1871 and canvassing for the new one began almost immediately after its publication and ended only about a month before the appearance of the successor volume. To be included in the 1872–73 edition, therefore, the Elmers could have settled in Cleveland anytime between about June 1871 and the following May.

40. The photograph is dated 1865 by the Cleveland Public Library, holder of the negative. In that year, however, the auction house of James Moriarty, whose sign is clearly legible in the photograph, was called Penn & Moriarty and was at another location. The firm became James Moriarty in 1869 and took up quarters at the address shown in the photograph, 52

and 54 Public Square, about March 1872. By September 1873 it had moved to a new location on Superior Street.

41. *Cleveland Daily Leader,* October 18, 1871. The Academy of Music was run by Mr. and Mrs. John Ellsler and it was their daughter Effie, the soubrette of the company, who played Bertha to her mother's Hester Smith. Maud Elmer speculated that Effie Ellsler, perhaps the object of the artist's admiration, could have been the inspiration for the choice of the name of his daughter, Effie Lillian. She based this suggestion on the fact that a picture of a beautiful but unidentified young woman had been unearthed among the family's possessions, and her belief that the family was not otherwise given to unusual names. This is a somewhat surprising idea coming from someone whose middle name was Valona, the origin of which she never discussed (William Miller, the Second Adventist, had a daughter named Balona), and considering the fact that her uncle's middle name was Romanzo and her aunt was called Delilah. Actually, Effie was not an uncommon name and there was another Effie Elmer—a very distant relation of Maud's—living in Shelburne Falls while she was going to school there. An equally plausible explanation for the choice of the name is that it was the name of the wife of John Ruskin, at least one of whose books the artist certainly consulted.

42. In *Willis Seaver Adams/Retrospection* (prepared by the American Studies Group at Deerfield Academy, Deerfield, Massachusetts, May 1966), Roger Black, author of the principal essay, states on page 9 that Adams "helped to found the Cleveland Art Club, informally called 'The Bohemians,' and to establish the old Cleveland Academy of Fine Arts" after his arrival in Cleveland in 1876.

43. Ryder, *Voigtländer and I,* pp. 216–28.

44. In the September 2, 1871 *Cleveland Daily Leader,* Miss Fox placed the following ad: "Lessons in Drawing and Painting from the cast, life, and nature by Miss L. L. Fox. Studio, Cleveland Academy, Huron Street. Residence, Room 19 Euclid Place. References: Henry Peters Gray, President of the National Academy of Design, New York; W. W. Whitredge [sic], Artist, New York; Miss C. Ransom, Cleveland; Miss L. T. Guilford, Principal, Cleveland Academy." Gray and Whittredge were both teachers at the Cooper Union School of Design for Women when Miss Fox was a student there. Her ads continue, with variations, for several more years.

45. Guilford, *The Story of a Cleveland School from 1848 to 1881.* p. 103.

46. *Cleveland Daily Leader,* February 27, 1873.

47. Cleveland City Directory, 1875–76.

48. The fact that Samuel is listed in July 1875 as a property taxpayer in Buckland of $83.10 (at the rate of $19 per $1,000) for the year 1874–75, argues for an earlier, rather than a later, return. At the tax rate given, the property would have been worth $4,375. In May 1875 Samuel had bought two small parcels of land in Buckland for $675, but the tax bill suggests that it was for their big new house, probably just being started, and possibly the land it was on. While in Cleveland Samuel made a small profit on a real estate transaction and had in other ways shown that of the two brothers, he was the one with the business sense. From the evidence of deeds on file in the Franklin County Courthouse in Greenfield, it would appear that early on Samuel became the owner of both the house and the land. By deed dated February 22, 1881, he sold a half interest to Edwin for $3,000, but retained half for himself.

49. Erastus Elmer had bought this plot for $850 in March 1874 from a widow, Amanda Richmond (who, the next year, married his brother Wilson Elmer).

50. A number of the publications that would have been available to amateur architects at that time contain many brackets, window caps, and columns similar to those found in the Elmer house, but no exact prototypes were found.

51. *Greenfield Gazette and Courier,* September 18, 1876.

52. *Greenfield Gazette and Courier,* January 28, 1878.

53. *Greenfield Gazette and Courier,* October 4, 1879.

54. The patent dated June 29, 1880 may be found in the Appendix.

55. *Greenfield Gazette and Courier,* October 11, 1880.

56. The July 23, 1883 *Greenfield Gazette and Courier* reports that "A large number of summer visitors are stopping with Mr. Elmer."

57. See Appendix for a copy of the patent.

58. Westfield, Massachusetts, a manufacturing center about forty miles south of Ashfield, had at this time a flourishing whip industry. The town sometimes called itself "The Whip City of America." By 1900 it was producing 95 percent of all whips made in the United States—

about two million a year. The whipsnaps or lashes had always been made by hand, mostly by women and children, but by men as well, though the rest of the whip was made by machine.

59. *Greenfield Gazette and Courier,* October 3, 1887.
60. Records on file at Franklin County Courthouse, Greenfield, Massachusetts. Of the five employees mentioned in the suit, all of whom evidently stopped work after Dr. Fessenden's ominous remark, one was the artist's nephew, Ellsworth Elmer, and two others were members of the Phillips family, related, if distantly, to Samuel. Probably there were not a great many more than this at work on the whipsnaps at any time. Samuel's obituary in the *Deerfield Valley Echo,* January 20, 1902, contains the assertion that "he supplied at one time nearly half of the whip snaps used in the Eastern states. . . ." In light of the fact that the machine was not patented and only one example has survived, and that only a handful of employees were mentioned in the lawsuit, it may be assumed that this was newspaper hyperbole.
61. *Shelburne Falls and Charlemont Directory,* 1888.
62. Maud's mother had died in 1882, and her father had remarried in 1888. In her memoir she admits that she did not get along with her stepmother, "a beautiful widow with a daughter two years older than I." The second wife had social ambitions and perhaps money of her own. The local papers reported on her parties during the years she lived in Buckland, and it is perhaps important to an understanding of Maud's feelings to know that while Maud went to a Normal School to prepare for a career in teaching, her stepsister was sent to Smith College. A son was born to this marriage in 1894. It may be that Samuel soon came to share Maud's dislike for his wife, because in November 1896 he drew up a will in which he wrote that, "It is my express will that my wife, Alice J. Elmer, shall receive no part whatsoever of my estate either real or personal except so far as absolutely provided by law." Maud never mentioned her half-brother, Blaine, in her memoir, and after her father's death he remained with his mother and his other half-sister, Blanche. Perhaps to even the score a little with Samuel for his treatment of his mother, Blaine, in his own will, made in 1930, left Maud $5, "it being my desire that she receive no other part of my estate." Blanche also received $5 but was the residuary legatee of his estate.
63. *Greenfield Gazette and Courier,* May 31, 1890. The airbrush was first patented in October 1881 by Leslie L. Curtis as an "atomizer for coloring pictures."
64. *Greenfield Gazette and Courier,* November 8, 1890.
65. *Greenfield Gazette and Courier,* August 27, 1892. The reporter stated that Elmer estimated his loss at $1,000 and that he had no insurance. He concludes with the observation that, "It will come quite hard on Mr. Elmer. He will not rebuild."
66. *Greenfield Gazette and Courier,* November 15, 1890.
67. *Greenfield Gazette and Courier,* September 1891.
68. *Deerfield Valley Echo,* June 29, 1893: "Those paintings on exhibition in F. H. Chandler's window are done by Mr. Elmer and one of his scholars. He has a class in town."
69. His ad in the *Greenfield Gazette and Courier,* May 14, 1892, page 8, reads as follows: "CRAYON PORTRAITS. I am now making fine crayon portraits at from $6.00 to $10.00 each, elegantly framed in gilt, oak or oxydized silver; warranted perfect or no pay. Good, live agents wanted; commission liberal and steady employment. First class references required." By June 11, 1892, he had switched his ad to the front page and was looking for "academy graduates" to be his agents "in every town in this county."
70. An article called "The Free Crayon Portrait Humbug," which appeared in the February 1, 1894 *Deerfield Valley Echo,* warns the unwary that some of these portraits are made from very dark prints that require little handwork and, moreover, will fade.
71. For instance, *Crayon Portraiture,* by J. A. Barhydt, New York, 1886 and 1892. His preface begins "In issuing this second treatise on Crayon Portraiture, Liquid Water Colors and French Crystals, for the use of photographers and amateur artists, I do so with the hope and assurance that all the requirements in the way of instruction for making crayon portraits on photographic enlargements and for finishing photographs in color will be fully met. To these I have added complete instructions for free-hand crayons." The book shows that the enlarging of the photographs was done by means of a magic lantern projection onto sensitized paper. Barhydt is also credited for his article on "Crayon Portraiture" in *Appleton's Annual Cyclopedia* of 1890.
72. The Shelburne Falls column of the June 20, 1896 issue of the *Greenfield Gazette and Courier* has the following item: "The cry of hard times seems to be quite general in nearly all lines of business, but the local portrait artist, E. R. Elmer, seems to be an exception to the

general rule, as he has been rushed with work right along, both in portrait and frame works. He has over fifty orders on hand at present for portraits alone. His works seem to be highly appreciated. His agent, A. F. Barnes, has just received from the O. Armleder Co. of Cincinnati, Ohio the finest delivery wagon in this place."

73. *Greenfield Gazette and Courier,* January 8, 1898.

74. *Greenfield Gazette and Courier,* April 2, 1898.

75. The painting, entitled *The Young Dominican,* was done in 1878. Accounts of the College's first acquisitions in 1879 mention a painting called *Contemplation* and Satterlee did show a painting of this title at the National Academy in 1878. It was very likely the picture later called *The Young Dominican.* That Satterlee's reputation did not long survive his death in 1908 is shown by the fact that his painting was among those omitted from the catalogue of Smith's collection published in 1925. No photograph was made of the painting, which was later sold.

76. Gill's first exhibition in 1878 was held in partnership with the local Springfield collector, George Walter Vincent Smith, but from 1879 until 1921 they were his own selection.

77. Larry Freeman, *Louis Prang, Color Lithographer,* Watkins Glen, 1971; Kathleen M. McClinton, *The Chromolithography of Louis Prang,* New York, 1975 and Peter C. Marzio, *The Democratic Art: Chromolithography 1840–1900,* Boston, 1979.

78. The Academy faculty for the school year 1899, which ran from the first Monday in October to mid-May, was as follows: Committee: Frederick Stuart Church, James Carroll Beckwith, Hugh Bolton Jones; Portrait Painting (day classes), and Antique and Life (night classes): Edgar M. Ward; Antique and Still Life (day classes): Francis C. Jones; Life and Composition (day classes): George W. Maynard; Perspective: Frederick Dielman; Anatomy: J. Scott Hartley.

79. *Deerfield Valley Echo,* June 27, 1900.

80. *Deerfield Valley Echo,* July 11, 1900; *Greenfield Gazette and Courier,* July 14, 1900. The crayon portrait still hangs in the Arms Library in Shelburne Falls.

81. *Greenfield Gazette and Courier,* September 29, 1900.

82. *Greenfield Gazette and Courier,* October 6, 1900. The principal public hall of a town was often called the Academy of Music or the Opera House, although opera was not often heard there. Most of the entertainments were staged by local or visiting theatrical companies and variety players.

83. Elmer was also appointed guardian of Samuel's minor son, Blaine. When he reached maturity, Elmer filed a paper with the Probate Court in Johnstown, New York, April 16, 1916, explaining that "Samuel Elmer's assets consisted mostly of stock in the Mountain Lake Electric Railroad of Gloversville, New York. After the terrible accident on that road July 4, 1902, the stock of that company became absolutely worthless. All of the good asset [sic] that came into my hand [sic] was paid towards the cost of settling the estate, counsel fees, etc. . . . After paying a few debts such as funeral expenses, taxes, etc. . . . nothing whatever came into my hands that could be applied to said minor Blaine Everitt Elmer."

84. *Deerfield Valley Echo,* September 28, 1904. "E. R. Elmer is making an extensive show of his fine work at the Brattleboro fair this week. He is getting many orders for his sketches and also his portrait work. He recently made a fine picture that he was going to exhibit, but one of his regular customers bought it before he had a chance to show it to the public. Mr. Elmer is gaining a large patronage for his work of enlarging pictures and a larger one for some of his special work and designs from nature. We are fortunate in having such a good artist in our town."

85. *Greenfield Gazette and Courier,* November 12, 1904.

86. *Deerfield Valley Echo,* November 23, 1904.

87. *Greenfield Gazette and Courier,* November 18 and November 25, 1905; *Deerfield Valley Echo,* November 22 and November 29, 1905.

88. *Hampshire Gazette,* October 5, 1905; *Deerfield Valley Echo,* October 11, 1905; *Greenfield Gazette and Courier,* October 14, 1905.

89. *Deerfield Valley Echo,* May 23, 1906.

90. A Methodist Church fair, recorded in the October 13, 1906 *Greenfield Gazette and Courier,* and an agricultural fair at the Odd Fellows Hall, reported in the *Deerfield Valley Echo,* October 16.

91. *Shelburne Falls Messenger,* December 11, 1907. The *Messenger* was the successor to the *Deerfield Valley Echo.*

92. *Deerfield Valley Echo,* May 10, 1905.

93. *Shelburne Falls Messenger,* August 26, 1908. In a column headed "Doings in Ashfield," an article called "Fair and Play for the Benefit of Sanderson Academy at Ashfield," we learn that "The leading features were the exhibits of mosses and seashells from the collection of Mrs. Henry C. Hall and the magnificent group of paintings owned by Mrs. E. R. Elmer." The article discusses sales of exhibited works, but it is not clear whether Elmer's works were offered for sale.

94. In the 1913 Northampton directory, which includes Ashfield listings, his occupation is given as farmer.

95. There are many local legends about the large number of suicides in the Elmer family. The estimates go as high as seventeen, and one Elmer is said to have accomplished the deed by putting his head in a dresser drawer. Suicide may have occurred with more than usual frequency in the family, but over four generations only six cases have been documented. An early ancestor, Gad Elmer, is the first suicide on record. Besides the artist, his brother Darwin, and his uncle Wilson, two children of his sister Emeline also were suicides. Ethel, her daughter, a young woman of twenty-one years who had married three years before and was pregnant at the time of her death, chose a rather bizarre method. The September 1, 1909 *Greenfield Recorder* reports that she went to the cellar of her parents' house, where she and her husband were then living, "took off her stocking, lay down in the narrow coal bin, placed the muzzle of the gun under her chin and pressed the trigger with her toe."

96. The principal exhibition in Shelburne Falls was that organized by Maud Elmer in November 1946. It included about twenty works which were shown at the Shelburne Falls Women's Club and in shop windows of the town.

97. Frankenstein was then conducting his ground-breaking study of the work of William M. Harnett and other American still-life painters, whose work is loosely classed under the heading *trompe l'oeil.* He had several years before discovered by diligent research and skilled detective work that a number of paintings signed with Harnett's name, were in fact the work of another artist, John Frederick Peto (1854–1907). Harnett had had considerable success in his lifetime, but his work had been forgotten until the New York dealer, Edith Halpert, put on an exhibition of it at her Downtown Gallery in April – May 1939. Peto, on the other hand, had achieved no fame at all, and it was a simple matter for forgers to substitute the more saleable artist's name on any of Peto's still lifes that happened to come their way. Among these was Smith College's own Peto, *Discarded Treasures,* bought from the Downtown Gallery show.

98. *Time* magazine had reproduced this painting in its July 17, 1950 article on the exhibition.

99. The exhibition, which ran from July 8 to December 17, 1950, was sponsored by the National Capital Sesquicentennial Commission to commemorate the establishment of the permanent seat of the federal government in Washington in the year 1800.

100. The photograph had actually been singled out several years earlier by Dorothy C. Miller, Curator of the Museum Collections at The Museum of Modern Art and an authority on American folk art and nineteenth-century art. As a special project, she had been asked to select works for a large volume on American art that the publisher Macmillan planned to issue. Miss Miller recalls that the publisher was somewhat embarrassed by the profits coming in from two novels—*Gone with the Wind* (1936) by Margaret Mitchell and *Forever Amber* (1945) by Kathleen Winsor—and wanted to use them for a publication of a more serious nature. The costs of reproducing many works in color turned out to be prohibitive and the publication was abandoned. Although, like Miss McCausland, Miss Miller "searched the entire American files of the Frick Art Reference Library," she did not work on *American Processional* and does not know who the Dorothy P. Miller named as Miss McCausland's assistant was. Possibly, after the Macmillan book was abandoned, she shared her own research—which included the discovery of Elmer's *A Lady of Baptist Corner*—with Miss McCausland.

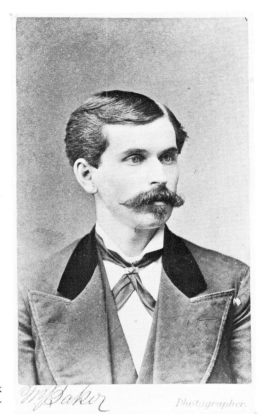

Fig. 30. Elmer, ca. 1885? Photograph, 3¾ x
2¼", by W. J. Baker, Buffalo, New York. Collec-
tion of Mrs. Robert Luce.

Fig. 31. Elmer, ca. 1890?
Photograph, 3⁵/₁₆ x 3⁵/₁₆". Col-
lection of Mr. and Mrs. R.
Russell Luce.

PART II. The Work

A number of circumstances make the study of Elmer's work challenging, among them the scarcity of evidence on which to form judgments. Only two pieces of the artist's writing are known at present. One is a very short letter to the compiler of a family genealogy asking if it has yet appeared.[1] The other is the letter he wrote to the editor of the *Deerfield Valley Echo* in November, 1899 describing his program of study and his activities since his arrival in New York the month before (see Appendix A). In a newspaper article about the Corcoran Gallery exhibition, *American Processional,* in 1950, the artist is said to have written his niece Maud at some unspecified date in the past that his work would not be recognized in his lifetime.[2] Otherwise, he left no clues as to his thoughts about his own work or that of any other artists.

Elmer's work falls obviously into two distinct periods, the years before his New York season in 1899–1900, and those following it. His most interesting and imaginative work comes from the first period, which probably began about 1865. Fewer than twenty works from these earlier years have been located, and his three most memorable compositions, the *Mourning Picture* (1890), the *Magic Glasses* (ca. 1891–92) and *A Lady of Baptist Corner* (1892), were all done within a three-year span. At the same moment that he was producing these works, which are characterized by a scrupulous attention to detail, he was also making a series of smaller oil paintings whose loose handling and summary treatment of form makes them look more like the work of a gifted Sunday painter.

The first work that can be definitely dated is the *Mourning Picture* of 1890, and the first work actually bearing a date, *The Mary Lyon Birthplace* (fig. 59), comes from 1891. Although several portraits of members of his family clearly come from an earlier time, Elmer's habit of painting from photographs eliminates two avenues which might otherwise have aided in their dating: the probable age of the sitters and their clothing style.

In the second period of his work, from 1900 onwards, he worked almost exclusively in pastel and charcoal—the first, a medium which, according to his niece, he learned to use in New York. Of the sixty-eight or so surviving works from this period, forty-five were done in just two years, 1905–06. The best of the extant pastels come from these years, and again the concentration of the material in a short span does not permit a study of how his command of this recently acquired medium developed.

41

Thus, no orderly, much less definitive, study of Elmer's progress as an artist is possible. The suspicion presents itself that in his art as in his business ventures he took up and left off working as some new idea caught his attention.

Maud Elmer did not believe that her uncle received any training in art before his year in New York, which she mistakenly stated occurred when he was "about forty-two years old." She did make clear, however, that both her uncle and her father, his brother Samuel, manifested an early interest in and talent for art. She mentioned some of Edwin's drawing books, none of which have survived, and observed that he had also shown an interest in natural sciences and a marked gift for mathematics at an early age.

Nevertheless, aside from the obvious confidence of Elmer's few major paintings of the nineties, there is other evidence to suggest that he did indeed have some earlier training. Maud herself said that in Cleveland in the years 1871–75, the brothers made friends with artists and painted and sketched in their spare time. Years later, when Elmer decided to go to New York, one newspaper reported that he was going "to take another course of art studies in New York City,"[3] while a second stated that he was going there "to complete his artistic education."[4] After E. Porter Dickinson bought *A Lady of Baptist Corner* in 1939, he wrote a colleague at the Frick Art Reference Library in New York that "his relatives *think* he studied with Champney the year (or winter) before he painted my canvas (1892)."[5]

The reference to "Champney" has been supposed to mean Benjamin Champney (1817–1907), the landscape painter who attracted many artists to the White Mountains where he painted almost every summer of his life, and it has been supposed that Elmer's studies with Champney were at the National Academy of Design.[6] Benjamin Champney, who lived in Woburn, Massachusetts, never taught in New York, however, nor has Elmer's name been found among the extant records of his private students.[7] A more likely Champney with whom Elmer might have studied was James Wells Champney (1843–1903), a cousin of Benjamin's and the first drawing master at Smith College from 1877 to 1880. He was an occasional lecturer on anatomy at the National Academy, though not in the year Elmer is known to have been there.[8] In 1876, he had bought a summer home in Deerfield, Massachusetts, and during the many summers he spent there he often gave sketch classes—patronized by women for the most part, it would appear. By the roads of the day, Deerfield was probably not more than a dozen miles' journey from either Shelburne Falls or Ashfield. Although there are no records to confirm that Elmer studied with James Champney, some qualities of the work of both artists make it seem possible. Champney, a successful genre painter, illustrator, and caricaturist, was much in demand during the last twenty years of his life for his pastel portraits and his pastel copies after old masters. One of the latter is preserved in the collection of the Smith College Museum of Art, and it shows the same tight, controlled use of the medium that characterizes Elmer's pastels.[9] At the time of the 1952 Elmer exhibition at Smith College, a charcoal work by Elmer described as "Madonna (copy after an old master)" was brought to the Museum. (The picture has since been lost.) Also, like so many other nineteenth-century

artists in this country and abroad, Champney was fascinated with photography and like Elmer made free use of it in his landscape and figure compositions (figs. 32 & 33).

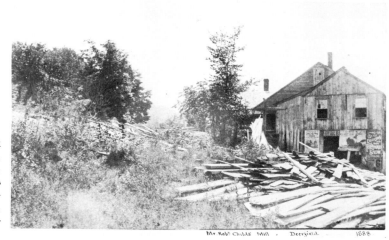

Fig. 32. Mr. Robert Childs' Mill, Deerfield, Massachusetts, 1888. Photograph by James Wells Champney. Historic Deerfield, Inc., Deerfield, Massachusetts.

Fig. 33. James Wells Champney (American, 1843–1903). *Teetering at the Saw Mill,* ca. 1888. Oil on canvas, 18 x 26″. Historic Deerfield, Inc., Deerfield, Massachusetts.

In all probability, however, the most critical part of Elmer's art education took place while he was still a youth in Ashfield, and it seems likely that Charles Eliot Norton's decision in 1863 to make Ashfield his summer home was to have lasting consequences for the artist. Before Elmer left for Ohio about 1867, the town had already been stirred to new activity by Norton and Curtis, and in succeeding decades, far from being a provincial backwater, Ashfield became an active intellectual milieu. When Elmer returned from Cleveland about 1875, he lived in the adjoining town of Buckland, but his roots were in Ashfield and in so small a community he would have had at least as much opportunity for contacts with artists and writers as in the larger city of Cleveland.

When Norton arrived in Ashfield, he had already become a close friend of John Ruskin and was thoroughly familiar with and sympathetic to his theories of art, if not wholeheartedly a believer in them. By the 1860s, Ruskin's fame in this country was firmly established, and his *Modern Painters, Seven Lamps of Architecture,* and *The Stones of Venice,* in particular, were almost more popular in the United States than in his native England. Through Ruskin, Norton had met the members of the Pre-Raphaelite Brotherhood, whose cause Ruskin had defended. Indeed, Norton had commissioned a painting and a portrait of Ruskin from Dante Gabriel Rossetti. Rossetti, together with John Everett Millais and William Holman Hunt, had chosen the term "Pre-Raphaelite" in 1848 not to express any disapproval of Raphael but rather to call attention to the little-appreciated work of artists of an earlier time, especially the Italian "primitives," Cimabue, Duccio, Giotto, and others, whose paintings, they believed, revealed a reverence for nature as the first source of art and a sincerity and simplicity absent in the art of the high Renaissance. In their view, painting since Raphael had become formalized and convention-bound, dependent on abstract formulae. The resulting artificiality could be avoided if artists would instead study and emulate the work of these earlier masters. Above all, they urged a close and rigorous study of nature herself. Although they spoke most often of the Italian primitives, one author has noted that much of the work of the Pre-Raphaelites—not just the original members but the many English artists who followed their lead—resembles even more that of early Flemish painters: "the exactness of detail, the clarity of the color and the sharp delineation of the forms recall Jan van Eyck more than any other source."[10]

Norton had become Ruskin's champion in America and perhaps his most trusted friend. They corresponded voluminously. When Norton returned to Ashfield in the summer of 1873 after an absence abroad of five years, he wrote a letter to Ruskin expressing his renewed delight with the town. But he also observed that "the population has diminished slowly in the last thirty or forty years. The soil is too thin, the hillsides too rocky, the winters too long, for the love of birthplace and home to contend with unvarying success against the temptations of Western prairies and of a gentle climate. Each year some family deserts the solitary, outlying farm, and migrates to easier life. The country pays its tribute, too, to the cities. The well-grown, hopeful boys go off, eager to make money, and attracted by the activity, the promise, the wider variety, the glare of Boston and New York."[11] In a town like Ashfield with fewer than twelve hundred

souls, it is not unlikely that the Elmers would have been known to Norton, a very civic-minded man. They were one of the town's oldest, if also among its poorest, families. In any case, Samuel and Edwin were two "well-grown, hopeful boys," who had gone off, not to New York or Boston, but to Ohio just about the time Norton left Ashfield five years before.

The son of a Unitarian minister, connected with many distinguished New England families, Norton came to Ashfield steeped in a tradition of *noblesse oblige.* He immediately set about reviving the town's library, which by 1864 had completely fallen into disuse, through a substantial gift of books. The early accessions records of the library do not show which gifts were his, but works by Ruskin are among the first additions. With the arrival of George William Curtis in the summer of 1865, a series of lectures by both men was inaugurated to aid the library, and a librarian was hired. The lectures were advertised in the Greenfield paper and no doubt drew audiences from considerable distances.

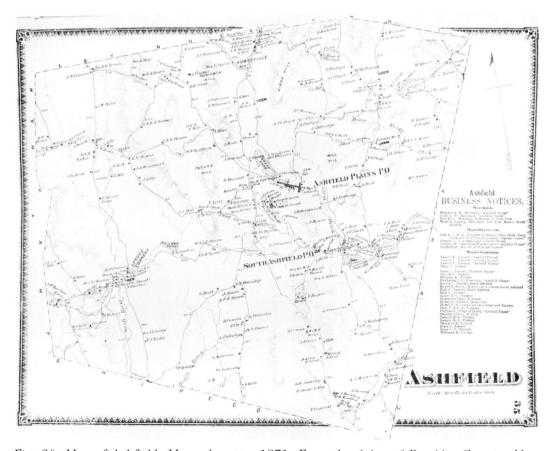

Fig. 34. Map of Ashfield, Massachusetts, 1871. From the *Atlas of Franklin County, Massachusetts,* F. W. Beers & Co., New York, publisher.

Although by 1864 Norton had achieved some renown as a contributor to the *Atlantic Monthly* and as the newly appointed co-editor (with James Russell Lowell) of the venerable *North American Review,* the citizens of Ashfield would probably have known Curtis's name much better. He was an immensely popular lecturer on the national scene, especially during the Civil War, when his abolitionist views were much publicized. He was also the editor of *Harper's Weekly* and the author of its "Easy Chair" column. Both men entertained many summer visitors including the Shaws and Sturgises of Boston, relations of Curtis's wife, and the Sedgwicks, relations of Norton. Norton was the less gregarious of the two and worried that Ashfield might become a place of popular resort if too much publicity were given to their activities there.[12] Nevertheless, his presence in Ashfield certainly did act as a magnet for several young artist disciples of Ruskin in the sixties.

That Edwin Elmer had become aware of Ruskin by the time he was a young man is evident from his wholesale borrowing of Ruskin's drawing of a window of Giotto's campanile for the background of his portrait of his brother (figs. 45 & 46), probably painted between 1872 and 1875. He could have found Ruskin's works in the Ashfield Library and, no doubt, the Cleveland Public Library as well. There is another possibility.

In the summer of 1865 a young English artist, Thomas Charles Farrer (1839–1891), and his wife settled in Northampton. Farrer had come to this country about 1858, following several years of study at the Workingmen's College in London, a school where Ruskin and Dante Gabriel Rossetti taught art. Farrer was evidently a natural proselytizer, because by late 1862—after at least one return visit to England and three months as a Union soldier in 1862—he had persuaded a group of talented young Americans living in New York to join with him in forming an organization to promulgate Ruskin's ideas. Called the Society for the Advancement of Truth in Art, the group held its first meeting at Farrer's quarters on Waverly Place. Among the first members were the artists Charles Herbert Moore (1840–1930), who later taught at Harvard and became the first director of the Fogg Art Museum, and John Henry Hill (1839–1922), the architects Russell Sturgis, Jr. (1836–1909) and Peter B. Wight (1838–1925), designer in 1862 of the National Academy of Design, the writer Clarence Cook (1829–1900), soon to become the *New York Tribune's* critic and later the author of *House Beautiful,* and the geologist Clarence King (1842–1901), first head of the U.S. Geological Survey. In May, 1863 the first issue of their journal, the *New Path,* appeared.[13]

Although the names of these architects and artists are rarely heard today, for a few years in the mid-1860s they were encountered with amazing frequency in New York newspapers and in magazines. Cook, one of America's first art critics, discussed their works regularly and in detail in his columns in the *Tribune,* generally with enthusiasm, though his treatment of other artists was often harsh, even vicious.[14] Sturgis wrote art criticism for the *Nation* magazine from its beginning in 1865 and was also a contributor to the *North American Review.* He had sent a copy of the first issue of the *New Path* to Norton and had received from him two letters apparently of both approbation and criticism, together with

the price of two subscriptions.[15] In the January 1864 issue of the *North American Review,* the first under Norton's editorship, a favorable review of the new periodical appeared:

> . . . there has been no discourse or criticism upon matters of Art in America so valuable as its pages contain, since the essays by Mr. Stillman in the earlier volumes of "The Crayon." For among the writers in "The New Path" are men, not only of talents, but of serious convictions and of independent thought. Disciples of Mr. Ruskin, they are no blind followers even of that great master, to whom every true lover of art must confess his inestimable obligations. They are beholden, indeed, to him, not only for quickened perceptions of natural beauty, but for understanding that truth to nature is the test of all art, the most imaginative no less than the most literal. . . . There is occasionally in its pages a tone of dogmatism and self-sufficiency, occasionally also a crudity and want of completeness, which, being combined with singular sincerity and simplicity, not unpleasantly reveals the youth while indicating the capacity for growth of the writers. . . . The fact that there is in this country so much empty, unmeaning, and ignorant talk about Art, is likely to prevent "The New Path" from receiving from the wearied public the attention it deserves. . . . but it gives happy promise for the future of Art in America, by giving proof of the increase and ability of the school of thinkers and artists to which the truth-seeking reformers who contribute to its pages belong. It is a small school as yet, but it includes the most genuine artistic aspirations and most ardent feeling of the times. Its influence is already deeply felt, and if its leaders hold firm to their own principles, they will finally be recognized as redeemers of American Art from its present servitude to tradition and falsehood, and its subserviency to the popular preference for what is showy and admired to what is intrinsically worthy of admiration.[16]

Norton's sympathic response must have gratified this young band. The fervor with which they espoused Ruskin's views on art attracted considerable notice elsewhere and not a little antagonism. Ruskin was not, after all, unknown to the educated public of 1863 and, as Norton had noted, his views had already been set forth in the pages of the *Crayon,* America's first art magazine, which had flourished from 1855 to 1861.

For three years, probably from 1862 until the spring of 1865, Farrer was a teacher of drawing and painting from still life at the Cooper Union School of Design for Women.[17] A two-part unsigned treatise in one of the periodicals of the day, the *Round Table,* used Farrer's methods of teaching as a vehicle for a scathing attack on both Peter Cooper and Abram Hewitt for their abandonment of the original vocational aims of the school in favor of an academic curriculum. Farrer's system, "which he had learned from Mr. Ruskin," is described as "the total abandonment of the usual paraphernalia and machinery of drawing and painting academies—the plaster casts, the lithographic models—and the putting in their place whatever natural objects could be easily procured and conveniently employed. Single leaves, small twigs and boughs, a lichened branch or stone . . . were placed before the pupils, and they were set at copying them with all the accuracy possible Mr. Gray had a class in figure painting, and Messrs. McEntee and Whittredge in landscape, but these classes never had any real vitality. Mr. Whittredge afterwards set his young ladies at drawing old boots and shoes, powder-flasks, and empty gamebags, but even these poetic objects failed in bringing his class up to the standard attained by Mr. Farrer's and one, by one, these gentlemen left the school."[18]

Farrer spent most of the summer of 1865 in Northampton, painting and drawing views and still lifes which were exhibited in the autumn at the home of a local patron.[19] Two paintings from this campaign have survived, a view of Mount Tom and a panoramic landscape of the town of Northampton and the valley of the Connecticut River (fig. 35).[20] On October 13, 1865 the Farrers' first child, a son, was born in Northampton,[21] and as soon as mother and child could travel the family moved up to Ashfield, where they had evidently determined to spend the winter. Farrer had sold his view of Northampton, and in late October he took it down to its owner in New York, Porter Fitch. The following month, it was included in the Artists' Fund Society exhibition, where it attracted considerable, somewhat unfavorable attention.[22] Returning to Ashfield in late November, Farrer found his wife and son comfortably settled, presumably in the town's center, called Ashfield Plain. In a letter written from Ashfield to a Brooklyn friend on February 15, 1866, Mrs. Farrer reports that her husband "has opened a free drawing class in the Academy and teaches several evenings in the week. It is well attended. Some who walk miles to attend will surely learn."[23] If as Maud Elmer

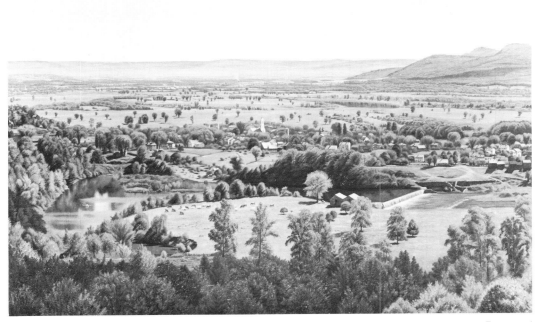

Fig. 35. Thomas Charles Farrer (English, 1839–1891). *View of Northampton from the Dome of the Hospital.* 1865. Oil on canvas, 28⅛ x 36″. Smith College Museum of Art, Northampton, Massachusetts. Purchased 1953.

asserted, Edwin Elmer showed an interest in art at an early age, it seems impossible that as a boy of fifteen he would not have taken advantage of a free art class given in his little town by a New York artist of some celebrity, particularly as the sessions were in the evening, when he could be spared from chores. At that time the Elmers were probably living on upper Phillips Road, about three miles from the center of Ashfield where Sanderson Academy was located.

Mrs. Farrer concluded her letter by saying that the family expected to return to New York in May. A letter to Norton from one of his Ashfield friends in November 1866 suggests that the Farrers may have come back to Ashfield for a second winter.[24]

Whether Farrer spent two winters in Ashfield or just one, he was not the only artist of this circle whose work Elmer could have seen in those years. Charles Herbert Moore and Farrer had formed a close friendship in the early sixties. Besides encountering each other in New York at meetings of the Society for the Advancement of Truth in Art, Moore entertained Farrer at his family's house in Stratford, Connecticut, and in his own studio in Catskill, New York, and described him as "the greatest gentleman friend I have in the world."[25] Moore's biographer, Frank Jewett Mather, Jr., believes that Moore probably came to Ashfield in the summer of 1865.[26] The visit may have taken place shortly after his marriage in July, 1865.[27] No letters between Farrer and Moore have been found for this period, but strong evidence of their continued close friendship is the name the Farrers chose for their newborn son: Charles Moore Farrer (not, as Mrs. Farrer jokingly wrote to her Brooklyn friend, "Gothic Revival Farrer").[28] Two letters from Moore to Norton of February 12 and April 8, 1866 make clear that the Moores and the Nortons had not only met but that Norton had taken a lively interest in Moore's work.[29] Indeed, the letters show that Norton had lent Moore his watercolor by Dante Gabriel Rossetti, *Before the Battle,* for copying.[30]

Two other artist members of this Ruskinian band may also have visited Ashfield in 1865. The *Northampton Free Press,* in its August 29, 1865 account of Farrer's visit, closes with the statement that "Mr. Hill, also a New York artist of celebrity, arrived in town last evening having just returned from a European tour." The Hills, John William (1812–1879) and John Henry (1839–1922), father and son, were both associated with the Society for the Advancement of Truth in Art, but the father's connection was probably quite informal. He had much earlier, in the fifties, become a convert to Ruskin's teaching.[31] It was probably John Henry Hill who arrived in Northampton from Europe that August,[32] but the possibility that both Hills visited during Farrer's stay in the vicinity is raised by a sentence in a letter of March 17, 1866 written from Ashfield by Farrer to Mrs. Gordon L. Ford: "We quite miss the visits we used to have from old Mr. Hill and his earnest 'they are not seeking the truth, sir.'"[33]

The probability is strong that Edwin Elmer came under the influence of Ruskin's teaching at an early age through the agency of Farrer's art and teaching, if not also through the art of Charles Moore and the Hills. The little pencil drawing of a woodland still life (fig. 36) is such a conscious effort to put into practice Ruskin's advice that the young artist should study nature closely, "selecting

nothing, and rejecting nothing," that it seems entirely possible that it was done after a reading of Ruskin or even under the tutelage of Farrer. Ruskin's disapproval of the academic studio table-top still life, artificially arranged according to invented rules of composition, was shared by many of the English Pre-Raphaelites, especially the still-life painter William Henry Hunt (1790–1864), affectionately known as "bird's-nest Hunt" to distinguish him from the more famous William Holman Hunt (1827–1910), one of the original members of the Pre-Raphaelite Brotherhood. Russell Sturgis, Jr. expressed the Ruskinian attitude very clearly in his criticism of a watercolor by his friend, John William Hill, which showed a branch of plums lying on the grass: ". . . a cut off branch of fruit thrown upon the ground is not dignified. It is good study, but poor picture-making. Even the great and authoritative example of William Hunt proves only that a picture may be made admirable in spite of a poor subject, for a poor subject cut flowers and plucked fruit must always remain. The orchard bough is better than the ground beneath the tree."[34] Hill was the closest of the Americans to William Henry Hunt, and his *Bird's Nest and Dogroses* (fig. 42), painted the year after Sturgis's article, gives evidence that he took the reprimand to heart. A follower of both Hunts must certainly have been the little-known English artist William J. Webbe (active 1853–1888), who painted the little

Fig. 36. *Woodland Still Life with Snake*, ca. 1865–66? (cat. 3).

Fig. 37. William J. Webbe (English, active 1853–1888). *A Hedge-Bank in May*, 1864. Egg tempera on board, 11″ diameter. Present whereabouts unknown.

scene called *A Hedge-Bank in May* (fig. 37), which bears a curious resemblance to Elmer's pencil study.[35]

Elmer's profile portrait of his sister Emeline (fig. 39) probably dates from the same period as the woodland still life. It is done with the same hard pencil and the same tightness of line. It was unfortunately cut out in silhouette style some time after it was done, so its original dimensions are unknown, but the paper is similar to that of the woodland still life and both may have come from the same sketchbook. Farrer's drawing of a young New York girl (fig. 38), done while he was teaching at Cooper Union between 1862 and 1865, may have been the kind of drawing that Elmer was trying to emulate.[36]

His double portrait drawing of his parents (fig. 41) probably dates from the years 1865–66 as well, but its looser, more confident strokes speak of an increasing grasp of the medium. The heads are done with a softer pencil and consequently have a fresher, more vigorous handling than the portrait of Emeline. This freer quality and the fact that they are profile portraits lead to the conclusion that they were done from life, not from photographs.

The *Portrait of My Brother* (fig. 46) is the earliest oil painting yet found. Maud Elmer, the daughter of the subject, Samuel Elmer, dated it about 1875 when she lent it to the 1952 exhibition at the Smith College Museum of Art. A few years later, however, in a letter to Robert O. Parks, then Director of the

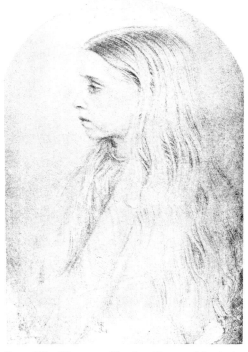

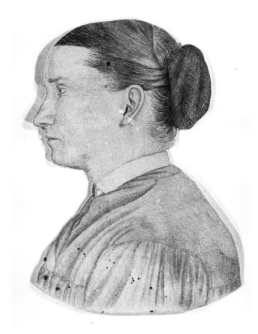

Fig. 38. Thomas Charles Farrer (English, 1839–1891). *Head of a Street Child.* 1863. Pencil. Present whereabouts unknown.

Fig. 39. Emeline Elmer, ca. 1865–66? (cat. 4).

Fig. 40. Charles Herbert Moore (American, 1840–1930). *Pine Tree.* Pen and ink and pencil, 25 x 20″. The Art Museum, Princeton University, Gift of Elizabeth Huntington Moore.

Fig. 41. *Erastus and Susan Smith Elmer,* ca. 1865–66? (cat. 5).

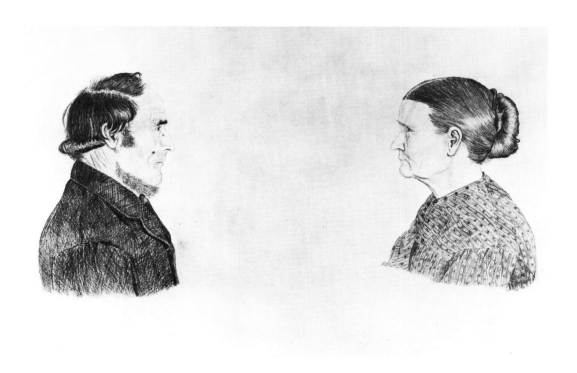

Museum, she speculated that it was done in the early 1870s. That dating would place it in Cleveland, and if it is compared to a photograph of Samuel (fig. 44) taken there in 1871–72 there is good reason to accept this estimate.[37]

It has already been mentioned that among the artists whom Elmer might have met in Cleveland was Leonora L. Fox, a graduate of the Cooper Union School of Design for Women, where she studied for two years, between 1863 and 1865, when Thomas Farrer was teaching there. In those years, an important collection of early European paintings had been placed on loan at the Cooper Union by Thomas J. Bryan. Called the "first art collector and connoisseur in New York City,"[38] Bryan was the son of a partner of John Jacob Astor (and reputedly a richer man than Astor). He had opened his Bryan Gallery of Christian Art about 1853 in second-floor quarters on Broadway as a commercial venture with an admission charge. Among the artists he claimed to present in his gallery were Cimabue, Giotto, Taddeo Gaddi, Fra Bartolomeo, Castagno, Botticelli, Leonardo, Raphael, Van Eyck, Memling, Gerard Dou, Cranach, Dürer, and Chardin. About 1860 he closed the gallery and deposited the collection at the art school which had just been founded by Peter Cooper.[39] It remained there until about 1865 or 1866, when "a spicy encounter between the philanthropist and the connoisseur terminated their friendly relations and the exhibition."[40] Both Farrer and Miss Fox undoubtedly had recourse to this unique collection, so readily available to them.

If Elmer did indeed choose Miss Fox as a teacher while he was in Cleveland, it may well have been she who called his attention to the works of the early masters she had been able to study in the Bryan collection.[41] Several Cleveland galleries—Ryder's and Sargeant's, among others—had stocks of Braun autotypes and other reproductions of the masters. Clearly, the work of the Italian primitives or an early Flemish master such as Memling (fig. 43) provided the inspiration for Elmer's placement of the figure of his brother on a balcony with a river

Fig. 42. John William Hill (American, 1812–1879). *Bird's Nest and Dogroses,* 1867. Watercolor, 10¾ x 13⅞". Courtesy of The New-York Historical Society, New York City.

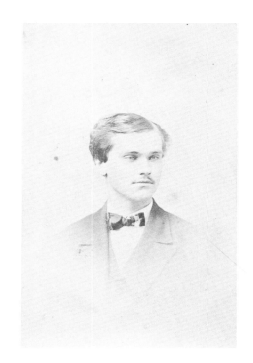

Fig. 43, above left. Hans Memling (Flemish, ca. 1440–1494). *Virgin and Child with Saints and Donors* (triptych), ca. 1470 (detail from central panel). Reproduced by courtesy of the Trustees, The National Gallery, London.

Fig. 44, above right. Samuel Elmer, ca. 1871–72. Photograph, 3½ x 2¼″, by J. F. Ryder, Cleveland, Ohio. Collection of Evelyn E. Whiting.

Fig. 45, right. John Ruskin (English, 1819–1900). "Tracery from the Campanile of Giotto at Florence." Drawing for Plate IX of the first (1849) edition of the *Seven Lamps of Architecture*. Smith College Library Rare Book Room, Northampton, Massachusetts.

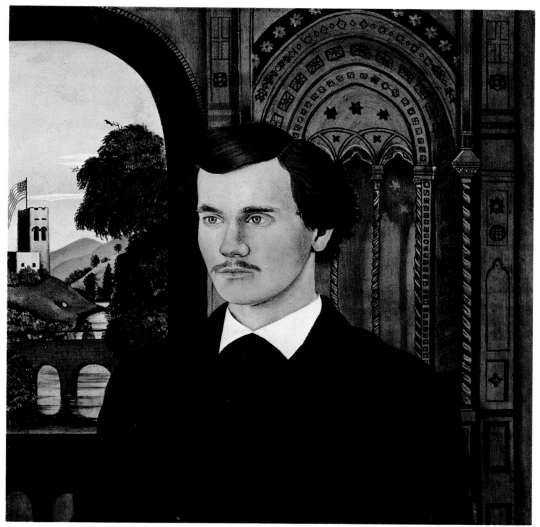

Fig. 46. *Portrait of My Brother,* ca. 1872–75? (cat. 6).

landscape in the background. The little landscape itself, more primitive in handling than the other parts of the picture, has the flag-topped, crenelated tower so popular in Hudson River "buckeye" paintings (fig. 47). The transporting of a trifora window from Giotto's campanile in Florence to a rural American setting may seem to the modern eye a little incongruous, but Venetian palaces and other manifestations of the Gothic Revival had been springing up all over the country, P. B. Wight and Russell Sturgis being among the foremost practitioners of that style. No doubt Elmer's only information about this architectural detail came from the reproduction of Ruskin's drawing (fig. 45) in the *Seven Lamps of Architecture,* which he copied faithfully, with only a few alterations. Ruskin's

Fig. 47. Unknown American artist. *Hudson River Scene,* ca. 1850. Oil on wood (keg top), 15¾" diameter. Abby Aldrich Rockefeller Folk Art Center, Williamsburg, Virginia.

drawing does not give any hint of the fact that what Elmer has rendered as a kind of brownstone is in the campanile actually marble in hues of white, pink, and green, nor does it make clear that what looks like a cast shadow on a wall is actually the suggestion of an identical window on the opposite side of the tower. Whether Samuel posed for the portrait or it was done from a photograph cannot be determined, but the painstakingly accurate rendering of the rep suit that Samuel seems to wear so proudly, as if it were quite new, suggests that Elmer had a photograph at least for reference.

In this early picture can be seen tendencies that were to show up throughout the artist's work, such as the use of other pictorial sources—photographs or works of art. It must be said that the precedents for this practice were legion. As is becoming increasingly evident as research into nineteenth-century art unearths more and more information, after the invention of the daguerreotype in 1839, photographs were used by many nineteenth-century artists, among them some of the masters. For some of the English Pre-Raphaelites, photographs, carefully copied, could supply background elements for pictures—or even serve as the basis for the whole composition.[42] Ruskin himself had endorsed the use of photography as an aid and in the *Seven Lamps of Architecture* had used his own drawings made from daguerreotypes.[43] His young American disciples also wrote admiringly of photographs in the *New Path,* recommending them for their truth and their beauty.[44] To artists following an injunction to work directly from nature, recording everything they saw, the camera was obviously an attractive device in its very incapacity to make choices. Its ability to eliminate the peripheral in a way that the unaided human eye cannot do, and to isolate and, paradoxically, to select details, could have inspired the kind of close-up still life so

56

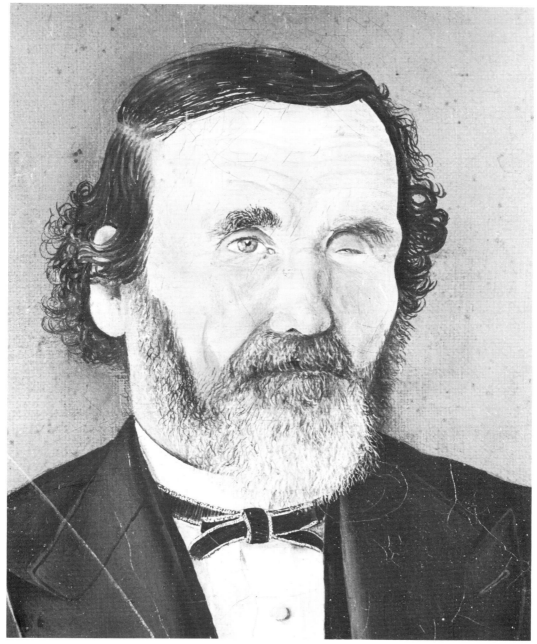

Fig. 48. *Erastus Elmer, the Artist's Father,* ca. 1875–80? (detail, fig. 49).

popular among Ruskin's disciples. For others, the photograph had more practical applications, and in this period there was no stigma attached to such direct use of photographic sources. The so-called crayon portrait, an enlarged photograph worked up with crayon, was already popular in Cleveland while Elmer was

there, and other works began to appear that looked like oil paintings but were simply painted photographs.[45]

In the portrait of Samuel Elmer we see, too, the curious alternation between careful and exacting brushwork and the kind of generalized handling typical of the untrained artist. In a sense, Elmer's early work represents an amalgam of two types of primitivism—that of the Late Gothic masters, in which every individual detail is rendered with equal fidelity, and that of the naive artist in which generic forms replace the specific detail.

Although the portraits of Elmer's parents (figs. 49 & 50) are not dated, they have a greater assurance and a sophistication of brushwork that argues for a date slightly later than the portrait of Samuel. If the latter was indeed done in Cleveland in the early seventies under the spell of Ruskin and the Flemish primitives, these two paintings seem to have more to do with Dürer, another artist admired by Ruskin. Both are strongly linear in their description of form and unshrinking in their dispassionate examination of every detail of the faces, almost as if they were terrains to be mapped. This marked linearity and a certain airlessness may derive from the fact that Elmer was using photographs, perhaps daguerreotypes, as his guide. Though the artist was in Ohio from about 1867 to 1875, he probably visited his parents at least once in those years and could have painted the pictures on such a trip. If the pictures were painted after his return from Cleveland in 1875 and before 1878 when his mother died, they could also have been done from life; however, the photograph of his mother (fig. 3), probably taken during those years, shows an older woman than the painted image. Furthermore, her dress in the painting is of a style popular in the late sixties and early seventies. The unarticulated backgrounds and the limited palette are further evidence in favor of a photographic source. In contrast, the portrait of Samuel is not only far more ambitious in composition but a great deal more adventurous in color. Perhaps the stimulation of working among other artists in Cleveland provoked Elmer to strive for greater breadth and complexity in that painting.

Samuel's portrait is very close in size to those of his parents and may have been intended as part of a set of family likenesses, which might have included a self-portrait. It is surprising that no self-portrait has been found, aside from that in the *Mourning Picture* (fig. 55).[46]

Between these three portraits and the next known work, *Mourning Picture,* 1890, there may be a gap of as much as fifteen years. Whatever work may have been done during that period has probably been destroyed. There is no evidence that Elmer was active as an artist or trying to sell his work during those years. It is likely that anything he did as a pastime would have remained within the circle of his family and friends and would thus have come to light long since, had it survived.[47] But because he did not begin to sign his pictures until 1891, some works may be buried among the thousands of anonymous paintings in the private and public collections of this country. When the *Greenfield Gazette and Courier* reported Elmer's crayon portrait of the late postmaster in May 1890, there was no hint as to how long he had been making portraits of this kind, nor was any mention made of any earlier activity when the first exhibition of the

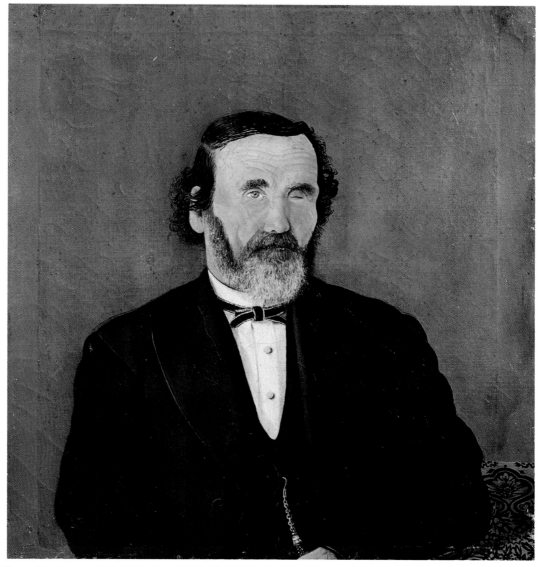

Fig. 49. *Erastus Elmer, the Artist's Father,* ca. 1875–80? (cat. 8).

Mourning Picture was reported the following November. A newspaper notice of May 1906 stated that he had been an artist for the past fifteen years.[48] In his own mind, apparently, he did not formally begin the practice of art until about 1890 and it must be assumed that there had been little output during the previous fifteen years.

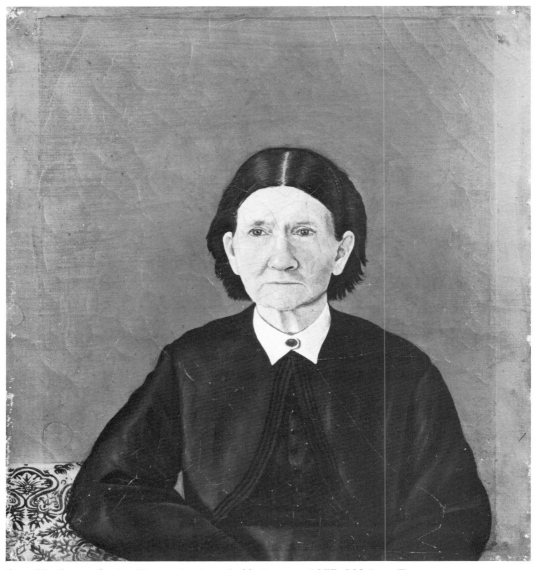

Fig. 50. *Susan Smith Elmer, the Artist's Mother,* ca. 1875–80? (cat. 7).

From 1865 onwards, as already noted, the cultural and artistic life of Franklin County began to quicken markedly, stimulated in large part by the presence of Norton and Curtis in Ashfield, and it continued to be active for decades thereafter. In 1865, William Cullen Bryant (1794–1878) bought his family's old homestead in the adjoining town of Cummington, and he, too, began to spend his summers in these Berkshire hills. Bryant was venerated as a poet (several of his best works were composed during his youth in western Massachusetts,

Fig. 51. *Susan Smith Elmer, the Artist's Mother,* ca. 1875–80? (detail, fig. 50).

including *To a Waterfowl* and *Thanatopsis*), and much respected as the editor of the *New York Evening Post,* a position of considerable influence. His sympathetic interest in art and friendship with the leading artists was memorialized by Asher B. Durand (1796–1886) in his famous picture of Bryant and Thomas Cole, *Kindred Spirits,* 1849.[49] The young American followers of Ruskin admired Bryant too, and Farrer did a number of drawings illustrating his poems.

Bryant died before Norton and Curtis inaugurated the Ashfield dinners in 1879 to raise funds for the renewal of the town's neglected high school, Sanderson Academy, so he did not figure among the speakers they invited. The Academy dinners were a far more ambitious project than the lectures they had given in the sixties to raise funds to re-establish Ashfield's library. Although Norton did not want his summer retreat turned into a resort and once chided Curtis for allowing the press to mention Ashfield as his summer home, these dinners without doubt transformed the tranquil village into a lively vacation colony. Ashfield House, the town's small hotel, which had opened in 1835, added forty rooms in the eighties to accommodate the growing throng.

Each year at the Ashfield dinner Norton would give the welcoming address and Curtis, the closing speech. In between, the townsfolk and other visitors from far and wide could hear as many as nine other speakers. Some were local dignitaries or divines, or hometown boys who had made good, like G. Stanley Hall, President of Clark University and a leading psychologist of the day. Very often they were figures of national or international fame. William Dean Howells spoke in 1880 and 1886 and Charles Dudley Warner, who had grown up in nearby Charlemont, was there in 1881, 1887, 1894 and again in 1899. The poets Christopher Pearse Cranch and James Russell Lowell read their works in 1885. The writer, George Washington Cable, who had taken up residence in Northampton, spoke in 1886. Booker T. Washington came in 1898, and Richard Henry Dana addressed the audience in 1900. William James was a speaker, too. Educational institutions produced a number of speakers, among them President L. Clark Seelye from Smith College, President T. C. Mendenhall of Worcester Polytechnic Institute, and President Clark of Williams College. In 1881, after he had accepted an invitation to speak, Mark Twain wrote to Howells to find out what the dinners were like and who attended. Howells replied on August 16, "Your audience will be the farmer-folks of the region, quiet and dull on top but full of grit and fun; they are fond of speaking, and rather cultivated, but not spoiled. They know *you* like a book, and you can trust all your points to them. Their life is one of deadly solitude and suffocating frugality; but they are smart. They will stand lots of human nature from you. You speak at a cold public dinner in the Town Hall."[50]

Although Twain undoubtedly would have made them laugh,[51] the intellectual fare at most of the dinners was by no means light. Norton's daughter, Sara, recalled that the subjects included tariff reform, political corruption, Negro education, civil-service reform, and anti-imperialism.[52] The question of the Philippines also became a topic, and Norton's outspoken views on it in 1901 offended a segment of the townsfolk, who vowed they would not come to another Ashfield dinner. Norton, who had carried on the dinners after Curtis's death in

1892, defended his right to speak his views, pointing out that he had provided spokesmen for the other side as well, but this disapproval of people of the town he had grown so attached to must have hurt him. In 1903, owing partly to ill health, he ended the dinners. After his death in 1908, it was acknowledged that the citizens had always liked Curtis better than Norton. They admired Norton enormously and were grateful for the tangible economic benefits his presence had brought the town, but Curtis had the common touch, while Norton was considered somewhat snobbish. They found his approach too "esthetic." For instance, he regretted the neglect of the beautiful old stone fences, no matter how hard the farmers tried to make him understand that their cows could climb them much more easily than they could the new barbed-wire fences.

Besides Farrer, Moore and the Hills, already mentioned, other artists came to Ashfield, too. They include Christopher Pearse Cranch (1813–1892), a painter as well as a poet and minister, and the famous painter of New York street urchins, John G. Brown (1831–1913), who came at least once in 1891.[53]

Other artists of some reputation were part of a summer colony in nearby Deerfield. James Wells Champney, already mentioned as a possible teacher of Elmer's, had bought a summer house there in 1876. George Fuller (1822–1884) was a native and long-time resident of Deerfield. Although his mature work shows no trace of a Pre-Raphaelite influence, in the late 1850s in New York he was a friend of several of the American Ruskinians, including Charles Herbert Moore, and he may very well have known Farrer then, too. In 1860 he went abroad with William J. Stillman, editor of the first American Pre-Raphaelite journal, the *Crayon.* Through him Fuller met Rossetti, Holman Hunt and Ruskin. From 1860 until about 1875, he farmed in Deerfield and painted only in his spare time. He was also a friend of Howells, who contributed an essay to the memorial volume issued about him in 1886.[54]

Fuller's boyhood friend in Deerfield was the Boston painter Edwin Tryon Billings (1823–1893), whose work is little known, but who painted an extraordinary genre picture of the interior of his father's wagon shop in Deerfield that suggests that he, too, may have been touched by Ruskinian ideas.[55] Toward the end of the century, Augustus Vincent Tack (1870–1949), who married Fuller's daughter, joined Deerfield's artistic community. Public lectures were offered here, too, and besides Champney and other residents, speakers included Ernest Fenellosa, the Oriental scholar.

Among the other artists in the area whose work Elmer could have known was the visionary folk painter Erastus Salisbury Field (1805–1900), today a rival claimant of Elmer and Fuller as Franklin County's most famous artist. Field was born in Leverett, lived for several years in New York where he studied very briefly with Samuel F. B. Morse, and then after other travels, returned to Franklin County and settled in Sunderland, where he died. Besides his many strong portraits, Field painted classical and biblical subjects. His most ambitious project was the *Historic Monument of the American Republic,* over nine feet high by thirteen feet long, now in the Museum of Fine Arts, Springfield, Massachusetts.[56] Field was a local character of some note and although he painted little after the mid-eighties, Elmer probably knew of his work.

Much closer to home was the Greenfield painter, George Washington Mark (?–1879), a flamboyant sign painter and picture maker who was called "The Count" and who opened a public gallery to show his work. A few of his paintings are known, and they range from the charming portrait of a little girl peeking through a doorway,[57] to the luridly-colored painting called *The Dismal Swamp.*[58]

In Shelburne Falls, Elmer was preceded in the business of making frames and enlarged photographs by Josiah B. King (1831–1889), a miniaturist whose profile portraits are sometimes confused with those of the more famous James S. Ellsworth. Before he ended his days as a worker in the local cutlery mill, King was, according to his business card, a dealer in "steel engravings, chromos, photographs (enlarged in India ink, very cheap), crayons, etc.," and a manufacturer of "picture frames and door plates (new and beautiful designs)."[59]

Probably the best opportunity offered to Elmer to learn what other artists were painting was provided by the annual exhibitions held in Springfield—about forty-five miles distant from Shelburne Falls—each February from 1878 until 1921. The exhibitions were put on by the enterprising dealer, James D. Gill, at first under the patronage of the local collector, George Walter Vincent Smith. At the beginning, most of the pictures shown came from New York artists. A number of the country's best-known artists were included, among them Eastman Johnson (1879 and 1884), Winslow Homer (1878, 1880, 1881, 1892), Martin Johnson Heade (eight exhibitions between 1878 and 1893), Albert Bierstadt (seven times) and Jasper Francis Cropsey (nine times). Thomas Eakins, Frederic E. Church, John F. Kensett, and Worthington Whittredge were each shown once in this period. Favorite artists who were seen almost annually included James Wells Champney, Walter Satterlee, Morston C. Ream, John G. Brown, John Henry Dolph, Alfred T. Bricher, and William Trost Richards. Dolph (1835–1903) had worked in Cleveland in the decade before Elmer's arrival. He was a popular genre painter who specialized in animal subjects, including many paintings of puppies and kittens. William Trost Richards (1833–1905) was a Philadelphia member of the Society for the Advancement of Truth in Art and a friend of Farrers in the sixties. Like Bricher (1837–1908) his favorite subjects were New England coastal views. Ream (1840–1898) was a still-life painter.

Gill also showed several Springfield artists, including George Newell Bowers (1849–1909) and Willis Seaver Adams (1844–1921); Adams had earlier lived in Cleveland and Greenfield. Other lesser-known artists living in the area were occasionally included in exhibitions. Elmer, however, was never one of them. Perhaps he was too shy or too sensitive to risk refusal, but probably, between the years 1878 to 1890 at least, he had little work to show.

It seems incredible, nevertheless, that the *Mourning Picture,* done in the spring of 1890, could have been almost the only work produced during the preceding fifteen years or so. A work of such imaginative strength could hardly have been done by an artist who had stopped working years before. Assuredly, powerful forces had brought it into being: grief for the death of his beloved only child, and perhaps sadness at his imminent departure from the grand house he

had built with his own hands and which must have symbolized such an important change in his life's condition. Indeed, relinquishing the house must have been a kind of admission of defeat, the end to all the bright hopes and joyful ambition that had brought it into being. Whatever the explanation, the painting seems to appear out of nowhere, the revival of a neglected pastime in answer to the irresistible demands of an emotional crisis.

The *Mourning Picture* is always classified with primitive and naive painting and has been included in many surveys of this genre. Certainly a folk element appears in Elmer's work from time to time, but when one considers the three works that closely follow this one in the next two years, it may be more to the point to attribute its naive qualities to a fortuitous confluence of circumstances. Although Elmer may not have painted actively in the years immediately preceding this work, it seems clear that he was not strictly speaking an untrained artist. If the picture seems to exhibit the naive painter's obsessive desire to show all he knows is there with the same clarity he uses for the things nearest to him, there may be other more conscious intentions. In the light of the early influence of Ruskin's ideas on Elmer, it is worth looking at the *Mourning Picture* as a latter-day effort to realize those aims. The carefully painted grass and clover in the foreground might easily have been inspired by the memory of an old admiration for the meticulously observed landscapes of the Flemish primitives such as Gerard David (fig. 52), intensified perhaps through the example of a work such as Farrer's *Anemones* (fig. 54).[60] Elmer had been a sometime inventor and manufacturer of mechanical devices, with a lifelong fondness for mathematical problems. He would have had a natural respect for the accuracy of details, a regard for the particular, sometimes perhaps at the expense of the general. He must also have acquired some skill as a draughtsman to have been able to design and build a house and to make accurate drawings to accompany his two patent applications.

That he had to rely on a photograph for the image of his daughter is to be expected (fig. 58), although it is a little surprising that no other painted image of her by him has been found. One or more photographs must certainly have provided the basis for the house and for the figures of the artist and his wife. The fact that his armchair and her platform rocker are not outdoor furniture brings up the possibility that the photograph had been taken indoors. Several years later, a somewhat similar photograph was taken in the Shelburne Falls parlor (fig. 27). For the house there may have been a separate photograph taken a little later than that reproduced in fig. 10, which dates from about 1881. Or perhaps the parents and the house were taken together, and the chairs brought out especially for the purpose.[61]

What the modern eye finds "eerie" in this picture may be the result of an unconscious awareness of Elmer's struggle to fuse his photographic sources into a single coherent composition. Usually in group portraits, except for those artfully composed to show some activity in progress, the sitters look at the painter. In the *Mourning Picture,* each individual is looking in a different direction, thus conveying a sense of their entrancement and detachment one from the other. They seem to be lost in their own dreams or caught in a spell.

Fig. 52. Gerard David (Flemish, ca. 1460–1523). *Altarpiece of John the Baptist* (triptych), ca. 1502–07 (detail from central panel). Stedelijk Museum voor Schone Kunsten, Bruges (Copyright A.C.L. Brussels).

Fig. 53. *Mourning Picture,* 1890 (detail, fig. 55).

Fig. 54. Thomas Charles Farrer (English, 1839–1891).*Anemones,* ca. 1865? Pencil. Destroyed.

Fig. 55. *Mourning Picture*, 1890 (cat. 9).

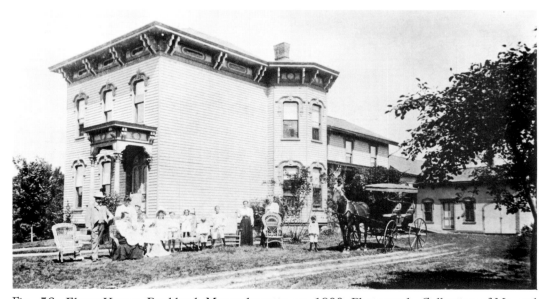

Fig. 56. Elmer House, Buckland, Massachusetts, ca. 1900. Photograph. Collection of Mr. and Mrs. Winthrop T. Anderson.

Fig. 57. *Mourning Picture,* 1890 (detail, fig. 55).

Fig. 58. Effie Lillian Elmer, ca. 1889. Photograph, 5⅜ x 4″, by J. K. Patch, Shelburne Falls, Massachusetts. Collection of Mrs. Robert Luce.

A further disconcerting element for the viewer may be the conscious or unconscious realization that the light source on the right of the picture comes from the right, whereas for Effie and the sheep it is directly in front of them, while the insubstantial, cut-out cat is lit from the left. Clearly there was no photograph of that animal, its tail carried high with delight, nor probably for the sheep whose wool is not rendered with the expected meticulousness.[62] It is part of the picture's power, however, that the viewer does not wonder what has become of Effie's left leg. It should be visible, even planted slightly forward of the other, but it is a detail we do not miss.

We know little about how Elmer's contemporaries perceived this picture, if they had more than one opportunity to see it. The earliest, and briefest, comment on it was the notice in the local newspaper when it was first exhibited in November of the year it was painted (quoted on page 22).[63] Fifty-six years later, again in November, a correspondent for the same paper, reporting on an exhibition of Elmer's work in Shelburne Falls, wrote: "A large primitive painting, one of his early works, depicts the house now owned by Mrs. Eleanor Buell on Bray Road which was built by the artist and at the time the picture was painted was

the house of the Elmer family. Shown in large scale, with a lamb in the foreground, is the deceased daughter of the family, and in the background are sitting the parents with tragic expressions."[64] In August 1950, when the picture arrived at the Smith College Museum of Art, Henry-Russell Hitchcock, the Museum's Director, wrote in a letter to his friend James Thrall Soby, an authority on surrealism (and subsequently author of monographs on Balthus and Magritte, among other artists of this movement): "******Press Release: The Smith College Museum of Art announces the arrival on extended loan of 'Mourning Becomes Shelburne Falls,' one of two masterpieces by the Balthus of the Berkshires, the Magritte of the Pioneer Valley, the late Edwin Romanzo (sic!) Elmer. . . ."[65]

Almost all subsequent writers have characterized the picture in the same way, as a primitive work with surrealist overtones. Words and phrases like "haunting," "disquieting," "visionary," "brooding," "hallucinatory," "magic realism," "something unnatural" and "a sense of uneasiness" have been used. It may be interesting to note that the phrase "hallucinatory vividness" has also been used to describe certain aspects of English Pre-Raphaelite painting[66] and that in writing about the works of the young American Ruskinians of the 1860s, Joshua Taylor observed that "only in a feverish vision would the mind fail to subordinate some visible facts."[67] Before the emergence of photo-realist painting in the 1960s, the last major manifestation of painting resembling photography had been the work of the precisionist painters of the thirties such as Charles Sheeler, Niles Spencer and others. These artists, however, were not so much concerned with capturing every detail as they were with a kind of mechanical purity and cleanness of line, and a photographic clarity of image. They did not try to imitate the all-seeing properties of the camera, but rather tended to simplify and eliminate unnecessary detail. Elmer's paintings were rediscovered as abstract expressionism was gaining its ascendancy in the United States and the art world saw in his *Mourning Picture* an obsession with detail which they attributed to an emotional derangement or, at least, to the eccentric fixation of a folk artist totally immersed in his own vision and unaware of the larger world of art outside. They found in the work intimations of surrealism. Salvador Dali's characterization of his own paintings, in which he strove to emulate the detailed clarity of the Van Eycks and the luminous brilliance of Vermeer, as "hand-painted dream photographs" was fresh in their minds.[68]

To understand the fascination that the *Mourning Picture* has for the modern viewer, it may be important to distinguish between what the artist has put into the picture and what viewers have found there. Elmer was certainly trying to create a work of the utmost realism, which would express the profound loss he felt. Although the presence of the sheep may not be without symbolic intention, had he put it there solely for that purpose he might rather have made the animal look more like a lamb instead of the fairly well-grown animal that was in fact his daughter's pet.[69] Did he choose to show himself and his wife in black because they were in mourning, or because people always dressed up in their Sunday best for a picture, and Sunday best meant black? Were their serious, sad expressions present in whatever photograph he used? Did Elmer decide to use one

photograph of Effie (fig. 58) instead of another (for instance, fig. 18) because her glance was cast heavenward? Would the viewer understand the picture's tragic origins if it were called simply *Family Portrait*?[70]

We cannot know the answers to most of these questions, but to the last one the answer is probably yes. Although there is an emotional reticence in the picture very different from the exaggerated sentiment of much contemporary Victorian painting, the accumulation of details does add up to something greater than the sum of them, and the picture does not need symbols or expressive gestures to convey its message.

This epitaph for a part of the artist's life that had been cruelly ended is today a kind of icon, such is its popularity with the public. It is, in fact, far better and more widely known than the artist himself—a reversal of the more common experience in which the artist's name is famous long after his work has been neglected. The *Mourning Picture* has been the inspiration for a poem by Adrienne Rich,[71] for a musical composition,[72] and—perhaps the highest compliment of all—an imitation.[73]

In 1891, the same year in which Elmer painted his view of the birthplace of Mary Lyon (fig. 59), a volume of photographs and sketches accompanied by a

Fig. 59. *The Mary Lyon Birthplace.* 1891 (cat. 11).

Fig. 60. *The Mary Lyon Birthplace,* 1891 (detail, fig. 59).

long descriptive text was published under the title *Picturesque Franklin.* Charles F. Warner, the author of this survey of Franklin County towns and their histories, hiked into the Buckland site of Mary Lyon's birth and wrote the following description: "It is a secluded spot, no house in sight, woods below, and above steep pastures, hills strewn with boulders, crossed by stone fences, dotted here and there with trees or clumps of bushes, cattle or sheep grazing about and the rippling company of the little brook in the near hollow. There is a lonely grandeur about the surroundings, with softening touches in the sound of the brook and the company of the cattle, which, with the historic associations of the place, should contain inspiration for some poet The place was not in Mary Lyon's time so removed from humanity. The county road ran over the hill, passing not far from the house, and there must have been a variety of travel and the daily stages to give outside interest to the dwellers here." Although his speculations about the liveliness of the place a hundred years before do not conform to Mary Lyon's recollections, his description of the landscape is what we see in Elmer's painting, except that Elmer has restored to its place the house that had been destroyed twenty-five years before and filled it with tenants, who have a fire going.

As a composition, the picture is neither so stark nor so startling as the *Mourning Picture,* but it exhibits an even more noticeable concern for the minutiae of nature. Many of the trees and wild flowers are readily identifiable, such is the botanical accuracy with which their foliage is painted. Absolute exactness in the transcription of nature was, of course, a credo of the American Ruskinians.[74] The whole landscape in this painting is a kind of carpet of infinitely graded hues of green—tiny strokes of color carefully modulated from a dark, cool blue-green up to a bright, almost acid, yellow-green. Among the greens are dashes of yellow grasses, an occasional touch of red, and little dots of white scattered along the stone fences like so many pearls. Each little tile of the distant roof is glistening in the sun, and the trees of the middle ground sparkle with little points of bright green. But the distance recedes in a series of well-orchestrated stages. Black is used sparingly.

Although there is perhaps a suggestion of the horror vacui of a *mille-fleurs* tapestry in the landscape, the composition has a harmonious coherence that is due in part, no doubt, to its basis on a single photograph, probably taken by the artist himself.[75] In spite of its fantastic accumulation of minute details, there is no trace of the obsessive, nor is there any hint of the naive in this painting, unless it be in the fantasy of the wonderfully imagined lacelike clouds, trailing long, spiky, white tails behind them.[76]

No other still life from Elmer's first period has survived, so that the ancestry of the *Magic Glasses* (fig. 64), the brilliant little still life with a magnifying glass, cannot be traced. The artist's niece recalled his penchant for puzzles published in the *Boston Post,* and added that Elmer was sometimes the only one to solve them. There is perhaps something of the puzzle or visual trick in the painting, and a love of the hidden or the obscure may be a greater motivation than any desire to fool the eye. An interest in illusionism nevertheless had figured many years before in his painted decorations for the hallway of his house (figs. 12, 13 & 14).

It may be that the artist acquired a taste for this kind of still life through the example of De Scott Evans, who worked in Cleveland during the last year or more of Elmer's stay there. Evans has been identified as the painter of a series of charming little still lifes with peanuts or almonds in glass-covered niches. These pictures are actually signed S. S. David, or Stanley David or Stanley S. David, but in an article in the *Yale University Art Gallery Bulletin,* Nancy Troy argues persuasively that these are pseudonymns for De Scott Evans, whose name was actually David Scott Evans (he gave it a French twist after he returned from study with Bouguereau in Paris).[77] While he was in Cleveland Evans seems to have been known only for his rather soft, conventional portraits and genre scenes, such as figure 9. If he had already begun to make these little *trompe l'oeil* compositions, he was evidently not exhibiting them publicly.[78]

In his letter of August 24, 1950 to James Thrall Soby, Henry-Russell Hitchcock expresses the opinion that the *Magic Glasses* is finer than the *Mourning Picture,* "—say the finest American *trompe l'oeil* or the greatest piece of 'magic realism' since Van Eyck's Arnolfini Wedding!"[79] The convex mirror in the background of the Van Eyck, which reflects the couple and a window in the room—

though not the window we see in the actual room—is indeed recalled by the convex reflection in Elmer's magnifying glass. Perhaps Elmer found inspiration for his concept in this or another Flemish or Dutch painting in which a mirror or drinking glass gives back a curved image of a part of the room outside the picture's confines, or a view of the exterior landscape, as in Petrus Christus's *St. Eligius in His Shop with Two Customers* (The Metropolitan Museum of Art, New York) or Quentin Massys's *The Money Changer and His Wife* in the Louvre.

Closer to his own time are two other painters who might have affected his ideas. One is an English painter named Edward Ladell (active 1856–1886), who seems to have painted nothing but table top still lifes with fruit, the contents varying only slightly from one to the other, but almost all of them containing a large wine glass in which one or more windows is reflected (fig. 63). According to William H. Gerdts and Russell Burke, authorities on American still-life painting, Ladell's work was known in America.[80]

A more likely artist to have influenced Elmer was the still-life painter Morston Constantine Ream (1840–1898) who, with his brother Cadurcius Plantaganet Ream (1837–1917), turned out hundreds of still life paintings during their many active years in New York city. Morston, the younger brother, was born in Lancaster, Ohio and came to Cleveland in the sixties to become a photographer. About 1869 he gave it up for reasons of health and went to New York, where Cadurcius was already a successful fruit and flower painter. Under his brother's tutelage he acquired sufficient skill as a still-life painter to prompt him to send one of his works back to Cleveland for exhibition at J. F. Ryder's gallery in January 1874. From the newspaper description of the painting, it was a work very similar to that reproduced in figure 62. Elmer would probably have made a point of going to see a work so readily available and which had received an unusually long notice in the paper.[81] Ream has used the fishbowl's curved surface to give a reflection of the wall behind him with its two paintings—one of them a still life (perhaps one of his)—and to give as well nine different reflections of the windows of the room. A young man like Elmer with a gift for the mathematical and mechanical would no doubt have found a painting like this intriguing.

In the long period between 1874 and 1891–92 when he probably painted the *Magic Glasses*. Elmer need not have stored in his memory this painting, because works by Morston Ream and many other more famous *trompe l'oeil* still-life artists were shown annually from 1878 onwards at Gill's shows in Springfield. Ream, who seems to have been a particular favorite with Gill, was usually represented by at least two works. Indeed, a lively public for still-life painting evidently existed in Springfield throughout the eighties and nineties. Still lifes by Martin Johnson Heade (1819–1904), George Henry Hall (1825–1913), George Cochran Lambdin (1830–1896), William Mason Brown (1828–1898), the Fall River artists Edward Chalmers Leavitt (1842–1904) and Frederick S. Batcheller (1837–1889) were among those included in the exhibitions. Of even greater significance, perhaps, was the inclusion of three masters of the *trompe l'oeil* genre, William M. Harnett (1848–1892), John

Fig. 61, above left. Morston C. Ream (American, 1840–1898). *Still Life with Wineglass,* 1871. Oil on composition board, 8 x 6″. Museum of Fine Arts, Springfield, Massachusetts, The Horace P. Wright Collection.

Fig. 62, above right. Morston C. Ream (American, 1840–1898). *Goldfish in Bowl and Fruit on Table.* Oil on canvas, 29 x 36″ Photograph courtesy of Kennedy Galleries, Inc., New York.

Fig. 63. Edward Ladell (English, active 1856–1886). *Still Life.* Oil on canvas, 20 x 16″. Private collection.

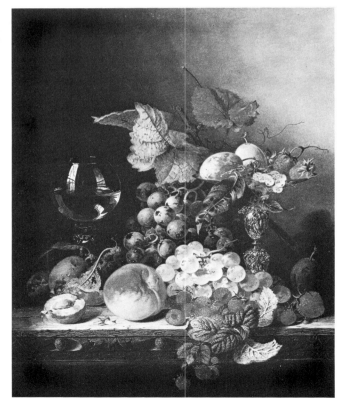

74

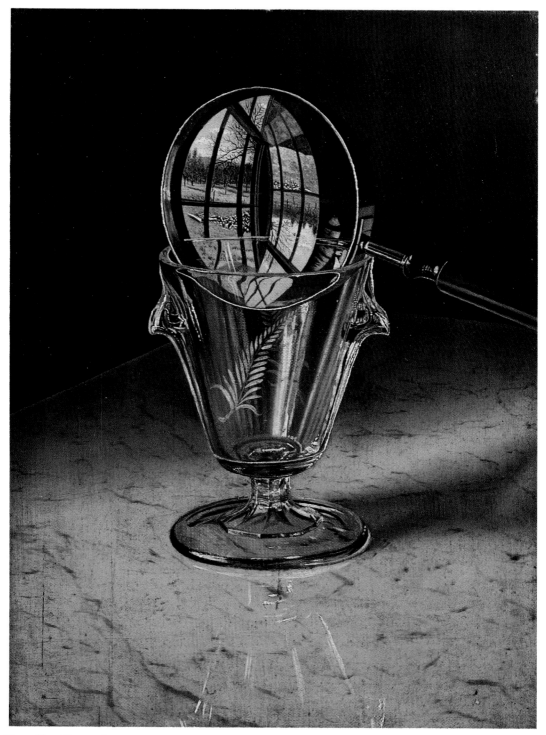

Fig. 64. *Magic Glasses (Still Life with Magnifying Glass)*, ca. 1891–92 (cat. 12).

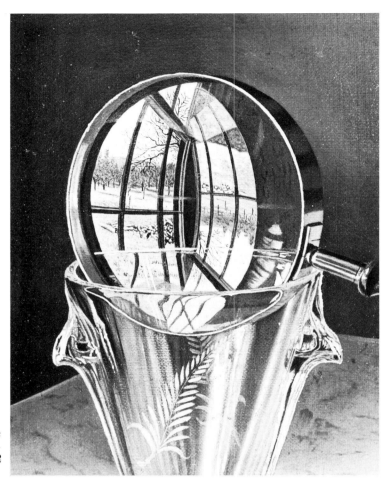

Fig. 65. *Magic Glasses (Still Life with Magnifying Glass),* ca. 1891–92 (detail, fig. 64).

Haberle (1856–1933), and Richard LaBarre Goodwin (1840–1910). Haberle had been first represented in the 1888 exhibition at Springfield and continued to be seen as late as 1894. In the catalogue for 1891 it is reported that his *Grandma's Hearthstone* was bought by James T. Abbe, "and hangs in the sample rooms of the Holyoke Envelope Company."[82] Another of his paintings was bought by Charles T. Shean, owner of Springfield's Hotel Charles, and a great fancier of still-life painting, who also bought a work by Richard LaBarre Goodwin, *Hunter's Cabin Door* (now in the Museum of Fine Arts, Springfield). Goodwin showed two paintings in 1892. Harnett's work was seen in 1889 (*An Evening Comfort*) and again in 1891, when his *Emblems of Peace* (now also in the collection of the Museum of Fine Arts, Springfield) was shown. It was priced at $2,000, a figure which might well have been an incentive to an artist just beginning to try to earn his living at the trade, especially since the sale was to a local man, William Skinner of Holyoke, a bustling factory town on the Connecticut River just north of Springfield. The biographical note on Harnett reads in part: "Mr. Harnett has gained world-wide reputation for eminent delineation of still life through his 'After the Hunt,' exhibited in the Paris Salon, and

now owned, together with his picture of 'Music,' by Mr. Stewart of Warren Street, New York, as well as by his 'Ease' that was painted for Mr. James T. Abbe of this city and Holyoke, and since sold by him from the Cincinnati Exposition to Mr. Collis P. Huntington for $5,300. Mr. Harnett recently executed a $5,000 commission to go to Philadelphia."

Perhaps the hope of financial reward, albeit a much smaller one, inspired Elmer to paint the *Magic Glasses* that year. The Gill shows were regularly held in February, and the view out of the window in the *Magic Glasses* is a wintry one.

Magic Glasses is the work of an artificer, the creation of a mind fascinated with mechanics and optics. The magnifying properties of the glass are not exploited. Rather Elmer was interested in the property of the lens, with its convex outer surface which reads from the "inside" as concave, and produces two reflections of the same image, one right side up, the other inverted.[83] The composition puts the viewer in a room about which he is prevented from knowing anything except that it contains a marble-topped table, a glass sugar-bowl, a magnifying glass and a window. By incorporating the window into the still life through its reflection, the viewer, like a prisoner, gets a tantalizing glimpse of the landscape outside.

There is great control in the painting of the tiny little landscapes with their piles of firewood, and the delicate precision of the beaded impasto along the highlighted edges of the two glasses is a fine piece of painting. The season is winter and the color throughout is shades of gray, brown, and yellow. A photographic source might also account in part for the somber quality of color, but in any case, the picture was probably plotted and laid out like a draughtsman's design, perhaps with the aid of the magic lantern projector.

The *Magic Glasses* intrigues us in the way that a complex piece of machinery does. We admire the ingenuity of its conception and the finish of its execution. It is all the more surprising that it appears to have been the only work of its kind that Elmer did. The magnifying glass, which may be detected (by use of a magnifying glass) in the photograph of Elmer at work on a crayon portrait (fig. 21), and which was evidently acquired as a tool for that unimaginative trade, has here served him as the vehicle for one of his masterpieces.

A Lady of Baptist Corner, 1892, is the most sophisticated of the four major paintings from the years 1890–1892 and finds Elmer at the height of his creative powers. The picture is much more strongly focused than either the *Mourning Picture* or *The Mary Lyon Birthplace* and is more ambitious and complex than the *Magic Glasses.* Appropriately for a picture of an indoor scene in wintertime, the color is somber in comparison to that of the *Mourning Picture* or *The Mary Lyon Birthplace,* both spring or summer scenes, but it is fresher and more varied than that in the *Magic Glasses.*

Elmer has here orchestrated the love of detail manifested in these three pictures to telling effect. The painting of the carpets clearly reveals that one is a hooked rug and the other an ingrain carpet. Little touches of light define the outer forms of the large, dark machine, and even the dimly seen reflections of the

spools in its green surface are not overlooked. But whereas in *The Mary Lyon Birthplace* the detail was overall, here the delicate filigrees of paint that outline the parts of the machine and the threads, the hands and face of Mary Elmer, and the back of her chair are set off against broad areas of flat color, giving the picture a greater balance and sophistication.

A detail that has sometimes been seen as confirmation of a proto-surrealist element in Elmer's work is the enormous size of the spools of thread on the floor. This is, however, based on a misapprehension. The spools actually were large, commercial ones made for factory use and readily available to Elmer and his brother, as dealers in sewing machine twist with a cottage industry of whip-snaps on the side.

The subject is not an exceptional one in American genre painting—though this must be the only picture of a woman at work at a whipsnap machine. Interior scenes with women at their chores or otherwise occupied were frequent subjects in American paintings of the last quarter of the nineteenth century. Artists like Thomas W. Dewing (1851–1938), Joseph De Camp (1858–1923), and other members of the "The Ten," as well as many genre painters of the period, were drawn to the subject of solitary women engaged in sewing or some other domestic task, reading, or, in the case of Dewing, lost in some private reverie. Closer to Elmer was the Springfield painter, George Newell Bowers, who often painted women alone in interiors, such as seen in figure 66. The Gill

Fig. 66, above left. George Newell Bowers (American, 1849–1909). *Meditation.* 1889. Oil on canvas, 18 x 14½". Museum of Fine Arts, Springfield, Massachusetts, The Horace P. Wright Collection.

Fig. 67, above right. Whipsnap machine, ca. 1887. Wood and metal, 49" high x 22" wide x 20" deep. Invented and manufactured by Elmer. Edwin Smith Historical Museum, Westfield Athenaeum, Westfield, Massachusetts, Gift of Mrs. George W. Kingsley.

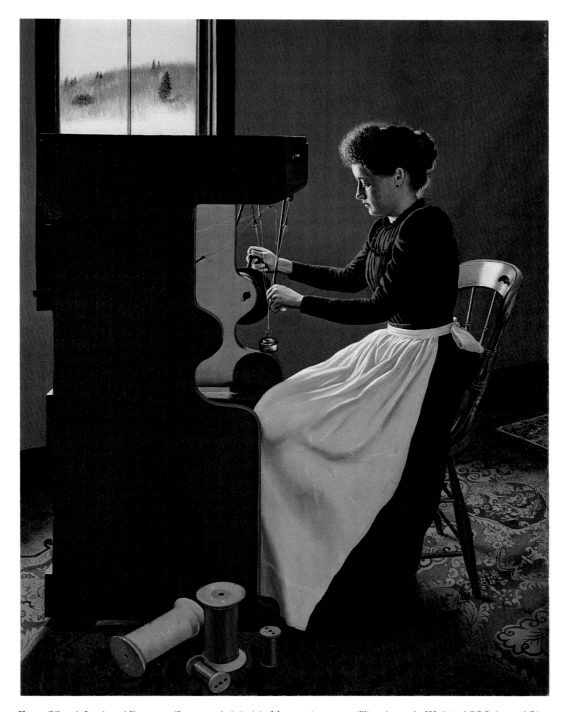

Fig. 68. *A Lady of Baptist Corner, Ashfield, Massachusetts (The Artist's Wife)*, 1892 (cat. 13).

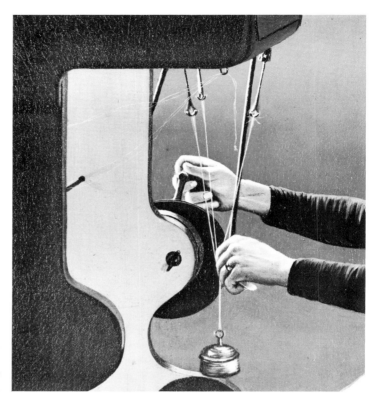

Fig. 69. *A Lady of Baptist Corner, Ashfield, Massachusetts (The Artist's Wife)*, 1892 (detail, fig. 68).

exhibition in Springfield in February 1891 included a painting by J. G. Brown entitled *Grandmother at the Loom*.[84] *In Ambush*, the other painting he showed that year, was brought with him to Ashfield in the summer of 1891, where it was sold. Whether he brought the *Grandmother at the Loom* as well, or whether it had any role in Elmer's decision to make a painting of his wife at the whipsnap machine, we do not know.[85]

While the subject is not unusual for American genre paintings, the handling seems entirely original. The artist has introduced into his work a new element, the use of light as a compositional device. Certainly there are no hints of Brown's late, rather monochromatic works here, nor is there the freedom of Winslow Homer, perhaps the most accomplished of American genre painters in the use of light. It is hard to think of another American genre painting in which the immaculate quality of light has been so successfully expressed.[86] European sources seem more likely, from Vermeer down to Joseph Wright of Derby and Northern European painters such as the Germans Caspar David Friedrich (1774–1840) and George Friedrich Kersting (1785–847), or the Danish artist Christen Købke (1810–1848).[87] The work best known to us today for its exploitation of the halo effect of back lighting from a window is the portrait of Mlle du Val d'Ognes done at the beginning of the nineteenth century in France (now in the collection of the Metropolitan Museum of Art, where until recent years it was attributed to Jacques Louis David). Apparently no reproduction of this work was made until after Elmer's painting was done, but works of the Northern

Fig. 70. *A Lady of Baptist Corner, Ashfield, Massachusetts (The Artist's Wife),* 1892 (detail, fig. 68).

European artists may have been known to him through prints.

In spite of its rather prosaic subject, *A Lady of Baptist Corner* has a magical air imparted not only through the delicate touches of light throughout, but also through the presence of an unexplained, mysterious light source that seems to come from within the machine itself. The rest of the picture makes it appear that the window is the only source of light, in which case the inner wall of the machine should be in deep shadow. Instead its warm red surface is brightly lit. As can be seen from photographs of the machine itself (figs. 67 & 109), the back was open, but there is no evidence within the picture of any illumination from behind. Perhaps the explanation is simply that on dark days a candle or small lamp was placed inside the machine to help the worker see what she was doing.

A provocative view of *A Lady of Baptist Corner* as a late manifestation of luminism was expressed by Edgar P. Richardson during a symposium held at the Corcoran Gallery in October 1950 in connection with the *American Processional* exhibition. His comments, published the following year in the *Corcoran Bulletin,* are worth quoting at length:

> One of the things coming out of this exhibition that most needs investigation is an aesthetic problem, not a problem of historical record. There appears to my eye, in those paintings in the exhibition between the Civil War and 1900, a remarkable

development of what I would call, for the lack of a better word, a native American school of luminism, which existed side by side with the development of French impressionism and was eventually overwhelmed by impressionism about 1890. It was a movement of independent character, and to my taste a movement of great distinction. Its masterpiece in this exhibition is, in my opinion, Winslow Homer's *Country School.* Think of that picture if you will—that warm tonality with beautiful cool accents—how different it is from the tonality that French painting developed. It was based upon very penetrating observation, very accurate and expressive drawing, but at the same time it was done with a very fresh and sensitive eye for air and light. Homer's solution of the problem of combining drawing and light was an American solution. It is not found anywhere else that I know of. There are other paintings in the exhibition—the painting by Louis C. Tiffany, Whittredge's painting of the *Camp Meeting* of 1874, Healy's *Arch of Titus*—each is a beautiful study in what I call luminism. It cannot be called impressionism, for it is something else. The industrial scene by John Ferguson Weir and Eakins' *Agnew Clinic* belong to it. The great period of luminism was apparently in the 60s and the 70s. But it lingers on, and there is something of it in the curiously unforgettable picture by Edwin R. Elmer *A Lady of Baptist Corner, Massachusetts,* 1892, one of the discoveries of the exhibition. By that date luminism was changing its character. But in general it was an aesthetic movement much more related to the early Corot of his Italian sketches than it was to impressionism. Where did it come from? What was the source of the change? Who were its leaders? Where did it first appear? It is a very interesting, purely aesthetic problem for us, and yet one which I feel much stimulated to think about as a result of this exhibition.[88]

This was evidently the first application of the term "luminism" to this strain in mid-nineteenth century American painting. John I. H. Baur had earlier identified and described the movement or tendency, but did not use the term "luminism" for it until 1954 in his article "American Luminism," in *Perspectives USA.*[89] That study has rightly been called a springboard for all succeeding studies of the subject. The quintessential luminists, in his view, were Martin J. Heade and Fitzhugh Lane. He remarks about Lane's work that "time of day and kind of day are always recognizable," and goes on to observe that "like that of others in the movement, Lane's technique was a polished and meticulous realism in which there is no sign of brushwork." If *A Lady of Baptist Corner,* as well as, perhaps, *The Mary Lyon Birthplace,* can be considered late manifestations of luminism (and some of the artist's later pastels exhibit other traces of the style), his exposure to examples of it might well have been the Gill exhibitions. Heade showed the *Sunset at Black Rock* in 1881,[90] and works by Frederic E. Church, John F. Kensett, Alfred T. Bricher, Worthington Whittredge, Eastman Johnson, Winslow Homer, William T. Richards, and David Johnson were shown one or more times during the 1880s and early 1890s. In another passage of Baur's *Perspectives USA* article, he quotes from Henry James the following suggestive observation: "There is a certain purity in this Cragthorpe air which I have never seen approached—a lightness, a brilliancy, a *crudity,* which allows perfect liberty of self-assertion to each individual object in the landscape. The prospect is ever more or less like a picture which lacks its final process, its reduction to unity."[91] Whereas in his three previous paintings Elmer had allowed "perfect liberty of self-assertion to each individual object," in *A Lady of Baptist Corner* he has taken the picture to its "final process, its reduction to unity."[92]

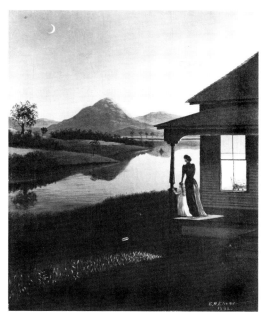

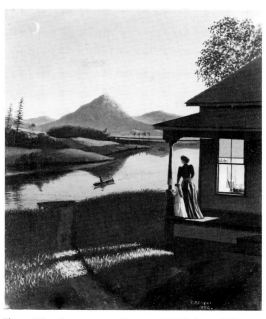

Fig. 71. *Imaginary Scene*, 1892 (cat. 14). Fig. 72. *Imaginary Scene*, 1892 (cat. 15).

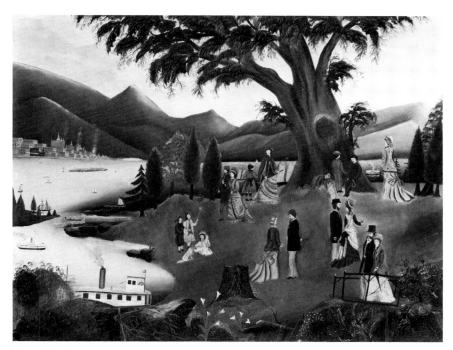

Fig. 73. Unknown American artist. *Outing on the Hudson*, ca. 1875. Oil on cardboard, 19 x 24″. Abby Aldrich Rockefeller Folk Art Center, Williamsburg, Virginia.

Except for their consistent regard for clarity and accuracy of delineation, the four major paintings Elmer completed in the three years between 1890 and 1892 differ so widely one from another that an unsuspecting viewer might be forgiven for not recognizing that all came from the same hand. But if these pictures seem to lack many common traits, the series of six small canvases done in the same year as *A Lady of Baptist Corner* have even less resemblance to what preceded them.

Three versions of the *Imaginary Scene* are almost identical (figs. 71 & 72).[93] At twilight a woman and a little girl stand on a cottage porch watching the approach of a rowboat. Across the water pointed mountains are set against a sky, in which the last vestiges of sunlight linger and a crescent moon has risen. The light from the cottage windows plays across the backs of the mother and child and singles out blades of grass beside the porch. Inside the cottage a chair and a table set with plates and teacups can be seen. Details of the woman's coiffure and dress resemble very closely those of the artist's wife in *A Lady of Baptist Corner,* and the porch column bears a distinct resemblance to one on the artist's own house, as seen in the *Mourning Picture* (fig. 55). The light from the window edges the details of the porch delicately and touches the elbow of the little girl with a highlight in a way that recalls the handling of light in *A Lady of Baptist Corner.* But the clumsy modeling of the figures and the casual rendering of other parts of the painting—the mountains and trees in particular—resemble much American folk painting (fig. 73).

Harold Rosenberg, commenting on the nature of folk art, remarked that "Folk art stands still. It neither aspires upward, like academic painting, nor advances forward, like the inventions of the modernist art movements. The lions of Hicks are not the ancestors of the lions of Rousseau."[94] Although Elmer's mountains in these pictures do seem to be descendants of those of hundreds of folk painters, in his repetition of this subject and others, virtually without alteration, he confirms Rosenberg's observation. The impulse to return over and over again to the same theme or subject has many motivations. Some artists made exact or nearly exact copies of their works to fill a popular demand: Gilbert Stuart's numerous portraits of George Washington, done by his own hand, are a case in point. Other artists, especially in Europe, having created an image that caught the public's imagination, had their assistants turn out replicas or repetitions, though a guarantee that the hand of the master had touched the painting was sometimes demanded. Nevertheless, even late into the nineteenth century, after photography had been enthusiastically embraced by many painters as a source of ideas or compositional details, no great stress was laid on originality.

For Monet's studies of changing light, it was essential that the image be the same each time, and he did his many views of haystacks, water lilies or the façade of Rouen Cathedral in order to explore, develop and understand an idea through repeated examination of it. Heade's many studies of the haystacks of the marshy New England coast land may have more in common with the replicas of Elmer and folk painters like Edward Hicks, Thomas Chambers, or William Matthew Prior. These artists' repetitions have the stamp of the artisan (or in Elmer's case, the manufacturer), who has made a good thing and wants to make

others as much like it as he can. The theme is not re-examined or developed, merely duplicated with minor changes. Besides Heade, other luminist painters such as Alfred T. Bricher, William Stanley Haseltine, and William Trost Richards also went back again and again to the same subject, with little change in approach, though the landscape details were varied and the sites were different.

One can only guess what made Elmer lapse so suddenly into this Sunday painter vein. These pictures probably represent imagined or remembered scenes, and whereas in the previous works he had pictorial sources or models from nature to copy, here he had none, and his basic lack of a thorough artistic education was revealed. The resemblance of the women in these three works to the figure of his wife in *A Lady of Baptist Corner* suggests that the little girl may also represent his daughter and that the scene is a fantasy on a remembered or dreamed-of occasion. What is not naive in these pictures is their well-realized feeling for the time of day.

Two moonlight landscapes, again almost identical, also date from 1892 (cat. nos. 17 & 18).[95] Their inky black trees set against a lurid lavender and green sky are reminiscent of the colors found in George Washington Mark's *Dismal Swamp*.[96] The tone of the pictures suggests a print source—perhaps one of the many moonlight subjects popularized by Currier and Ives, or a chromolithograph.

The sixth of these little 1892 oil paintings is almost unique in Elmer's work (cat. no. 19).[97] It shows a barefoot boy and girl beside a stream by which a cow is grazing and is the most nearly anecdotal work by Elmer yet found. The color recalls that of the *Mourning Picture* in its intensity, but the blues and greens have more the flat brightness of chromolithographic color. The landscape seems clearly to have been borrowed from another source and is not a local scene painted from nature. Although the work of John G. Brown comes to mind because of his visit to Ashfield the previous summer, the painting more nearly resembles the work of S. S. Carr (1837–1908), who did many rural scenes with children.[98]

The *Imaginary Landscape* (fig. 74) is close in size to the preceding works and similar in mood and subject to the *Imaginary Scenes* (figs. 71 & 72). It is painted on a very thin cardboard, not canvas, and is not signed or dated, as those works are. It could have been painted as late as 1896, when it was given to Mary Elmer's niece as a wedding present. Once again, it represents a twilight scene by the water, but this time it is the ocean. The lighted cottage is present, but there are no attendant figures, and the rowboat on the calm inlet waters has two occupants. Far out on the ocean, where the splashing waves are caught by the last rays of the sun, are a tiny steamer and a sailing ship, while closer to land a sailboat turns along the coast. In the sky are a crescent moon and little horizontal strands of clouds that climb up from the sea like steps, growing pinker and darker as they rise. Although this painting has all the hallmarks of a folk paint-ing, what sets it apart from the general run of such work (fig. 73) is its fine appreciation for atmospheric effect. The ambiguity of twilight—here expressed by the brilliant yellow of the setting sun, the white crescent moon, and the

Fig. 74. *Imaginary Landscape,* ca. 1892–96 (cat. 20).

orange artificial light in the cottage windows—has fascinated many artists be-
fore and after Elmer. Heade, Church, and Sanford Robinson Gifford come to
mind among those whose work Elmer could have seen.[99] In this little work he
has managed to capture the beauty of a fleeting moment with great freshness and
charm.[100]

Except for crayon portraits, no other works that can be reliably placed in the
first period of Elmer's work have been identified. The *Arab Modeling* (cat.
no. 21) was probably done after he went to New York. He apparently began to
feel some dissatisfaction with his career towards the end of the decade and toyed
with the idea of going to Alaska to seek his fortune. Instead, he decided to go to
New York to perfect his art.

Elmer's letter of November 20, 1899 from New York (Appendix A) outlines the regimen at the National Academy of Design: painting class from 1:00 to 4:00; sketch class from 4:30 to 5:30, and the "antique" from 7:00 to 10:00 p.m. He hoped to be admitted to the life class in February. His teachers probably would have been Edgar Melville Ward, Francis Coates Jones, and George W. Maynard (see Part I, n. 78). Ward and Jones were younger brothers of more famous artists, respectively the sculptor John Q. A. Ward and Hugh Bolton Jones, a successful landscape painter. George Maynard is known today mainly as one of John LaFarge's assistants on his Trinity Church murals in 1876. Elmer was, of course, also working privately with Walter Satterlee. The few accessible examples of the latter's work (fig. 75) do not suggest that Elmer's study with him would have greatly developed his gifts though it might have increased his understanding of the current fashions in art. But it is hard to see what would have made him seem an attractive teacher to Elmer, and it is not known how he came to choose him. [101]

On professional cards and billheads (figs. 25 & 29) dating from before and after 1900, Elmer itemized the mediums in which he worked. Before going to New York, he listed oil and crayon. After his return he added ink, sepia and watercolor. No works in ink or watercolor have so far been found, and the largest number of works that have survived are in a medium not mentioned, namely

Fig. 75. Walter Satterlee (American, 1844–1908). *June Roses*. Oil on canvas, 40 x 20⅛". Courtesy of the Syracuse University Art Collections, Gift of Mr. Edward M. Byrne.

pastel. He may have used the term "crayon" for the medium of both his photo-portraits and his pastels, and "sepia" may mean pastels done in sepia tones. Maud Elmer states that he acquired and mastered the technique of pastel when he was at the National Academy.

Pastel had long been a popular medium in France, but after Colonial times it was not much used in the United States until the last quarter of the nineteenth century. For decades, popular taste in America had been accustomed to admire "finish" in works of art, and the loose, wispy quality of some pastels was probably unsettling, as was also, no doubt, the much brighter palette that the impressionists began to bring to the medium. James Wells Champney, who had begun to work almost exclusively in pastel by about 1885, was one of a growing number of American artists who took up the medium about this time. Given the French impressionists' fondness for it, it is not surprising that its popularity here was especially marked among their American followers. In 1882, The Society of American Painters in Pastel was founded by James Carroll Beckwith, Edwin Blashfield, Robert Blum, William Merritt Chase, Hugh Bolton Jones, Francis Miller, and Charles Ulrich.[102] A review of their first New York exhibition in 1884 observed that "'Impressionism' is here seen at its sanest and best, and those who are susceptible to the charms of cleverness and dash can find much to delight them in this first effort to acquaint the general public with the possibilities of pastel."[103] The Society held three more exhibitions in 1888, 1889, and 1890, in which additional artists were seen, among them John LaFarge, John Henry Twachtman, Irving Wiles, J. Alden Weir, Theodore Robinson, Childe Hassam, and Robert Reid.

By the time Elmer went to New York, the Society had long since disbanded, but several of its founders were still associated with the National Academy. Beckwith and Hugh Bolton Jones were listed as members of the Academy Committee for the year 1899–1900, but their names are not included in the faculty roster. Jones's younger brother, Francis, taught the day class in antique and still life, and it may be from him that Elmer learned pastel.

In any event, mastery of this medium appears to have been the principal legacy of his season in New York. He seems to have been largely untouched by impressionism or any other new ideas that must then have been in the air. In a younger man this would be surprising, but Elmer was a fifty-year-old man who had been making pictures, however erratically, a good part of his life. His niece said that he "at once stood out among the students at the Academy of Design both in his maturity of judgment and in his ability in art." These qualities probably also made it difficult for him to experiment or assimilate new trends. In any case, his painting had been in every way the antithesis of the spontaneous manner of the impressionists and though he might well have appreciated their concern for capturing the precise effects of light, he was probably too old to try seriously to learn their techniques.

Elmer returned to Shelburne Falls in May 1900 and in June he placed an advertisement in the local paper offering his services as a portrait artist and styling himself E. R. Elmer. N.A.D.[104] It is somewhat odd that he did not mention his newly acquired skills in the medium of pastel, and it is surprising

that no pastel dated before 1904 has been found, although one undated work (cat. no. 25) is thought to have been done in 1902.

The earliest works that have survived from Elmer's first year back in Shelburne Falls are two oil paintings. *North River, Shelburne Falls* (fig. 76), a summer scene, exhibits in its foreground his former regard for the botanical differences in foliage, but a new looseness, a slight relaxation evident in this work, can probably be traced to his New York experience. Although the hills and buildings in the background are clearly defined (so much so that a photographic source seems likely), the colors are softer, and the whole palette is cooler and more muted. The two birch saplings at the right, their sunlit trunks brightly accented in white, lend the work an air of informality, even perhaps a touch of "artiness," not seen in Elmer's work before.

Fig. 76. *North River, near Shelburne Falls,* 1900 (cat. 22).

Another effort to put into practice some of the lessons of New York can be seen in *Hunting Scene* (fig. 77), on which the date 1900 is just barely discernible. Probably done in the fall, it shows two hunters and their dog in a clearing in the autumn wood. Scattered across the canvas are little dabs of impasto applied with a palette knife. This effort at spontaneity seems lacking in conviction, however, and the rather clumsy figures suggest that Elmer had not been admitted to the life class, as he had hoped to be. The picture, however, displays his former appreciation for light, and the mood of the forest interior with occasional patches of bright sunlight on the autumn foliage is well conveyed.

Until Elmer's work was shown in 1952 at the Smith College Museum of Art, he had been regarded as an eccentric, naive talent, who followed his innocent vision totally unhampered by the art of the outside world. This notion had been formed on the basis of a few of the oil paintings dating from before 1900. In the 1952 exhibition, eighteen of the twenty-seven works were pastels done after 1900. They were found to be disappointing and cited as examples of the tragedy of an original talent corrupted by a little education.

Fig. 77. *Hunting Scene.* 1900 (cat. 23).

Fig. 78. *Lake Pontoosuc, Pittsfield, Massachusetts.* 1905 (cat. 52).

Fig. 79. *Lake Pontoosuc, Pittsfield, Massachusetts.* Tinted photograph, $2^{1}/_{16}$″ x 6½″. Collection of Mrs. Robert Luce.

Fig. 80. Charles Herbert Moore (American, 1840–1930). *Morning over New York,* 1861. Oil on canvas, 11⅞ x 30″. Vassar College Art Gallery, Poughkeepsie, New York, Gift of Matthew Vassar.

Certainly the pastels do not share with the earlier work the same intensely personal and almost compulsive creative force. They are largely conventional in composition and in subject—landscapes and still lifes—and, owing to the nature of the medium itself, less ambitious than the oil paintings. Nevertheless the best of them—and there are many fine works—reward study.

Old Saw Mill Near Shelburne Falls, 1904 (cat. no. 26), is the earliest dated pastel and is noticeably looser in its drawing than most of those that follow, perhaps still reflecting the artist's effort to bring greater freedom to his work. But very soon he reverted to the clear, precise, linear manner that had characterized the best of his earlier work.

This work manifests an obvious new characteristic in Elmer's later works, not necessarily one acquired in New York: a marked preference for a long, narrow format, both horizontal (e.g. cat. nos. 33 & 86) and vertical (e.g. cat. nos. 25 & 58). In a number of works, the ratio of dimensions is 1:2, but in several it is as much as 1:2.7 and in the little 1905 pastel of *Lake Pontoosuc* (fig. 78) it is nearly 1:3. An exaggerated horizontal format is, of course, one of the distinctive features of luminist landscapes and could have been picked up through a study of such works at the Gill exhibitions.[105] The link between the Ruskinians and the luminists is well illustrated by the 1861 painting by Charles Herbert Moore, *Morning over New York* (fig. 80) which exhibits a luminist concern for light and a luminist format—about 1:2.5.[106] Elmer may have recalled works like this that he had seen much earlier, but his adoption of this new format after 1900 might have had other inspirations as well. In January 1900, a large exhibition of paintings and prints by contemporary Japanese artists was shown in New York.[107] It probably included works of the extended horizontal and vertical formats so favored by earlier Japanese artists. Whether or not Elmer saw the exhibition we do not know. The only work by another artist that he is known to have possessed, however, is a tiny Japanese print (see Appendix A), though it is not of unusual proportions. Panoramic photography is another likely source for this unusual format, the more so since Elmer did do some photography himself, and continually used photographs—his own and those of others— as the basis for his compositions. Indeed, in this second period of his work he frequently made exact transcriptions of photographs (e.g. cat. nos. 54 & 74). One of the most successful of such works is *Lake Pontoosuc* (fig. 78), based on a small tinted photograph (fig. 79). One of the luminist photographers included in the National Gallery's *American Light* exhibition was Louise Deshong Woodbridge (1848–1925) who is represented by two views of *Lake Pontoosuc* (near Pittsfield, Massachusetts) taken in 1885.[108] Although these photographs do not have an exaggerated horizontal format, she may nevertheless have taken the one Elmer used for his composition.

One of John I. H. Baur's observations about Fitzhugh Lane's landscapes seems especially relevant to Elmer's compositions. He writes that "Lane was not much interested in composition; indeed there is evidence to show that he scarcely composed at all except to choose, like a photographer, his place in the landscape and the extent of his view."[109] In many of Elmer's pastels, such as the two views from the iron bridge in Shelburne Falls (figs. 81 & 82) or the views on

Fig. 81. *View on the Deerfield River from the Iron Bridge at Shelburne Falls,* 1905 (cat. 33).

the Deerfield River near the junction with the North Rivers (cat. nos. 38, 39, 40, & 41), one feels that the artist took up a more or less central location and recorded everything he could see. These local scenes must surely have been based on his own photographs, for among the repetitions there is virtually no variation in the details of landscapes. Indeed, catalogue number 24 is probably a touched-up enlargement of Elmer's photograph.

Fig. 82. *View on the Deerfield River from the Iron Bridge at Shelburne Falls,* 1905 (cat. 34).

Fig. 83. *Mount Tom, East Side*, 1905 (cat. 48).

Fig. 84. *River Landscape*, 1905 (cat. 49).

94

Fig. 85. *Mount Tom,* ca. 1905? Photograph, 3¼ x 3⅜″, probably by Elmer. Collection of Mrs. Robert Luce.

Even when he used his own photographs, however, Elmer made sure that the perspective was correctly transcribed. The little snapshot (fig. 85) with string tied around it to parallel the line of the mountains and the river bank is evidence that even when copying a photograph he made sure that he understood the perspective. Four of the pastels that have been located are based on photographs found in little souvenir booklets issued about the turn of the century by the Boston and Maine Railroad. The photograph used for catalogue number 75, *Noontime, Lancaster, Massachusetts,* has been identified as the work of Henry Greenwood Peabody (1855–1951), and it seems likely that he also took the other photographs in these booklets that Elmer used. Catalogue number 75 is done in sepia tones, as is catalogue number 74. The two views of Echo Lake, New Hampshire (cat. nos. 53 & 54) are transcriptions in color. *Echo Lake and Moat Mountain* (fig. 86) is the more successful of the two and has a kind of silent grandeur that quite transcends the black-and-white photograph. Although

Fig. 86. *Echo Lake and Moat Mountain, New Hampshire,* 1905 (cat. 53).

Fig. 87. "Moat Mountain and Echo Lake, New Hampshire." Photograph, probably by Henry Greenwood Peabody, in *Mountains of New England,* Boston and Maine Railroad publisher.

MOAT MOUNTAIN AND ECHO LAKE, NEW HAMPSHIRE.

96

Fig. 88. *Bridge on the Colrain Road,* 1905 (cat. 43).

this and other pastels done from photographs are quite beautiful in color, there is a certain lifelessness to them as well. *Bridge on the Colrain Road* (fig. 88) and *Street Railway Power Station* (fig. 89), two of the most successful pastels which are not known to have been based on photographs, have by comparison a greater liveliness and sparkle that seem to reflect a response to the scene itself in all its sunlit detail.

Fig. 89. *Street Railway Power Station, Colrain,* 1905 (cat. 42).

97

Fig. 90. *Still Life with Pears and Clover,* 1905? (cat. 60).

Although in his early efforts at pastel Elmer may have experimented with a somewhat freer line, most of the extant pastels show that the quick, sketchy quality of impressionist pastels had no appeal for him, nor did he try for correct tonal effects through smudging or blending of colors with his fingers. Most of the pastels are done on a gray or buff paper of French manufacture, with a very fine grind of marble dust on its surface. Along the edges there is usually evidence that he sharpened the crayon to a finer point from time to time. But if he rejected the bravura of impressionism in favor of linear control, the bright palette of many of the landscapes may owe something to that movement.

In contrast, the still lifes are generally somber in color. They usually are done at close range, and in one case, (fig. 90), the top of the composition is cropped, suggesting once again that a photograph may have been used. Some of them have a darkness that does not seem to come from natural lighting. There are no memories in them of Ruskinian strictures against formal studio arrangements. Indeed, they are all indoor, table top compositions, often juxtaposing a bowl of fruit with a vase of flowers. There is no recollection, either, of the *trompe l'oeil* approach of the *Magic Glasses* (fig. 64), but the pastel medium, even as Elmer used it, does not invite attempts at that kind of effect.

Fig. 91. *Vase with Zinnias,* 1907 (cat. 79).

Fig. 92. *Apples and Cider (Still Life with Apples),* 1904 (cat. 31).

Fig. 93. *Peaches and Grapes,* 1905 (cat. 59).

Maud Elmer wrote that her uncle had told her that his teachers thought he was "remarkably clever in striking the exact colors directly" in his pastels, and in the best of these works the color is strong and fresh. For Elmer pastels were not quick sketches or colored drawings. He brought to them the same deliberate care that he used in an oil painting. He tried to achieve his effect through the choice of color and the density of pigment. In the *Vase with Zinnias* (fig. 91), for instance, the mottled earthenware of the pot is accurately suggested through a buildup of pigment. For all the delicacy of their skillful handling, his pastels often have almost the weight of oil paintings.

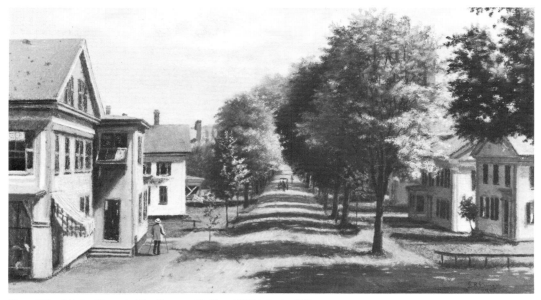

Fig. 94. *Main Street, Shelburne Falls,* 1905 (cat. 35).

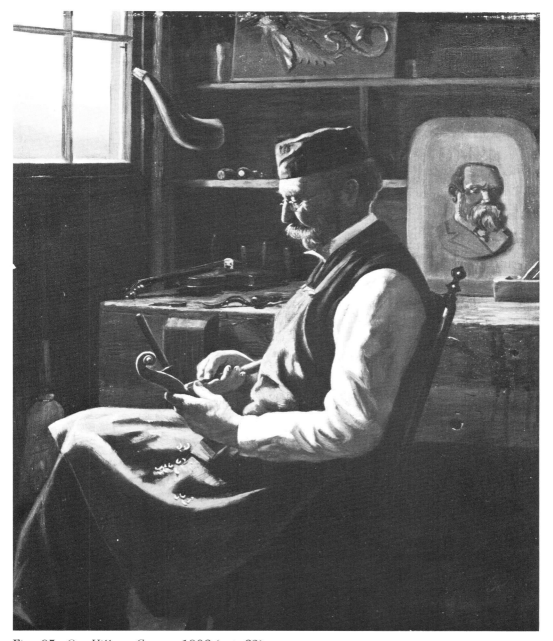

Fig. 95. *Our Village Carver,* 1906 (cat. 62).

Among the few oil paintings done in the second period of Elmer's activity, one of the most interesting is his 1906 portrait called *Our Village Carver* (fig. 95). The subject, Dr. Andrew E. Willis, had retired from medical practice and taken up the carving of violins and low-relief portraits of famous men including Charles Eliot Norton and George William Curtis. In its use of a visible window

101

Fig. 96. *Gray's Meadow from Graves's Hill, Ashfield,* 1908 (cat. 86).

Fig. 97. *Girl in Woods,* 1908 (cat. 83).

as the painting's source of light, the composition recalls *A Lady of Baptist Corner*, although the brushwork in Dr. Willis's portrait is much looser, and the forms are not etched by light with the same precision as they were in the earlier work. It differs in color, too; it is nearly monochromatic, with an overall brown tonality that is strongly reminiscent of works by John G. Brown.[110]

Elmer's last known oil painting, catalogue number 89, was done only two years before his death. Although his touch had obviously grown feeble, his ability to paint light had barely faltered.

In the years since 1945, when Maud Elmer first began to try to locate her uncle's works, ninety examples have been identified. From the evidence of documents, newspaper reports, and recollections, it seems probable that they represent less than half the number Elmer made. Discovery of additional works may change our understanding of his achievement, but if he had painted nothing except the *Mourning Picture*, the *Magic Glasses*, and *A Lady of Baptist Corner, Ashfield, Massachusetts*, his claim to a place among the most original of American artists of the past century would be assured.

Fig. 98. *View of Artist's Home, Ashfield*, 1908? (or 1920?) (cat. 87).

1. Letter of June 21, 1893 to Samuel E. Elmore of Hartford, Connecticut, in the Connecticut Historical Society, Hartford, Connecticut. Much of Elmore's correspondence and his manuscript of the genealogy is preserved, though he did not finish the project, which was completed by another family member, William W. Johnson *(Elmer-Elmore Genealogy)*.
2. *Greenfield Gazette and Recorder,* July 22, 1950. The letter has not been preserved, nor have any other letters the artist may have written to Maud.
3. *Deerfield Valley Echo,* October 7, 1899.
4. *Greenfield Gazette and Courier,* October 11, 1899.
5. Letter to Ethelwyn Manning, December 2, 1940, on file at the Frick Art Reference Library.
6. For instance, by Muller, *Paintings and Drawings at the Shelburne Museum,* p. 65 and by Alfred Frankenstein in *After The Hunt,* p. 152.
7. Information from Mrs. L. H. Greene in an undated letter to the author, ca. October 1982.
8. Champney was a lecturer in anatomy at the Academy in 1879–80 and again in 1885–86; at present there is no reason to believe that Elmer studied at the Academy in either of these years.
9. *Madonna and Child* (after Raphael), 1892 (pastel, 31¾ x 25″) given by the artist in 1893.
10. Curtis G. Coley, *The Pre-Raphaelites,* introduction to the catalogue of an exhibition held at the Herron Museum of Art, Indianapolis, February 16–March 22, 1964, and at the Gallery of Modern Art in New York, April 27–May 31, 1964. It should not be overlooked, either, that Ford Madox Brown, one of the most influential Pre-Raphaelite painters, studied in Antwerp, Ghent, and Bruges and must have known the masterpieces of Flemish painting to be seen in those cities.
11. Norton and Howe, *Letters of Charles Eliot Norton,* vol. II, pp. 13–14.
12. The effect on Ashfield of the arrival of Norton and Curtis was discussed many years later in a newspaper story of about April 1887 by the special correspondent of the (New York?) *Evening Post,* preserved in the Norton-Curtis scrapbook at the Milo Belding Library in Ashfield. Headed "Professor Norton and Ashfield/Elevation of a Little Town by a Big Man," the article notes that the value of Ashfield's real estate in 1885 was $450,000 (a gain of $100,000 "within a few years"), while that of nearby Charlemont, a town of about the same size, was just $315,000.
13. The *New Path* was published from May 1863 to December 1865. Among its editors were Cook, Sturgis and Wight, and Eugene Schuyler, a scholar and diplomat.
14. One of the victims of his attacks was his brother-in-law Christopher Pearse Cranch (1813–1892), a minister, poet, and artist, who took the opportunity to complain about Cook's bias in a piece, "Art-Criticism Reviewed," in *Galaxy* magazine, May 1867 (vol. IV, pp. 77–81). Referring to "The 'Tribune' critic," he asks "why Farrer's disagreeable 'Sunset on the Catskills' should have a column of puffery, in which the great body of artists are charged with being so warped by conventional ideas that they can't see Nature as she is—and as Mr. Farrer paints her—while poems on canvas like those of George Innes [sic] and others we might name never even have a *mention honorable. . . .*"
15. Letter from Russell Sturgis to Charles Eliot Norton, June 22, 1863, Norton Papers, Houghton Library, Harvard University.
16. The *North American Review,* vol. 98, no. 202, January 1864, pp. 303–304. In his biography of Norton, Kermit Vanderbilt states that although Lowell and Norton were titular co-editors, Norton was in fact the real editor, and it was undoubtedly he who wrote the review of the *New Path.*
17. The Fifth Annual Report of the Trustees of the Cooper Union, July 1864, lists Farrer as member of the faculty, and from letters and other documents it appears that his teaching there lasted from about 1862 to the spring of 1865. Farrer may have been helped in getting the position by Thomas Addison Richards (1820–1900), a painter and illustrator who had been Organizer and first Director of the School of Design for Women from 1858–60. In the fall of 1862, Farrer was living in rooms at New York University, where Richards also lived at the time. Coincidentally, Richards had done an illustrated article on "The Valley of the Connecticut," for *Harpers' New Monthly Magazine,* August 1856. His companion on the trip was the painter Sanford Robinson Gifford. Richards wrote warmly of their stay in Northampton.

18. *Round Table,* new series, no. 5, October 7, 1865, p. 71 and no. 6, October 14, 1865, pp. 92–93. Phrases such as "as Mr. Cooper, in founding it, had only the dimmest shadow of a sentiment to embody it. . . ." and "if Mr. Cooper had had a little knowledge, there might have been danger that he would insist upon petrifying his crude notions and vagaries into laws. . . ." or "for Mr. Hewitt has undertaken the management of a great institution devoted to science and art, when he is as ignorant of all science and as blind to all art as is possible for an uneducated person to be whose mind and time are incessantly absorbed in a business that requires only ordinary intelligence to manage. . . ." give the articles a tone somewhat reminiscent of the style of Clarence Cook. Henry Peters Gray (1819–1877) was an academic history painter, and Jervis McEntee (1828–1891) and Worthington Whittredge (1820–1900) were second-generation members of the Hudson River School, both of whom retain to this day a considerably more exalted reputation in the art world than Farrer.

19. *Northampton Free Press,* October 13, 1865.

20. *Mount Tom* is in the collection of Mr. and Mrs. Wilbur L. Ross, Jr., and *Northampton from the Dome of the Hospital* is in the collection of the Smith College Museum of Art. Both pictures are reproduced in *Arcadian Vales: Views of The Connecticut River Valley,* the catalogue of an exhibition organized by Martha J. Hoppin and shown in 1981–1982 at the George Walter Vincent Smith Museum in Springfield, Massachusetts. In the catalogue entry for these two works the present author has given an account of the identification of the Northampton view as the work of Farrer.

21. Vital records, Northampton Town Hall, book 4, p. 146, 1865.

22. The Sixth Annual Exhibition of the Artists' Fund Society of New York opened in November, 1865 at the National Academy of Design. Farrer's *Northampton* was the subject of extended comment in three periodicals: the *New Path* (vol. II, no. 12, December 1865, the final issue), the *New York Daily Tribune* (December 27, 1865, page 5), and the *Nation* (November 30, 1865, pp. 692–93). Probably Sturgis was the author of the *Nation* piece, and he found the picture generally unsatisfactory, chiding Farrer for his "preference of the forcible to the tender, this disregarding of the more important truth of gradation for the less important truth of contrast, this Rembrandtesque treatment of noonday landscape." Cook, the author of the *Tribune* piece, also comes down very hard on the picture for its "crudeness of color, and the hardness with which everything is made out. . . . It is the prose, not the poetry, of landscape. The sky is the best part of the picture, and just misses, by its coarse painting, of being beautiful. The clouds are well drawn, although we do not accept Mr. Farrer's understanding of them." The reviewer in the *New Path,* probably at that time Eugene Schuyler, admires the whole middle ground of the picture, but pronounces the foreground to be "very faulty" and "untrue, untrue to Nature."

23. Letter from Mrs. Thomas C. Farrer (the former Annie McLean) to Mrs. Gordon L. Ford, Ford Collection, Rare Books and Manuscripts Division, New York Public Library, Astor, Lenox and Tilden Foundations. The letter is headed February 15, Ashfield, with no year mentioned, but internal evidence makes it clear that the year is 1866.

24. Letter from Joseph Bement to Charles Eliot Norton, November 15, 1866, Norton Papers, Houghton Library, Harvard University. Bement writes in part ". . . I was confined to the house, and therefore did not call upon Mrs. Farrer as I otherwise should have done, and as she has been out of town for a week or two past, I have not had the pleasure of seeing in regard to the matter under consideration. . . ." The "matter" mentioned apparently had to do with Norton's efforts to buy additional property in Ashfield. Farrer, a regular exhibitor at the National Academy of Design from 1861 to 1865 and at the Brooklyn Art Association from 1862 to 1865, did not show at either place in 1866. He showed his *Mount Tom* at the Brooklyn Art Association exhibition in March 1867 and among his entries at the National Academy in spring 1867 was the *Maple Woods, Ashfield, Massachusetts.*

25. Letter from Charles Moore to his sister Lucy, November 30, 1862 in the possession of Mrs. Theodore Krueger. ". . . my dear friend Farrer is getting on nicely. He has been quite successful lately and has a fine pleasant room in the University. He went to the war for three months but returned safely. He is the greatest gentleman friend I have in the world. We have delightful talks and social times at his room."

26. Frank Jewett Mather, Jr., *Charles Herbert Moore, Landscape Painter,* Princeton, 1957, pp. 23–24.

27. In a letter from Charles Moore to his grandmother, April 21, 1865 (also in the possession of Mrs. Theodore Krueger), he mentioned Springfield and North Bridgewater, Massachusetts as places the couple planned to visit on their honeymoon. Probably at the time this letter

was written, the Farrers had not yet arrived in Northampton, so the Moores may have altered their plans to include both it and Ashfield.

28. Letter from Mrs. Thomas C. Farrer to Mrs. Gordon L. Ford, from Ashfield, January 1, 1866, Ford Collection, Rare Books and Manuscripts Division, New York Public Library, Astor, Lenox and Tilden Foundations.

29. Both letters, written from Catskill, New York, in the Historical Collection of the New York State Museum, Albany, New York.

30. Mather, *op. cit.* p. 24. He cites a letter of March 11, 1867 from Moore to Norton apologizing for keeping the picture so long.

31. Edward Cary, "Some American Pre-Raphaelites: A Reminiscence," the *Scrip,* vol. II, no. 1, October 1906, pp. 1–7. Cary states that the elder Hill was "past forty" when he began to follow the ideas of Ruskin. In the early sixties Cary was editor of the *Brooklyn Union* at which time he hired Farrer to write some criticism for the paper. He wrote with a candor that provoked considerable furor among the injured artists. Cary later became editor of the *New York Times,* and in 1894 he wrote a biography of George William Curtis.

32. John Henry Hill had spent eight months in 1864–65 in London studying the works of Turner.

33. Ford Collection, Rare Books and Manuscripts Division, New York Public Library, Astor, Lenox and Tilden Foundations.

34. The *Nation,* November 29, 1866, p. 435.

35. The Webbe painting first appeared on the market in a Christie's auction of the B. C. Windus collection on February 15, 1858. Windus was an art dealer who had some dealings with another dealer, named Farrer, who favored the Pre-Raphaelites, but about whom nothing more has been learned. Thomas C. Farrer appears to have come from a family of modest means, and his father is said to have prevented him from learning to read until he was in his teens. Whether there was any connection between him and the dealer Farrer remains to be discovered.

36. Reproduced in Cary, *op. cit.,* frontispiece. Whereabouts unknown. Maud Elmer recalled seeing in her uncle's sketchbooks "a drawing of a hen's egg, which both brothers considered very beautiful in form." Farrer exhibited a drawing of three eggs in December, 1865 at Goupil's in New York, in an exhibition of watercolors and drawings done during his summer in Northampton. Russell Sturgis singled out the drawing for criticism in his review in the *Nation* (December 28, 1865, pp. 819–820). That Ruskinian criticism resembled Ruskinian art in the minuteness of its scrutiny is illustrated in Farrer's letter of correction, dated Ashfield, January 1, 1866, and published in the January 11, 1866 issue of the same magazine, pp. 48–49. "The summing-up of the criticism is in these words: 'The inevitable tendency of this sort of work is shown by the little drawing of three eggs. But, in doing this, the painter has been compelled to lower the tone of the whole, and they are not white eggs that we have. That they were meant to be, the high light seems to show.'

"Now, they were *not* meant for white eggs. The central one was, as it appears in the drawing, *white;* but the other two were the pale buff color always to be found in any large number of city eggs.

"I would not trouble you with this were it not that in criticisms that profess to be accurate and just, and which help to form public opinion, any mis-statement is important."

37. The photograph of Samuel Elmer was taken by J. F. Ryder. The address on the back of this *carte de visite* is given as 171 & 173 Superior Street, an address Ryder left in August 1872.

38. John Edwin Stillwell, "Thomas J. Bryan, The First Art Collector and Connoisseur in New York City," *New-York Historical Society Quarterly,* vol. I, no. 4, January 1918, pp. 103–105.

39. In its July 21, 1866 issue, p. 455, the *Round Table* reported that the Bryan Gallery at the Cooper Institute had been closed "for the present." The writer went on to say that the collection contained "of course, a large proportion of spurious trash, but there are a sufficient number of really good pictures in the collection to render it well worthy of a visit."

40. Stillwell, *op. cit.* Part of the collection was sold in Europe, and the balance was given to the New-York Historical Society in 1867.

41. Besides the distinct probability that Elmer and Miss Fox shared the acquaintance of Farrer, Elmer would probably also have been attracted to Miss Fox because of her association with the Cleveland Academy, which was directed by a graduate of Mount Holyoke Seminary who had been a student of Mary Lyon herself. Linda (or Lucinda) T. Guilford had persisted in her efforts to open a school founded on the principles put forward by Mary Lyon, despite the

fact that Miss Lyon disapproved, fearing she would undermine the work of a similar school not far away. Miss Guilford was a native of the western Massachusetts town of Lanesboro. There were several families named Guilford in Ashfield, and she may have had relatives there.

42. Aaron Scharf, in *Art and Photography,* London, 1968, page 79, quotes from Ford Madox Brown's diary of November 12, 1847 as follows: "went to see Mark Anthony about a Daguerreotype: think of having some struck off for the figures in the picture, to save time." Other examples are also cited by Scharf.

43. In the preface to the 1849 edition, Ruskin states that the plates were "either copies of memoranda made upon the spot, or enlarged and adapted from Daguerreotypes, taken under my own superintendence."

44. The *New Path,* vol. I, no. 4, August 1863, p. 41.

45. It was alleged that the Cleveland portrait painter Caroline Ransom, who attained national prominence when she was commissioned by Congress to paint a portrait of General George Thomas, had actually produced a painted photograph of him. The *Nation* for June 5, 1866, p. 715, lists "coloring photographs," or "portrait coloring," among the courses offered at the Cooper Union School of Design for Women.

46. The small scale of Elmer's work at this time may reflect the preference of the Ruskinians, who chose for the most part to do small paintings. Even on small canvases, however, they lavished many months of painstaking work.

47. In addition to the story of the loss to the elements of many of Elmer's works following his wife's death, there is a story that some of his drawings from the nude were discovered once by a prudish relative who destroyed them. Another, less believable, explanation for the disappearance of pictures was given by one of Elmer's relations, who said that after the artist's death Mary Elmer gave most of his paintings away "to a salesman who dropped by to sell her something."

48. *Deerfield Valley Echo,* May 23, 1906. The note attributes his present ill health to "a too close application to his business as artist for the past 15 years."

49. The painting, commissioned by the art patron Jonathan Sturges for presentation to Bryant, hangs in the New York Public Library. A great many of the country's most famous artists gave examples of their work to the Century Club in honor of Bryant in 1864. Bryant was also a contributor to the *Crayon,* whose editor, after William J. Stillman, was Durand's son John.

50. Henry Nash Smith and William N. Gibson, eds. *Mark Twain-Howells Letters, The Correspondence of Samuel L. Clemens and William D. Howells, 1872–1910,* Cambridge, Massachusetts, 1960, pp. 364–65.

51. Twain did not come in the end. President James A. Garfield had been shot on July 2, but lingered until September 19. As Twain wrote to Norton, he "had no heart to talk nonsense, nor the people to listen to it" under those circumstances.

52. Norton and Howe. *Letters of Charles Eliot Norton,* vol. II, p. 90. A partial list of speakers is given on p. 456. In Frederick G. Howes *History of Ashfield, Massachusetts,* the years that various people spoke are recorded on pp. 197–98.

53. Information in the files of the Holyoke Library and Museum, Holyoke, Massachusetts, confirms that Mr. and Mrs. J. K. Judd of Holyoke, the donors of their John G. Brown painting, *In Ambush,* bought the picture while they and the artist were vacationing in Ashfield in the summer of 1891.

54. Josiah B. Millet, ed. *George Fuller, His Life and Works,* Boston, 1886.

55. The painting is reproduced in Williams, *Mirror to the American Past,* p. 128 where it is credited to the collection of E. F. Fischer. It was shown in the Centennial exhibition at Philadelphia under the title *Wheelwright's Shop* and is reproduced in Edward Strachan's *Masterpieces of the International Exhibition*, Philadelphia, 1876, vol. 1, p. 45. On page 93, Strachan comments on the "extraordinary scrupulosity with which every detail in the shop is individualized The artist does not spare us a chisel, a saw, a gauge, or a glue-pot. It is Dutch patience celebrating American skill. There is capital training for the painter in the eleborating of one of these laborious toys of art; there are provoking little problems of drawing, perspective and grouping to be worked out, and the general difficulty of giving each item its prominence without losing breadth; and one would say that every artist no matter how large a style, how masterly a generalization he is ultimately to attain to, might profitably spend a year of his youth in putting together one of these intricate puzzles." Although Billings did return to Deerfield occasionally, it is not known whether Elmer might

have had a chance to study this exemplary work.

56. This painting is usually dated about 1876, and it has been assumed that Field began it a few years earlier in anticipation of the country's Centennial with the hope that it might be shown in the big exhibition in Philadelphia. A news item in the *Hampshire Gazette and Northamption Courier* for May 28, 1867 recently discovered by the present author reveals, however, that it was actually done long before, probably inspired by Lincoln's assassination. The note, under Franklin County news on page 2, reads: "A new artist, E. S. Field of Sunderland, has painted a grand historical and allegorical picture twelve feet long and nine feet wide, representing the country's history from the landing of the Pilgrims to the death of Lincoln and intends to exhibit it through the States with an explanatory lecture."

57. In the collection of the Henry Ford Museum, Greenfield Village, Michigan.

58. In the collection of the Virginia Museum of Fine Arts, Richmond, gift of Edgar William and Bernice Chrysler Garbisch Collection.

59. Reproduced in "King *versus* Ellsworth," by Julia D. Sophronia Snow, *Antiques,* March 1932, p. 119.

60. Cary, *op. cit.,* reproduced facing p. 5.

61. The similarities between this painting and some of the photographs taken by three Ashfield contemporaries of Elmer's, Alvah, Walter, and George Howes, has frequently been noticed. As itinerant photographers between the years 1886 and 1906, they ranged throughout the state and beyond, taking photographs of houses with their owners seated in the front yard, factory workers and factories, loggers, school classes, hotels, small shops and their keepers, etc. They spent the summer of 1888 in Shelburne Falls and could well have photographed their fellow townsman and his wife and house at that time. Thousands of their glass plates are in the collection of the Ashfield Historical Society. (See Newman, *New England Reflections.)*

 The Howes brothers were by no means the only local practitioners of this trade. The Lithotype Printing Company that took the view of the Elmer house and its occupants in about 1881 (fig. 10), had been through in 1879 "taking views of shops, private residences, natural scenery and individuals." Two brothers from Bernardston, George R. and Elihu R. Rockwood, who had headquarters in New York, were photographing the Montague Paper Company in 1877. Before photography became widely used commercially, lithographers had made portraits of the principal houses and other buildings of towns for atlases and gazetteers.

62. It is probably this rather loose handling of the sheep's coat that led James Thomas Flexner to make the curious statement that "the seated figures and the house are revealed with all the minute accuracy of a perfectly focused photograph, while the girl's face and the lamb in the foreground are painted with summarized forms that belong in the background. To this reversal of its natural practice, the eye automatically responds with a shiver and a warning." (*Nineteenth Century American Painting,* New York, 1970, p. 120).

63. *Greenfield Gazette and Courier,* November 15, 1890.

64. *Greenfield Recorder-Gazette,* November 12, 1946.

65. Letter of August 24, 1950 in the files of the Smith College Museum of Art.

66. Graham Reynolds, "The Pre-Raphaelites and their Circle," *Apollo,* June 1971, p. 494.

67. *America as Art,* Washington, D.C., 1976, p. 128.

68. Another "surrealist" feature of the picture, the brick-like fracturing of the clouds, is the fortuitous result of a technical error on the artist's part. These traction cracks occurred when the blue and gray underpaint contracted and pulled apart the leaner, already dried, upper layer of white.

69. Although the artist was not a member of any church, even if he had been an atheist he probably would not have rejected the use of the lamb as the Christian symbol of innocence and purity, with its concomitant association with the death of children.

70. The present title was given to the picture after it was received as an extended loan by the Smith College Museum of Art in August 1950. Hitchcock's play on the title of Eugene O'Neill's *Mourning Becomes Electra* in his letter to Soby may have prompted the selection of the title. Certainly the composition does not bear any resemblance to other pictures commonly given this name. These late eighteenth- and early nineteenth-century memorials, with which Elmer would certainly have been familiar, generally showed bereaved family members gathered at the deceased's grave monument in exaggerated attitudes of mourning. Almost obligatory in such pictures was a willow tree and a stream or some body of water, perhaps in recollection of the text of Psalm 137: "By the rivers of Babylon, there we sat

down, yea, we wept, when we remembered Zion. We hanged our harps upon the willows in the midst thereof.''

The portrayal of the dead as living has been practiced for centuries. In New England in the nineteenth century, parents frequently had portraits painted of their dead children, either from photographs or from the corpse itself. It is not so common to show, as Elmer has done, both the living and the dead in one composition.

71. The poem, entitled ''Mourning Picture'' (1965), may be found in *Adrienne Rich's Poetry,* Barbara Charlesworth Gelpi and Albert Gelpi, eds., New York, 1975, pp. 31 – 32.

72. It was the visual source of one of twelve piano pieces composed in 1975 by Seymour Bernstein for his work, *American Pictures at an Exhibition.* Each of the twelve paintings was also the subject of a poem by Owen Lewis. A performance of both the music and the poetry was held at the New-York Historical Society in the winter of 1975.

73. At Christie's (London) auction, October 29, 1980, catalogue number 127 was a work described as follows: ''J. L. T. 'The York Family at Home, Pepperhill, Massachusetts,' signed with monogram and inscribed on the reverse, on plywood panel, 14½ x 19½''.'' The title is taken from a work by the well-known nineteenth-century American folk painter, Joseph H. Davis, *The York Family at Home* (1837, Abby Aldrich Rockefeller Folk Art Center, Williamsburg, Virginia), but the composition is actually a free copy of the *Mourning Picture.* The figures of the parents have been moved forward and their positions reversed. Between them a little white dog has been added. The woman is wearing a white lace collar like the daughter's, and the father has a beard, but no hat. The handling of the figures is deliberately naive and does not at all resemble the photographic quality of Elmer's painting.

74. An amusing illustration of the insistence on botanical accuracy is to be found in an exchange of letters between two members of the Society for the Advancement of Truth in Art, Russell Sturgis and John Henry Hill. In a review in the *Nation* for November 29, 1866 (p. 435) Sturgis says of one of Hill's works, ''the 'Study from Nature' of elm trees, No. 310, has a certain truth of character of foliage for which we may look in vain in the newer drawing, No. 285, and in many more of his recent works.'' Hill replies (the *Nation,* December 20, 1866, p. 502) in part, that ''if examined carefully by anyone who is familiar with different trees, it will be found that there is a straightness and angularity about the stem and branches which is characteristic of chestnut, or, at least, quite foreign to the nature of elm.'' To which Sturgis answers, same issue: ''In regard to the circular drawing, No. 310, the central clump of trees are certainly elms in the vase-like forms of the group and in the lines of topmost spray seen against the sky. The foliage is not like that of elms, and the trees on either side are not elms; but those in the centre in spite of the look of their leaves, were and are elm trees to the spectator.'' He goes on to excuse Hill for this confusion, which he supposes to be caused by Hill's excessive admiration for elms. ''A painter who loves heartily a lovely thing may well, in his youth, be over-much impressed by it; and throughout his life Turner's trees in general landscape were as balloon-like as he could make them.''

75. The outlines of the photograph may have been traced onto the canvas by means of the magic lantern projector which Elmer had probably already acquired for use in making his photoportraits.

76. In an old blueprint photograph of this painting, the clouds cannot be seen, either because they have faded out over the years or because they were added later. The signature and date are clearly visible.

77. ''From the Peanut Gallery: The Rediscovery of De Scott Evans,'' *Yale University Art Gallery Bulletin,* no. 36, Spring 1977, pp. 36–43. The identification of De Scott Evans with S. S. David is certainly supported by close similarities among several works signed with both names. However, the appearance of other similar works signed Stanley David and Stanley S. David raises the question as to whether there may indeed have been a painter of this name. Certainly there was one called S. S. David who showed a picture called *Coal Rocks* at the National Academy of Design in 1859, when De Scott Evans would have been just twelve years old (see Cowdrey, *National Academy of Design Exhibition Record, 1826–1860*). In New York City directories for the years 1866–67 and 1869 an artist named Stephen S. David is listed with a studio at 923 Broadway and a residence in Yonkers, in the first year, and in New Jersey, the next.

78. None of these little still lifes have dates. If they were done as early as 1875 Elmer might well have seen some if he happened to visit Evans's studio.

79. Letter of August 24, 1950, in the files of the Smith College Museum of Art.

80. Gerdts and Burke, *American Still-Life Painting,* p. 252.

81. The account, which appeared in the *Cleveland Daily Leader* of January 3, 1874, read as follows: "Fruit on Canvas. People about town who remember a young man named Morston Ream, who worked in this city some years ago as an apprentice to the profession of photography, will be interested in the examination of an exquisite piece of still life painting on exhibition in the show window of Ryder's art gallery. Since finding the work of photography not altogether favorable to his health, Mr. Ream went to New York, entered the studio of his brother and sat down to the task of making himself an artist. Five years have made him one of the most eminent fruit painters in America. His pieces adorn the dining rooms of the most fastidious connoisseurs of art and are enough to make one hungry to look at. The piece on exhibition at Ryder's is a group of peaches, grapes, bananas, and plums, lying about a globe containing a gold fish. It is worth a careful study by every lover of good art."

82. The painting is now owned by the Detroit Institute of Arts.

83. It is not, as Frankenstein has stated in both his *Magazine of Art* article on Elmer and in *After the Hunt,* a view of two windows, one of them inverted, but two views of the same window.

84. The Fourteenth Annual Exhibition of American Artists, February 2–March 1, 1891, cat. no. 24. The present whereabouts of this picture is unknown.

85. See n. 53. Brown's stay in Ashfield in the summer of 1891 was not his first trip to Western Massachusetts. In 1875 he showed a painting entitled *Looking Down the Ravine, Huntington, Mass.,* at the National Academy of Design (see Naylor, *The National Academy of Design Exhibition Record,* 1861–11900, vol. II). In the previous decade Brown had been in touch with some of the American Ruskinians. At the Brooklyn Art Association in December 1864, a picture entitled *The Spring,* with figures by Brown in a landscape by Moore was shown (see Marlor, *A History of the Brooklyn Art Association*). Brown was also an early member of the American Water Color Society, founded in 1866, as were Moore, Farrer, the Hills, and William T. Richards.

86. In the chapter, "Luminism, An Alternative Tradition" (*American Painting of the Nineteenth Century,* p. 97), Barbara Novak reproduces a painting by Jeremiah Hardy entitled *Catherine Wheeler Hardy and Her Daughter* (collection of the Museum of Fine Arts, Boston). The painting, done in 1842, shows the mother and child seated before a window, their faces touched by its light and modeled by reflected light. Novak cites the picture as an example of the fact that luminism can be detected "not only in landscape painting but also in still life, genre, and portraiture." The picture is perhaps a little early to be truly luminist, though its "luminosity of tone," in the words of Edgar P. Richardson (who also reproduces it in *Painting in America,* pp. 206 and 235), is akin to that in Elmer's picture; its handling, however, is not similarly crisp and precise.

87. William H. Gerdts in *American Luminism* (exhibition catalogue, New York, Coe Kerr Gallery) and Barbara Novak in *Nature and Culture* have discussed the many interesting affinities between the American luminists and northern European, particularly Scandinavian, artists. Novak has called attention to the fact that the town where Friedrich was born was then under Sweden's control and that his schooling was in Copenhagen. She comments also on his "primitivism," which she defines as "a strong tendency to the linear and the flatly planar, an abstractness which maintains (even more than the American works) the mat quality of the paint, a frequent recourse to overall emphasis of parts, and an inherent bias toward draftsmanship, toward 'colored drawings' rather than paintings." I am grateful to Helen M. Franc for calling my attention to the work of Kersting who, like Friedrich, studied in Copenhagen. After his return from Germany he and Friedrich became close friends. Kersting was known for his interior scenes, and his best-known painting, *The Embroiderer* (Schleswig-Holsteinisches Freilichtmuseum, Kiel), shows a woman seated before an open window. She is seen from three-quarters rear, but her face is reflected in a mirror next to the window.

88. "Art Aspects of American Processional." The other speakers at the three-day symposium, October 27–29, 1950, were Henry Steele Commager and Lloyd Goodrich. Mr. Richardson's remarks were reported in an unsigned article titled "American Luminism," in the *Art Digest,* January 1, 1951. The same article noted that John I. H. Baur, who attended the symposium, had put forward the notion that luminism had its origins in America early in the century in the work of the British immigrant Francis Guy, and then split into two lines, one of extreme realism represented by artists such as Heade and Lane, and the other characterized by a freer, more impressionist handling, as seen in the works of Homer or Eastman Johnson. Mr. Richardson's remarks also suggest that *American Processional,* an

exhibition not usually cited in writings on luminism because it was essentially a show of genre painting, was in fact one of the first occasions in the twentieth century in which a group of luminist pictures had been brought together. It had been selected by Elizabeth McCausland (who also wrote the principal catalogue essay), assisted by Dorothy P. Miller, and by Hermann Warner Williams, Jr., Charles F. Buckley, John Palmer Leeper, and Eleanor B. Swenson. An earlier exhibition, *Romantic Painting in America,* organized by Dorothy C. Miller and James Thrall Soby at The Museum of Modern Art in 1943, had brought to public attention the work of Heade and had included as well paintings by Kensett, Homer, Eastman Johnson, and others.

89. No. 9, Autumn 1954, pp. 90–98. Baur's earlier writings on this movement are "Early Studies in Light and Air by American Painters," *Brooklyn Museum Bulletin,* 9, no. 2, Winter 1948, and "Trends in American Painting, 1815 to 1865." Richardson's prior use of the term has been overlooked by most authors on the subject, including Richardson himself, who does not cite his Corcoran lecture or its transcript in bibliographies in his own books. John Wilmerding, in his introduction to the catalogue of the large exhibition *American Light: The Luminist Movement, 1850–1875,* held at The National Gallery of Art in 1980, states that Baur "in 1954 first employed the specific term *luminism* for the title of an article." William H. Gerdts (*American Luminism,* New York, Coe Kerr Gallery) says that "the term was coined in 1954 by John I.H. Baur."

90. According to Theodore Stebbins (*Martin Johnson Heade,* p. 208), Heade was in Northampton in July 1882, but the length of his stay and purpose of the visit are not discussed.

91. *A Landscape Painter* (New York, 1919, pp. 50–51; first published in the *Atlantic Monthly* for February, 1866). The impact of Ruskinian thought on the development of luminism and the relationship of the American Ruskinians to luminism have been discussed by many of the authorities on this movement, including Linda S. Ferber, Theodore Stebbins, Jr., William H. Gerdts, John Wilmerding, and Barbara Novak. Farrer's *View of Northampton from the Dome of the Hospital* (fig. 35) is certainly an example of the joining of these two currents. Although its high viewpoint and its nearly square format are not typical of luminist landscapes, its panoramic scope, its meticulous detail, and above all its palpable atmospheric sense place it squarely within that tradition. As Baur said about Lane's work, time of day and kind of day are accurately rendered. Another passage from James's *A Landscape Painter* reads "I have encamped over against a plain, brown hillside, which, with laborious patience, I am transferring to canvas" (p. 26). Both these quotes from James evoke visions of a painter of the Ruskinian stamp. Farrer, Moore, and their colleagues were regularly criticized for failing to rise above mere documentation or simple botanical transcription, for failing to see the forest for the trees or, in Jamesian terms, for their inability to reduce their pictures to a unity. Though James's imaginary artist was not working at Newport, it was obviously this coastline that he described in his story. The Jameses lived in Newport off and on from 1857 to 1863, and it was there that James met the young John LaFarge in 1859 and studied art with William Morris Hunt in 1861. At least two other artists were there in the summer of 1863, the last summer James was there. They were Heade and Kensett. Farrer was also nearby that summer, painting his *Mount Hope Bay, Rhode Island* (now in the Museum of Fine Arts, Boston), and according to Theodore Stebbins (*Martin Johnson Heade,* n. 7, p. 188), Charles Herbert Moore painted the same subject that year (its present whereabouts unknown). In May 1864 Farrer showed a work at the Brooklyn Art Association entitled *Capt. Cabot Russel* [sic], *54th Mass. Killed at Fort Wagner.* Russell was the best friend of James's younger brother, Garth Wilkinson James, who was wounded at the same battle. In *Notes of a Son and Brother* (New York, 1914, pp. 241–42), James quotes a letter written from Newport in August 1863 describing the condition of his brother, who had just been brought back from Charleston by Cabot Russell's father (who had searched in vain for his own son) and recalls the latter's tender attentions to his brother. How Farrer came to make his portrait of Cabot Russell remains to be discovered.

92. For James, the process of creation was clearly a reductive one of elimination and simplification. For Elmer and the Ruskinians, it was nearly the opposite: a process of accumulation and inclusion, until there was a fullness or completion. Their paintings had "finish" in the popular sense of richness of detail, but remained unfinished by James's definition.

93. A good photograph of the third picture of this trio could not be secured, but the author has seen it and compared it to the others.

94. "The Peaceable Kingdom: American Folk Art," in *Art on the Edge,* New York, 1971, p. 290.

95. A good photograph of the second of these two pictures could not be secured, but the painting has been seen by the author.

96. Reproduced in color in Albert Ten Eyck Gardner, *101 Masterpieces of American Primitive Painting from the Collection of Edgar Williams and Bernice Chrysler Garbisch,* New York, 1961, pl. 64.

97. Regrettably, only a very poor snapshot of this painting could be obtained.

98. See Deborah Chotner, *S. S. Carr,* exhibition catalogue, Smith College Museum of Art, April 2–May 30, 1976. Carr showed at Gill's exhibitions in Springfield in 1879 and 1885.

99. Heade's painting, *Sunset at Black Rock,* shown at Gill's Fourth Exhibition in 1881, has clouds similar to those in Elmer's painting.

100. One of the most interesting modern, and surrealist, treatments of this moment of the day is René Magritte's *Empire of Light,* a subject which, interestingly, he painted more than once.

101. James Wells Champney might have given Elmer Satterlee's name. In 1879, when Champney was advising Smith College's president on his first purchases for the collection, a work by Satterlee was selected (see Part I, n. 75) and it may be that Champney and Satterlee were friends.

102. See Dianne H. Pilgrim, "The Revival of Pastels in Nineteenth-Century America: The Society of Painters in Pastel."

103. *The Art Interchange,* vol. 12, no. 7, March 1884, unpaginated. Quoted in Pilgrim, *ibid.,* p. 49.

104. *Deerfield Valley Echo,* June 27, 1900. Elmer may not have realized that to put the letters N.A.D. after one's name signified election to full membership in the National Academy.

105. In her essay "On Defining Luminism" in the *American Light* catalogue, Barbara Novak mentions the stress on the horizontal and "an extended format," as one of the many distinguishing features of luminist landscapes. William H. Gerdts, in his *American Luminism* catalogue essay had earlier given a very concise description of the properties of a typical luminist landscape. They included a number of elements besides exaggerated horizontality that are also typical of Elmer's pastels, such as little evidence of human activity; placid, mirror-like lakes or rivers; light, air, and atmosphere; and a tendency towards light color.

106. In his *Perspectives USA* article (p. 95), Baur had called Moore's work "a late echo" of luminism, but it is clear from the *Morning over New York* and other paintings that Moore's luminist work was done while the movement was at its height.

107. See the *New York Times,* January 6, 1900, p. 15, for a discussion of the show.

108. *American Light,* p. 144, figs. 168 and 169.

109. "American Luminism," p. 92.

110. See, for instance, Brown's painting of an elderly man in *Caning the Chair,* 1883, reproduced in color, no. 72, in "American 19th Century and Western Paintings, Drawings and Sculpture," Sotheby's, New York, sale 4841M, April 23, 1982.

CATALOGUE OF WORKS LOCATED

In dimensions, height precedes width. Dimensions of works on paper are sheet sizes unless otherwise noted. Oils are on canvas unless otherwise noted. Most of the pastels, sepia pastels and charcoals are on a fibrous paper, backed with muslin and coated with finely-ground pumice or marble dust. Numbers beneath the catalogue number refer to figures in the text.

In most cases, the exhibition history includes only four one-man exhibitions which are abbreviated as follows:

Shelburne Falls 1906: "Third Annual Free Art Exhibition from the studio of E. R. Elmer," held at C. W. Ward's Ice Cream Parlors, 10 Bridge Street, Shelburne Falls, December 13–15, 1906. Its checklist contains ninety-three items. (figs. 106 & 107).

Shelburne Falls 1946: An exhibition held in November 1946, organized for the Shelburne Falls Women's Club, by Maud V. Elmer, the artist's niece. The works were shown in the local Art Center and in shop windows along Bridge Street. No catalogue or checklist was prepared, but the November 12, 1946 *Greenfield Recorder* contains a long article citing about twenty works, most of them easily identified.

Northampton and Springfield 1952: The first museum exhibition of Elmer's work was held at the Smith College Museum of Art, October 1–24, 1952. Twenty-seven works were listed in the checklist which had as its text an article by Alfred Frankenstein, "Edwin Romanzo Elmer," reprinted from *Magazine of Art*, vol. XLV, October 1952, pp. 270–72. The exhibition, augmented by five additional works, was shown at the Connecticut Valley Historical Museum, Springfield, Massachusetts, November 1–30, 1952. No separate checklist was issued.

Northampton and Shelburne 1982: An exhibition held at the Smith College Museum of Art from April 8 through July 18, 1982. Fifty-eight works were listed in the seventeen-page checklist, which had a text by Betsy B. Jones, organizer of the exhibition, and also included much documentary material. A reduced version of the exhibition containing thirty-two works, accompanied by a modified checklist, was shown at the Shelburne Museum, Inc., Shelburne, Vermont from July 30 through October 17, 1982.

No catalogues or checklists for the artist's annual Shelburne Falls exhibitions in 1904, 1905, and 1907 have been found.

The largest single collection of the artist's work is to be found at the Shelburne Museum in Shelburne, Vermont. About 1960 its founder, Mrs. J. Watson

Webb, became interested in Elmer's work, and with the help of her agent, Richard Gipson, and the enthusiastic assistance of the artist's niece, Maud Elmer, she acquired six oils, seven pastels, an ink drawing and one of the crayon or photo-portraits, fifteen works in all.

No attempt has been made to catalogue the hundreds of crayon portraits.

Sixteen of the located works have a code written in pencil on the back, usually on the frame. It consists of the pairing of a set of letters with a set of numbers,

e.g.:

LEK	310
AOK	815
KRE	1125

Only ten letters of the alphabet are used: A, B, C, E, H, K, L, O, R and S; E and K appear with the greatest frequency. The figures always add up correctly. All but one of the works bearing this code are pastels dated 1905, or reliably assigned to that year. The exception (cat. no. 87) is an unsigned, undated oil painting probably done about 1908 (though sometimes dated 1920). Ten of the pastels can be identified with titles found in the checklist of the 1906 Shelburne Falls show, but the prices there do not conform to any of the three figures in the sums and are in every case lower than the total figure in each sum. If the oil painting is correctly dated 1908, it may be that the artist affixed this code at the time he was showing works at a fair that summer in Ashfield. Most of the works so marked figured in the auction of Mary Elmer's estate in 1928, or were acquired about that time by her relatives. The code may therefore have been one devised by the executor.

Fig. 99. "Birthplace of Mary Lyon." Engraving published in *The Power of Christian Benevolence Illustrated in the Life and Labors of Mary Lyon,* by Edward Hitchcock.

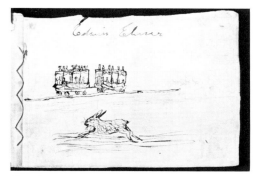

Cat. 1

boomerangs, a scene with an igloo and a sled drawn by reindeer, and other such exotic subjects that point to a pictorial source.

Cat. 2

1. BOOKLET OF PICTURES
 5 Ink on four strips of lined paper, folded to make a 16-page booklet, stitched at the left edge; pages each approximately 2¾ x 3½″ (6 x 9 cm.)
 Inscribed on cover page: Edwin Elmer; not dated
 Archives of American Art, Smithsonian Institution, Washington, D.C., Maud Valona Elmer Papers

Provenance: The artist's niece to present owner, 1957
Exhibitions: Northampton (no. 57) and Shelburne (no. 31) 1982

Maud Elmer believed her uncle had made this tiny booklet of pictures as a child. She bequeathed to a cousin another, almost identical such booklet with the name of her father, Samuel Elmer, on the cover (fig. 6). All but two or three of the scenes in these books are the same, suggesting that they were copied from a common source by the brothers, or were made for them by another person. They recall some of the miniature children's books of the nineteenth century (Greenfield, Wendell and Northampton all had publishers of children's books during this period). A Baltimore publisher, J. Steerwell, Jr., issued a book in 1825 called *The Little Traveller* with scenes of "Laplanders, American Indians, Otaheitians, Sandwich Islanders," etc. The Elmer booklets show bareback hunters using what appear to be

2. BIRTHPLACE OF MARY LYON
 Wash drawing, 6³/₁₆ x 8³/₁₆″ (15.7 x 20.8 cm.)
 Not signed, not dated
 Shelburne Museum, Inc., Shelburne, Vermont, gift of Richard Gipson, 1960

Provenance: Unknown
References: Muller, p. 65

Although this drawing is unsigned and its history before 1960 is unknown, Maud Elmer, who interested herself actively in the acquisition of her uncle's work by the Shelburne Museum, apparently did not question the attribution to her uncle. The drawing is based directly on a lithograph copyrighted in 1849 by Sarony and Major, New York, credited with the initials, A. H. F., probably standing for Amanda H. Ferry, née Amanda White. Mary Lyon lived with Mrs. Ferry's family in Ashfield, while she studied at Sanderson Academy and it was with Mr. White's assistance that she was able to continue her education after that. The view is also reproduced in the 1851 edition of Edward Hitchcock's *Life and Labors of Mary Lyon,* where the artist is identified

as Hannah White, a sister of Amanda White (fig. 99). If the present drawing is indeed by Elmer, it may have been done before 1863 when his family moved from the Mary Lyon birthplace, which they had bought in 1851.

3. WOODLAND STILL LIFE WITH SNAKE. ca. 1865–66?
36
Pencil, 8 x 5" (20.3 x 12.7 cm.)
Signed verso: Elmer; not dated
Collection of Evelyn E. Whiting

Provenance: The artist's niece, Maud V. Elmer; to her cousin, husband of the present owner, by bequest, 1963
Exhibitions: Northampton (no. 58) and Shelburne (no. 32) 1982
Maud Elmer inscribed her father's name on the mount to which this drawing was taped, apparently believing it to be his work. No other example by him survives, and the competence of this effort points to a practiced hand. The drawing has a Ruskinian flavor in its fidelity of detail and in its use of a natural setting rather than an arranged composition.

4. EMELINE ELMER. ca. 1865–66?
39
Pencil (cut out as a silhouette), 5 x 3½" (12.2 x 8.9 cm.)
Not signed, not dated
Private collection

Provenance: The artist's sister, Emeline Elmer, Ashfield, Massachusetts; purchased at the auction of her estate, April 1940 by Mr. and Mrs. Galen W. Johnson, East Buckland, Massachusetts; Joseph Holland and Vincent Newton, Los Angeles, ca. 1963; gift to present owner, 1982

Exhibitions: Northampton 1982 (no. 17)
Emeline Elmer (1844–1939), the artist's sister, married her first cousin A. Chapin Elmer, in October 1867. This drawing was probably done shortly before her marriage at the same time as catalogue number 3.

5. ERASTUS AND SUSAN SMITH ELMER. ca. 1865–66?
41
Pencil, 7¾ x 13½" (19.7 x 34.2 cm.)
Not signed, not dated
Collection of Benton L. Hatch

Provenance: The artist's sister, Emeline Elmer, Ashfield, Massachusetts; her son, Herbert Fitch Elmer, Greenfield, Massachusetts; Reginald French, Amherst, Massachusetts; to present owner, late 1950s
Exhibitions: Northampton and Shelburne 1982 (no. 16)
References: Buckland/Franklin County, Massachusetts/A Bicentennial Souvenir/1779–1979, repro. p. 10
This double drawing of the artist's parents may have been done from photographs, but the infrequency of profile photographs suggests that it was done from life, probably just before the artist left Ashfield for Cleveland.

6. PORTRAIT OF MY BROTHER, ca. 1872–75?
46
Oil on canvas, 11 x 10¾" (27.9 x 27.3 cm.)
Not signed, not dated
Smith College Museum of Art, Northampton, Massachusetts, bequest of Maud Valona Elmer, 1963

Provenance: The artist's brother, Samuel Elmer (1849–1902), Buckland, Massachusetts; his daughter, Maud V. Elmer, about 1945
Exhibitions: Shelburne Falls 1946; Northampton and Springfield 1952 (no. 1); Northampton and Shelburne 1982 (no. 1)
References: Frankenstein, repro. p. 271; M. V. Elmer, repro. p. 135; Jones, repro. p. 15

The canvas was dated 1875 by the artist's niece, Maud Elmer who, however, did not come into possession of it until the mid-forties when she found it in the attic of her grandparents' house in Buckland. Her dating may be based on her estimate of her father's age as shown in the painting. An exact date is difficult to assign, given the artist's habit of working from photographs. The architectural elements at the right are copied directly from a drawing by John Ruskin of Giotto's campanile in Florence (fig. 45), reproduced in the first edition of his *Seven Lamps of Architecture,* 1849.

7. SUSAN SMITH ELMER, THE ARTIST'S MOTHER. ca. 1875–80?
50.51
Oil on canvas, 12 x 10¾″ (30.5 x 27.3 cm.)
Not signed, not dated
Shelburne Museum, Inc., Shelburne, Vermont

Provenance: The artist's sister, Emeline Elmer, Ashfield, Massachusetts; purchased at the auction of her estate, April 1940 by Mrs. Joseph W. Seremeth, Greenfield, Massachusetts; Richard Gipson, Arlington, Vermont, as agent for the present owner, 1960
Exhibitions: Northampton and Springfield 1952 (no. 3); North-

ampton and Shelburne 1982 (no. 3).
References: Barbara Snow, "American Art at Shelburne," *Antiques,* vol. LXXVIII, no. 5, November 1960, p. 450; Muller, p. 63, fig. 133; Greene and Wheeling, p. 104, repro.

Susan Elmer (1807–1878) was known locally as a poet and several of her verses have survived. She was a deeply religious woman and in the fifties she contributed to a publication issued by the Second Adventists. The painting may have been done from a photograph.

8. ERASTUS ELMER, THE ARTIST'S FATHER. ca. 1875–80?
48.49
Oil on canvas, 12 x 11″ (30.5 x 27.9 cm.)
Not signed, not dated
Shelburne Museum, Inc., Shelburne, Vermont

Provenance: The artist's sister, Emeline Elmer, Ashfield, Massachusetts; purchased at the auction of her estate, April 1940 by Mrs. Joseph W. Seremeth, Greenfield, Massachusetts; Richard Gipson, Arlington, Vermont, as agent for the present owner, 1960
Exhibitions: Northampton and Springfield 1952 (no. 2); Northampton and Shelburne 1982 (no. 2)
References: Muller, p. 63, fig. 132; Greene and Wheeling, p. 104, repro.

This portrait of the artist's father, Erastus Elmer (1797–1890) was clearly done at the same time as the portrait of his mother (cat. no. 7). Both paintings are close in size to the portrait of his brother Samuel (cat. no. 6), but quite different in handling and palette. It seems likely that they were done later, perhaps even after Susan Elmer's death in 1878, from photographs.

9. MOURNING PICTURE. 1890
Oil on canvas, 28 x 36″ (71.1 x
91.5 cm.)
Not signed, not dated
Smith College Museum of Art,
Northampton, Massachusetts, purchased (1953: 129)

11.53
55.57

Provenance: Estate of the artist's widow, to his niece, Maud Valona Elmer, Seattle, Washington, 1927
Exhibitions: Shelburne Falls, Massachusetts, Post Office, November 1890; Shelburne Falls 1946; Northampton and Springfield 1952 (no. 4); Frankfurt, Städelsches Kunstinstitut, *Hundert Jahre Amerikanische Malerei,* March 14–May 3, 1953, cat. no. 29, repro., also shown Munich, Bayerische Staatsgemäldesammlungen; Hamburg Kunsthalle; Berlin, Charlottenburger Schloss; Düsseldorf, Kunstsammlungen der Stadt; Rome, Galleria Nazionale d'Arte Moderna; Milan, Palazzetto Reale; and New York, Whitney Museum of American Art, through May 23, 1954; Houston, The Museum of Fine Arts, *American Primitive Art,* January 6–29, 1956, cat. no. 2, repro.; Brussels, Universal and International Exhibition, *American Art,* April 17–October 18, 1958, cat. no. 102; Rotterdam, Museum Boymans-van Beuningen, *De Lusthof der Naïven,* July 10–September 6, 1964, also shown Paris, Musée National d'Art Moderne, October–November 1964, cat. no. 58, repro.; New York, Whitney Museum of American Art, *Art of the United States,* September 27–November 27, 1966, cat. no. 90, repro.; Northampton, Smith College Museum of Art (organizer), *19th and 20th Century Paintings from the Collection of the Smith College Museum of Art,* cat. no. 46, p. 33, repro., shown from June 1969 to October 1972 at Waterville, Maine, Colby College Art Museum; Manchester, New Hampshire, Currier Gallery of Art; Washington, D.C., National Gallery of Art; Houston, Texas, Houston Museum of Fine Arts; Seattle, Washington, Seattle Art Museum; Kansas City, Missouri, William Rockhill Nelson Gallery of Art; Richmond, Virginia, Virginia Museum of Fine Arts; Peoria, Illinois, Lakeview Center; Columbus, Ohio, Columbus Gallery of Fine Arts; Toledo, Ohio, Toledo Museum of Fine Arts; Dallas, Texas, Dallas Museum of Fine Arts; Athens, Georgia Museum of Art; Utica, New York, Munson-Williams-Proctor Institute; Detroit, Michigan, Detroit Institute of Arts; and Cleveland, Ohio, Cleveland Museum of Art; Dallas, Texas, Dallas Museum of Fine Arts, December 10, 1972–January 14, 1973 and Indianapolis, Indiana, Indianapolis Museum of Art, February–April 1973, *The Hand and the Spirit: Religious Art in America 1770–1900,* cat. no. 93, repro.; Washington, D.C., National Portrait Gallery, *American Self-Portraits, 1670–1973,* February 1–March 15, 1974, cat. no. 46, repro.; Munich, Haus der Kunst, November 1, 1974–January 12, 1975 and Zürich, Kunsthaus, January 25–March 13, 1975, *Art of the Naives—Themes and Affinities,* cat. no. 35, repro.; Northampton, Smith College Museum of Art, *American Faces/Faces by Americans,* April 23–October 10, 1976; Northampton, Smith College Museum of Art, *Great Explorations: Research into American Folk Art,* May 2–October 19, 1980, cat. no. 33, repro. p. 67; Northampton and Shelburne 1982 (no. 4)
References: Smith College Museum of Art *Bulletin,* nos. 29–32, June 1951, pp. 30–31, 34; Frankenstein, repro. p. 271; *Antiques,* vol. LXIV, no. 2, August 1953, p. 22, repro.; John I. H. Baur, *American Painting in the Nineteenth Century,* New York, 1953, p. 22, repro. p. 53; Alfred Frankenstein, *After the Hunt,* Berkeley 1953, Honolulu

1969 (rev. ed.), p. 151; John Maass, *The Gingerbread Age,* New York, 1957, repro. p. 190; Oto Bihalji Merin, *Das Naive Bild der Welt,* Cologne, 1959, p. 98, repro. pp. 198–99; Gillo Dorfles, "L'arte dei 'primitivi-contemporanei'," *Domus,* no. 379, June 1961, pp. 53–54, repro. detail p. 53; M. V. Elmer, repro. pp. 132–33, detail p. 134; J. W. Schulte Nordholt, *Amerika: Land, Volk, Cultuur,* Baarn, 1965, p. 225, repro. 24b; *Encyclopedia of World Art,* New York, Toronto, 1966, vol. XI, no. 715, pl. 334; Lloyd Goodrich, "American Art and the Whitney Museum," *Antiques,* vol. XC, no. 5, November 1966, repro. p. 659; Samuel Green, *American Art/A Historical Survey,* New York, 1966, pp. 376–77, Albert Dasnoy, *Exegèse de la Peinture Naïve,* Brussels, 1970, p. 226, pl. 187; Mario Praz, *Conversation Pieces: a Survey of the Informal Group Portrait in Europe and America,* University Park, Pennsylvania, 1971, p. 211, pl. 173; John Maass, *The Victorian Home in America,* New York, 1972, pp. 96–97, repro.; Hermann Warner Williams, Jr., *Mirror to the American Past: A Survey of American Genre Painting 1750–1900,* Greenwich, Connecticut, 1973, p. 196; Jean Lipman and Helen M. Franc, *Bright Stars: American Painting and Sculpture Since 1776,* New York, 1976, p. 86, repro.; Anita Schorsch, *Pastoral Dreams,* New York, 1977, pp. 42–43, repro.;

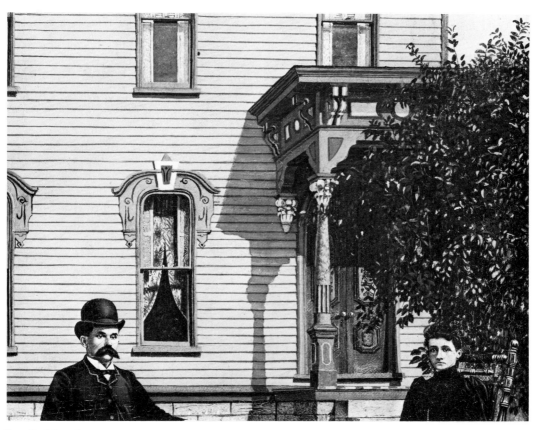

Cat. 9 (detail)

Rose-Marie Frenzel, *Biem Spiel: Ein Kunstbuch für Kinder/Ein Kinderbuch über Kunst,* Leipzig, 1977, p. 29, repro. p. 30; François Mathey, *American Realism,* Geneva, 1978, repro. p. 104; Jones, repro. p. 16; Robert Bishop and Patricia Coblentz, *The World of Antiques, Art and Architecture in Victorian America,* New York, 1979, pl. 38; Martha Pike and J.G. Armstrong, *A Time to Mourn: Expressions of Grief in 19th Century America,* Stony Brook, New York, 1980, p. 88, repro.; Russell Lynes, "Art in Academe," *Architectural Digest,* October 1981, color repro. p. 54; Werner Krum, *USA Ostküste,* Munich, 1981, color pl. VI

Except for a crayon photo-portrait, this is the first recorded work exhibited by the artist and the earliest work that can be assigned a year of execution. It was first shown in November 1890 in the local post office, having been painted, according to the artist's niece, in the spring following the death of Elmer's daughter Effie in January 1890. Its present title was probably given to it by Mary Bartlett Cowdrey or Henry-Russell Hitchcock, Assistant Director and Director, respectively, of the Smith College Museum of Art, when Maud Elmer brought it to show them in 1950. When she placed it on long-term loan the next year, it was listed in the Museum *Bulletin* as *Mourning Picture: The Artist, his Wife and Deceased Daughter.*

10. MILKING. ca. 1890–95?
Charcoal, with airbrush over a photographic enlargement, on cardboard, 15 x 19½" (38.1 x 49.6 cm.)
Not signed, not dated
Smith College Museum of Art, Northampton, Massachusetts, gift of Joseph Holland and Vincent Newton, 1982

Provenance: Dr. Ernest C. Payne, Shelburne Falls, Massachusetts; his sister, Mrs. Eva Payne Dickinson, Shelburne Falls, Massachusetts; to donors, ca. 1964
Exhibitions: Shelburne Falls 1946; Northampton 1982 (no. 18)

The boy at the left has been identified as Frank Payne, father of the first two owners, and a relation of the artist's wife. The man milking is thought to be the artist's father. The work has been dated about 1862, but though it is obviously a tentative effort, the technique and materials place it later. The airbrush was not patented until 1881, and the artist apparently acquired one about 1890.

Cat. 10

11. THE MARY LYON BIRTHPLACE.
59.60 1891
Oil on canvas, 21¾ x 28³/₁₆" (55.2 x 71.6 cm.)
Signed and dated on rock, bottom center: E. R. Elmer/1891.
Smith College Museum of Art, Northampton, Massachusetts, purchased (1976: 37)

Provenance: Malvern, Pennsylvania antiques dealer, 1976
Exhibitions: Northampton and

Shelburne 1982 (no. 5)
References: Jones, repro. p. 18

This is the earliest dated painting by Elmer yet located. The site, in Buckland, Massachusetts, is the birthplace of the founder, in 1837, of Mount Holyoke Female Seminary, later Mount Holyoke College. The artist, distantly related to Mary Lyon on his father's side, lived in the house from 1851 to 1863. It was torn down about 1864, so that while the handling of this picture points to a photographic source, the house itself would have been done from memory or from childhood sketches, or from an early photograph, not yet found.

12. MAGIC GLASSES (STILL LIFE WITH MAGNIFYING GLASS). ca. 1891–92
64.65 Oil on canvas, 14 x 10″ (35.6 x 25.4 cm.)
Not signed, not dated
Shelburne Museum, Inc., Shelburne, Vermont

Provenance: Estate of the artist's widow; purchased at the auction of her estate, 1928, by Mr. and Mrs. F. Sidney Wood, Shelburne Falls, Massachusetts
Exhibitions: Shelburne Falls 1946; Northampton and Springfield 1952 (no. 5); Northampton and Shelburne 1982 (no. 5)

Cat. 11 (detail)

References: Frankenstein, repro. p. 272; Alfred Frankenstein, *After the Hunt,* Berkeley, 1953, Honolulu, 1969 (rev. ed.), pp. 151–52, pl. 133; M. V. Elmer, repro. p. 131; James Thomas Flexner, *Nineteenth Century American Painting,* New York, 1970, pp. 119–20, repro. p. 122; Alfred Frankenstein, *The Reality of Appearance/The Trompe L'Oeil Tradition in American Painting,* New York, 1970, p. 136, repro. pp. 27, color and 137, black and white; Jean Lipman and Helen M. Franc, *Bright Stars: American Painting and Sculpture Since 1776,* New York, 1976, p. 87, repro. in color; Muller, p. 64, fig. 135; William H. Gerdts, *Painters of the Humble Truth/Masterpieces of American Still Life, 1801–1939,* Columbia, Missouri, 1981, p. 200, repro. p. 201

After Maud Elmer brought this painting to the Smith College Museum in August 1950, the Director, Henry-Russell Hitchcock, sent a letter to his friend, the critic and authority on surrealism, James Thrall Soby, calling it "the finest American *trompe l'oeil* or the greatest piece of 'magic realism' since Van Eyck's Arnolfini Wedding!" The term "magic realism" had been used to describe the work of certain surrealist artists who enjoyed the paradox of rendering imaginary or dream-derived events with meticulous, almost photographic accuracy. The catalogue for an exhibition at The Museum of Modern Art in New York in 1943, *American Realists and Magic Realists,* had featured a magnifying glass on the cover, and probably for this reason the painting was called *Magic Realism* in the 1952 Elmer exhibition at Smith. It is the only oil still life by Elmer so far found, though unlocated works with titles such as *Violin and Music* and *Basket of Peaches* may have been oils.

13. A LADY OF BAPTIST CORNER, ASHFIELD, MASSACHUSETTS (THE ARTIST'S WIFE). 1892
68.69. 70 Oil on canvas, 33¼ x 25″ (84.4 x 63.5 cm.)
Signed and dated lower left: E. R. Elmer/1892
Smith College Museum of Art, Northampton, Massachusetts, gift of E. Porter Dickinson (1979: 47)

Provenance: The artist's sister, Emeline Elmer, Ashfield, Massachusetts; E. Porter Dickinson, Amherst, Massachusetts, 1939
Exhibitions: Northampton, Massachusetts, Smith College Museum of Art, June 1940; Shelburne Falls 1946; Washington, D.C., The Corcoran Gallery of Art, *American Processional,* July 8– December 17, 1950, cat. no. 296, repro. p. 221; Northampton and Springfield 1952 (no. 7); Toronto, Ontario, The Art Gallery of Toronto, *American Painting 1865–1905,* January 5– February 5, 1961, cat. no. 27, repro. p. 39, also shown Winnipeg, Ontario, Winnipeg Art Gallery; Vancouver, British Columbia, Vancouver Art Gallery and New York City, Whitney Museum of American Art, through June 18, 1961; Northampton and Shelburne 1982 (no. 7)
References: Edgar Preston Richardson, "Art Aspects of 'American Processional,'" *The Corcoran Gallery of Art Bulletin,* vol. 4, no. 4, September 1951, repro. frontispiece; Frankenstein, repro. p. 270; M. V. Elmer, repro. p. 130; Hermann Warner Williams, Jr., *A Mirror to the American Past,* New York, 1973, pp. 196–97 repro. p. 197; Jones, repro. p. 17

Mr. Dickinson first saw this painting when in 1937 he visited Emeline Elmer in the company of several alumnae of Mount Holyoke College who were interested in her recollections of her youth in the house where the founder of their college, Mary Lyon, had been born.

While the women were talking, Mr. Dickinson wandered about the house and came upon a number of interesting paintings, which he learned from Mrs. Elmer had been done by her late brother. Several years later when he read of her death, he contacted her heirs and arranged to buy this picture, which had impressed him greatly. The picture may have come to Mrs. Elmer from the estate of her brother's widow, who had died in 1927. The present title was given the picture by Mr. Dickinson. At the time it was painted, the artist and his wife were living in an upstairs apartment in a house in Shelburne Falls, and it is probably a room in this house that we see in the picture.

The artist's wife, Mary Jane Ware (1860–1927), was a native of Ashfield.

14. AN IMAGINARY SCENE. 1892
71 Oil on canvas, 17 x 13¾" (43.2 x 34.9 cm.)
Shelburne Museum, Inc., Shelburne, Vermont

Provenance: the artist's sister, Emeline Elmer, Ashfield, Massachusetts; purchased at the auction of her estate, April 1940 by Mrs. Joseph W. Seremeth, Greenfield, Massachusetts; Richard Gipson, Arlington, Vermont, as agent for present owner, 1960
Exhibitions: Northampton and Springfield 1952 (no. 6); Northampton and Shelburne 1982 (no. 10)
References: Muller, p. 65

This painting and catalogue numbers 15 and 16 are three known versions, nearly identical, of the same subject.

15. AN IMAGINARY SCENE. 1892
72 Oil on canvas, 16⅞ x 13¾" (42.7 x 35.7 cm)
Signed and dated lower right: E. R. Elmer/1892.
Collection of William L. Hubbard

Provenance: Mrs. Waldemar Packard(?), Goshen, Massachusetts; purchased at the auction of her estate, ca. 1961
Exhibitions: Northampton and Shelburne 1982 (no. 9)

16. AN IMAGINARY SCENE. 1892
Oil on canvas, 17 x 13⅞" (43.2 x 35.2 cm.)
Signed and dated lower right: E. R. Elmer/1892.
Private collection

Provenance: Purchased by present owner at unspecified auction

17. FULL MOON ON THE RIVER. 1892
Oil on canvas, 14 x 17" (35.6 x 43.2 cm.)
Signed and dated lower left: E. R. Elmer/1892
Shelburne Museum, Inc., Shelburne, Vermont

Cat. 17

Provenance: Estate of the artist's widow; purchased at the auction of her estate, 1928, by Charles Adler, Shelburne Falls, Massachusetts; his son, Carl Adler, Shelburne Falls, Massachusetts; Richard Gipson, Arlington, Vermont, as agent for the present owner, 1960
Exhibitions: Northampton and Shelburne 1982 (no. 8)
References: Muller, p. 65

This painting and the one following are virtually identical in all details. The cursory brushwork, the rather lurid colors, and the harsh, inky blacks, suggest that both were copied from a reproduction, possibly a chromolithograph.

18. FULL MOON ON THE RIVER. 1892
Oil on canvas, 13⅞ x 16½" (35.2 x 42 cm.)
Signed and dated lower right: E. R. Elmer/1892.
Private collection

Provenance: Purchased by present owner at unspecified auction

19. BAREFOOT BOY AND GIRL, BRIDGE AND COW. 1892
Oil on canvas, 14 x 17" (35.7 x 43.2 cm.)
Signed and dated lower right: E. R. Elmer/1892.
Private collection

Provenance: Purchased by the present owner at an unspecified auction

This picture, just barely visible in the photograph of the artist at work in his studio room, taken about 1892 (fig. 21), is unlike any other known work in its anecdotal overtones. The scene may have been

copied. The bright colors hint at a chromolithographic source. The famous genre painter, John G. Brown (1831–1913) spent some weeks during the summer of 1891 in Ashfield, where at least one local patron bought a picture from him. Elmer was living in Shelburne Falls at the time but he visited Ashfield often in the summertime and would probably have made a point of seeing J. G. Brown or his work at first hand.

Cat. 19

20. IMAGINARY LANDSCAPE, ca. 1892–96
[74] Oil on paperboard, 17 x 14" (43.2 x 35.5 cm.)
Not signed, not dated
Collection of Mrs. Robert Luce

Provenance: Mr. and Mrs. Edward Charter, as a wedding gift from the artist, 1896; to their daughter, the present owner
Exhibitions: Northampton and Shelburne 1982 (no. 11)

In size and general conception, this picture resembles the three imaginary scenes (cat. nos. 14, 15, and 16), but it has no date or

signature and is done on a thin cardboard. The handling of these four pictures is in marked contrast to the precise brushwork in works such as *The Mary Lyon Birthplace* of 1891 or *A Lady of Baptist Corner* of 1892, dating from the same period. These more primitive works are closely related to traditional folk painting.

ably while the artist was a student in New York in 1899–1900. It does not show a firm command of the medium and its loose handling is in contrast to the earlier oils, so that if it was done during the New York stay, it may reflect an attempt at a freer style observed by Elmer in his younger fellow students.

Cat. 21

21. ARAB MODELING. ca. 1899–1900?
Oil on canvas, 24 x 20½" (61 x 50.8 cm.)
Not signed, not dated
Shelburne Museum, Inc., Shelburne, Vermont

Provenance: Francis R. Bray, Buckland, Massachusetts; Richard Gipson, Arlington, Vermont, as agent of present owner, 1960
Francis Bray, a nephew by marriage of the artist's brother, Samuel, believed the picture to be a self-portrait, but Maud Elmer thought it had been done from a model, prob-

22. NORTH RIVER, NEAR SHELBURNE
76 FALLS. 1900
Oil on canvas, 24¼ x 30⅛" (61.6 x 76.5 cm.)
Signed and dated lower right: E. R. Elmer/1900
Collection of Mr. and Mrs. Charles W. Scott

Provenance: Mr. and Mrs. Merle W. Scott, Greenfield, Massachusetts; to their son, the present owner
Exhibitions: Northampton and Springfield 1952 (no. 13); Northampton and Shelburne 1982 (no. 12)
References: Frankenstein, repro. p. 272
Elmer's only documented formal education in art was the period from October 1899 to May 1900, when he studied privately in New York with the genre painter, Walter Satterlee, and at the National Academy of Design. This was probably one of the first works done after his return, and it is one of the few oil paintings dating from this second phase of his career, when he concentrated largely on pastels.

23. HUNTING SCENE. 1900
77 Oil on canvas, 18½ x 24½" (47 x 62.2 cm.)
Signed and dated lower left: E. R. Elmer (partly illegible)/1900.
Collection of Mr. and Mrs. John B. Lesure

Provenance: Donn G. Roberts, Westfield, Massachusetts; to present owners, ca. 1970
Exhibitions: Springfield 1952; Northampton and Shelburne 1982 (no. 13)

The foreground figure is the artist's first cousin, John H. Elmer of Ashfield, a well-known local hunter. In the background is Ernest S. Barnes, grandfather of the present owner, and a nephew of the artist's wife. On the back of the picture's frame is an old sticker printed by J. Harrison Mills, an artist and fine arts packer and shipper with offices at 147 East 23rd Street in New York in the 1890s. The data filled in by the artist show that the frame once held a painting entitled *Feeding the Trout,* priced at $75 and offered for exhibition at the National Academy of Design. The Academy has no record of the picture, so that if it was submitted, it was refused. No painting answering this description has yet been found and there is no evidence to show that the present composition was painted over it. *Hunting Scene* came to the attention of the organizers of the 1952 exhibition too late for the catalogue and the Northampton showing, but it was seen in Springfield.

24. VIEW ON THE DEERFIELD RIVER NEAR THE NORTH RIVER. ca. 1902? Charcoal and airbrush, 16^{1}/$_{16}$ x 20″ (40.7 x 50.7 cm.)
Not signed, not dated
Collection of Mr. and Mrs. Kenneth L. Beals.

Provenance: Mr. and Mrs. Ernest S. Barnes, Ashfield, Massachusetts, 1902, as a wedding gift from the artist; to their daughter, the present owner

This picture probably has a photograph underneath the charcoal and airbrush. The paper is not the usual toothy-surfaced type favored by the artist for his charcoal and pastel drawings, but has a hard surface of the kind used for his photo-portraits. It is also mounted on a strainer as the photo-portraits were. Four other versions of this scene (cat. nos. 38, 39, 40, and 41) have been found, all of them probably done from a photograph taken by the artist. The view is taken looking south just below the confluence of the North and Deerfield rivers.

Cat. 25

Cat. 24

25. THE FRANK J. WOOD HOUSE, SHELBURNE FALLS. 1902?
Pastel, 12½ x 6¼" (32.7 x 15.9 cm.)
Not signed, not dated
Collection of Lucy Wood Decker

Provenance: Frank J. Wood, Shelburne Falls, Massachusetts, as a Christmas gift from his children, about 1902; his son, Robert Fellows Wood, Narberth, Pennsylvania; to his sister, the present owner, 1970
Exhibitions: Northampton 1982 (no. 23)

Robert F. Wood recalled that this pastel had been bought about 1902 from an exhibition of the artist's work; however, his first one-man show was not held until 1904, and the present owner believes that the picture was bought in 1902, when it was shown in a shop window in town.

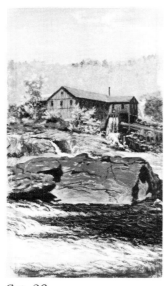

Cat. 26

26. OLD SAW MILL, NEAR SHELBURNE FALLS. 1904
Pastel, 12¼ x 7¼" (31.1 x 18.4 cm.) (composition)
Signed and dated lower right: E R E/1904

Collection of Mr. and Mrs. Kenneth L. Beals

Provenance: Estate of the artist's widow; purchased by Mrs. Harold A. Lesure, Ashfield, Massachusetts, at the auction of her estate, 1928; to her sister, the present owner
Exhibitions: Shelburne Falls 1906 (no. 29); Northampton and Springfield 1952 (no. 25); Northampton 1982 (no. 21)

Pastel number 29 in the 1906 checklist is called *Old Saw Mill.*

27. DEERFIELD RIVER FROM THE IRON BRIDGE AT SHELBURNE FALLS. 1904
Sepia pastel, 7⅛ x 18" (18.1 x 45.7 cm.)
Signed and dated lower left: E. R. Elmer/1904
Collection of Joseph Holland and Vincent Newton

Provenance: Estate of the artist's widow; purchased by Mrs. Charles Adler, Shelburne Falls, Massachusetts, at the auction of her estate, 1928; to present owners, ca. 1963

This work may have been shown in the 1904 one-man show which, according to newspaper accounts, included views on the Deerfield River. It is virtually identical to catalogue number 79, also a sepia pastel, but dated 1908. Both were probably done from a photograph, possibly taken by the artist.

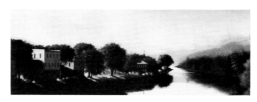

Cat. 27

28. MARY LYON'S BIRTHPLACE. 1904
Pastel, 16⅛ x 24⅛" (41 x 61.3 cm.)
Signed and dated lower left: E. R. Elmer/1904
Mount Holyoke College Art Museum, South Hadley, Massachusetts

Provenance: Unknown
Exhibitions: Northampton and Springfield 1952 (no. 14)

In 1904, the fiftieth anniversary of the death of Mary Lyon (1797–1849), the founder of Mount Holyoke College, Elmer made a number of pastel views of the site of her birth in Buckland, Massachusetts where he himself had lived as a child. He made sepiatone photographs of several of them, and added the word "Copyright" and the date 1904, perhaps with the intention of selling them to alumnae. Several such views are mentioned as inclusions in the artist's 1904 exhibition, and two pastels and two sepia pastels are catalogued in the 1906 exhibition. As for the provenance of this work and catalogue number 37, Mount Holyoke's archives record that one Mary Lyon view by Elmer was given by Mrs. Harriet E. Goodell in October of 1920. These same records show that the College at one time had three views by Elmer; this confirms the recollection of family members that both Maud Elmer and the artist's widow gave pastels of Mary Lyon's home to the College.

29. MARY LYON'S BIRTHPLACE. 1904
Sepia pastel, 9¹⁵⁄₁₆ x 16" (25.2 x 40.6 cm.)
Signed and dated lower left: Copyright 1904 by/E. R. Elmer
Collection of Mrs. Russell Purrington

Provenance: Mrs. Frank Field (née Fannie Demons), Shelburne Falls, Massachusetts, as a gift from her Sunday School class, 1905; purchased at the auction of her estate by present owner

This may be one of the views of the Mary Lyon birthplace mentioned in the newspaper review of the artist's 1904 exhibition.

In an article on Mary Lyon in the *Springfield Republican* of December 10, 1905, this picture is reproduced "from a copyrighted photograph by E. R. Elmer." The article states that "the picture was painted by Mr. Elmer, partly from sketches made on the spot and partly from memory. Mr. Elmer lived at the Mary Lyon farm from 1851 to 1864, and claims to be the only artist living who can paint anything like an accurate picture of the place. It is considered an excellent likeness by those familiar with it. The buildings of the farm were torn down about 40 years ago. . . ." Maud Elmer recalls camping at the Mary Lyon place with her uncle and aunt for three weeks one summer while he did many views. This was probably 1904 or 1905, the years

Cat. 28

Cat. 29

from which most of the views come. Sepiatone photographs of this view and two others have been preserved.

30. VIEW NEAR ST. JOHNS, NEW-FOUNDLAND. 1904
Charcoal, 14 x 28″ (35.6 x 71.1 cm.)
Signed and dated lower left: Elmer/1904
Smith College Museum of Art, Northampton, Massachusetts, gift of Joseph Holland and Vincent Newton, 1982

Provenance: Hunter W. Snead, Springfield, Massachusetts, to donors ca. 1963
Exhibitions: Shelburne Falls 1906 (no. 92 or 93); Northampton 1982 (no. 24)

In the 1906 checklist, under the heading "Charcoals and Crayons," there are two works entitled *View near St. Johns, Newfoundland.* Authorities in St. Johns confirm

that this drawing shows the town's harbor, with Fort Amherst on the promontory. There is no evidence that the artist ever visited St. Johns, but the photograph from which the drawing might have been made has not yet been found.

31. APPLES AND CIDER (STILL LIFE WITH APPLES). 1904
Pastel, 11⅞ x 17¾″ (30.2 x 45.1 cm.)
Signed and dated lower right: E. R. Elmer/1904
Shelburne Museum, Inc., Shelburne, Vermont

Provenance: Estate of the artist's widow, 1927; Maude V. Elmer; her cousin, Francis R. Bray, Shelburne Falls, Massachusetts; Richard Gipson, Arlington, Vermont, as agent for present owner, 1960
Exhibitions: Shelburne Falls 1906 (no. 23); Shelburne Falls 1946?; Northampton and Springfield 1952

Cat. 30

(no. 9); Northampton (no. 19) and Shelburne (no. 17) 1982
References: Muller, p. 65

The work was first shown in the artist's 1904 one-man show when it was singled out for mention in the *Greenfield Recorder* of November 23. In the 1906 checklist it is called *Apples and Cider* and priced at $8.50. It was no doubt one of the still lifes lent by Maud Elmer to the Shelburne Falls show in 1946.

32. WATERMELON AND JAR OF PUR-PLE FLOWERING RASPBERRY BLOSSOMS. 1904
Pastel, 15¾ x 23¾" (40 x 60.3 cm.)
Signed and dated lower left: E. R. Elmer/1904
Shelburne Museum, Inc., Shelburne, Vermont

Provenance: Estate of the artist's widow, 1927; Mr. and Mrs. Francis R. Bray, Shelburne Falls, Massachusetts; Mr. Bray's cousin, Maud V. Elmer; her nephew-in-law, Philip R. Joyce, Shelburne Falls, Massachusetts; Richard Gipson, Arlington, Vermont, as agent for the present owner, 1960
Exhibitions: Shelburne Falls 1906 (no. 7?); Shelburne Falls 1946?; Northampton and Springfield 1952 (no. 10); Northampton (no. 22) and Shelburne (no. 18) 1982
References: Muller, p. 65

The flowers have been variously called wild roses and blackberry blossoms, but the present identification is botanically correct. The pastel, number 7 of the 1906 checklist, is called *Watermelon,* and its price, $10.00, suggests that it was a relatively large work, such as this one. Maud Elmer lent a number of still lifes, not identified

Cat. 32

130

by title, to the 1946 exhibition at Shelburne Falls and it seems very likely that this was one of them.

33. VIEW ON THE DEERFIELD RIVER FROM THE IRON BRIDGE AT SHELBURNE FALLS. 1905
81
Pastel, 9⅛ x 26⅛" (25 x 65.6 cm.)
Signed and dated lower left: E. R. E./1905
Collection of Mr. and Mrs. Howard P. Binder

Provenance: Mr. and Mrs. Jacob A. Binder, Shelburne Falls, as a wedding present, 1907, possibly from the artist; to their son, the present owner
Exhibitions: Shelburne Falls, 1946; Northampton and Springfield 1952 (no. 17); Northampton 1982 (no. 41)

34. VIEW ON THE DEERFIELD RIVER FROM THE IRON BRIDGE AT SHELBURNE FALLS. 1905
82
Pastel, 10 x 25¾" (25.4 x 64.3 cm.)
Signed and dated lower right: E. R. E./1905
Collection of Mr. and Mrs. Richard R. Hollien

Provenance: Charles T. Shaw, Shelburne Falls, ca. 1905; to his daughter, the present owner
Exhibitions: Northampton (no. 42) and Shelburne (no. 28) 1982

Family tradition has it that Charles Shaw commissioned this work after seeing the artist working on a similar picture, possibly catalogue number 33.

35. MAIN STREET, SHELBURNE FALLS. 1905
94
Pastel, 9⅞ x 16" (25.1 x 40.6 cm.)

Signed and dated lower right: E. R. Elmer/1905
Collection of Mrs. Robert Luce

Provenance: Mr. and Mrs. Freeman Barnes, Ashfield, Massachusetts, 1915, as a Christmas present from the artist; to their daughter, Mrs. George Reniff, Ashfield, Massachusetts; to her daughter, the present owner, 1960
Exhibitions: Shelburne Falls 1906 (no. 52); Northampton (no. 30) and Shelburne (no. 22) 1982

36. DEERFIELD RIVER, LOOKING EAST. 1905
Pastel, 6⅞ x 17¾" (17.5 x 45.2 cm.)
Signed and dated lower left: E. R. Elmer/1905
Collection of Mrs. Deane H. Jones

Provenance: Mrs. Winfield Canedy, Shelburne Falls; to her niece, Nina Smith; to her daughter, the present owner
Exhibitions: Shelburne Falls 1906 (no. 24?); Shelburne Falls 1946; Northampton 1982 (no. 27)

The pastel catalogued as number 24 in the 1906 checklist is entitled *Deerfield Valley, from near Dr. Canedy's.* Its price, $7.00, suggests that it was a medium-sized work such as this one.

Cat. 36

37. MARY LYON'S BIRTHPLACE. 1905
Pastel, 18⅛ x 26⅛" (46 x
66.2 cm.)
Signed and dated lower left: E. R.
Elmer/1905
Mount Holyoke College Art Museum, South Hadley, Massachusetts

Provenance: Unknown
References: Jones, repro. p. 18
See note for catalogue number
28.

Cat. 37

38. VIEW ON THE DEERFIELD RIVER,
NEAR THE NORTH RIVER. 1905
Pastel, 6 x 12" (sight)
Signed and dated lower right: E. R.
Elmer/1905
Private collection

Provenance: Parents of the present
owner as a wedding present, 1907;
to present owner, 1950
Exhibitions: Shelburne Falls 1906
(no. 55?); Shelburne Falls 1946
The view, looking south, is taken
just below the confluence of the
North and Deerfield rivers, near a
house owned by J. A. Manning
around the turn of the century.
Number 55 in the 1906 checklist is
a pastel entitled *View on Deerfield
River, near Manning's,* but this or
the following work may also be
number 32, a pastel called *View on
Deerfield River, near North River.*

39. VIEW ON THE DEERFIELD RIVER,
NEAR THE NORTH RIVER. 1905
Pastel
Signed and dated lower right: E. R.
Elmer/1905
Private collection
See note for catalogue number
38.

Cat. 39

Fig. 100. Photograph of scene shown in cat.
nos. 24 and 38–41, 1981.

40. VIEW ON THE DEERFIELD RIVER,
NEAR THE NORTH RIVER. 1905
Sepia pastel, 9½ x 15" (24.2 x
38.1 cm.)
Signed and dated lower right: E. R.
Elmer/1905
Collection of Joseph Holland and
Vincent Newton

Provenance: Mr. and Mrs. H. Judd Payne, Bernardston, Massachusetts; to present owners, ca. 1964

Exhibitions: Shelburne Falls 1906 (no. 75?)

Number 75 under the heading "Sepia Pastels" in the 1906 checklist is a work entitled *View near North River Bridge,* which may be this or the following work. See also the note for catalogue number 24.

Cat. 40

Cat. 41

41. VIEW ON THE DEERFIELD RIVER, NEAR THE NORTH RIVER. 1905
Sepia pastel, 5 x 9½" (12.7 x 24.2 cm.)
Signed and dated lower left: E. R. Elmer/1905
Collection of Mr. and Mrs. Kenneth L. Beals

Provenance: Estate of the artist's widow, 1927; to her nephew, Ernest S. Barnes, Ashfield, Massachusetts; to his daughter, the present owner

Exhibitions: Shelburne Falls 1906 (no. 75?)

See catalogue number 40.

42. STREET RAILWAY POWER STATION, COLRAIN. 1905
89
Pastel, 6⅜ x 12¹⁵/₁₆" (16.2 x 31.3 cm.) (composition)
Signed and dated lower right: E. R. E./1905
Collection of Mr. and Mrs. Kenneth L. Beals

Provenance: Mrs. Waldemar Packard(?), Goshen, Massachusetts; purchased by present owners at auction of her estate, ca. 1961

Exhibitions: Shelburne Falls 1906 (no. 56?); Northampton (no. 38) and Shelburne (no. 25) 1982

The pastel at number 56 in the 1906 checklist is called *Frankton Pond and Power House* and its price, $3.00, suggests that it was a small work. Frankton was a village in Colrain. Regarding the provenance, one of the buyers of pictures at the auction of the estate of the artist's sister, Emeline, in 1940 was named Packard.

43. BRIDGE ON THE COLRAIN ROAD. 1905
88
Pastel, 6½ x 12⅜" (16.5 x 31.3 cm.)
Signed and dated lower left: E. R. Elmer/1905
Collection of Mrs. Raymond H. Reniff

Provenance: Estate of the artist's widow; purchased at the auction of

her estate, 1928
Exhibitions: Shelburne Falls 1906 (no. 66?); Northampton and Springfield 1952 (no. 20); Northampton (no. 25) and Shelburne (no. 19) 1982

The pastel at number 66 in the 1906 checklist is entitled *Shattuckville Bridge,* and its price, $2.00, suggests that it is a small work such as this. Shattuckville was a village on the North River just above Shelburne Falls.

Provenance: Estate of the artist's widow; purchased at the auction of her estate, 1928
Exhibitions: Northampton and Springfield 1952 (no. 18); Northampton 1982 (no. 35)

Cat. 44

44. ON FOUR MILE ROAD, EAST CHARLEMONT. 1905
Pastel, 7⅞ x 13⅞" (20.2 x 30.4 cm.)
Signed and dated lower right: E. R. E./1905
Collection of Mrs. Raymond H. Reniff

45. SCOTT'S BRIDGE OVER THE DEERFIELD RIVER AT EAST CHARLEMONT. 1905
Pastel, 12½ x 30¾" (31.7 x 78.1 cm.) (composition)
Signed and dated lower left: E. R. Elmer/1905
Collection of Mrs. Raymond H. Reniff

Cat. 45

Provenance: Estate of the artist's widow; purchased at the auction of her estate, 1928
Exhibitions: Shelburne Falls 1906 (no. 19); Northampton and Springfield 1952 (no. 19); Northampton 1982 (no. 37)

Number 19 in the 1906 checklist is entitled *Scott's Bridge.*

Cat. 46

46. ASHFIELD POND AND CLUB HOUSE. 1905
Pastel, 10 x 16″ (25.5 x 45 cm.)
Signed and dated lower left: E. R. Elmer/1906
Collection of Priscilla Barnes Bingham

Provenance: Della Robbins, Ashfield, Massachusetts; Howard C. Barnes, Ashfield, Massachusetts; to his daughter, the present owner, 1960s
Exhibitions: Shelburne Falls 1906 (no. 9)

Della Robbins and her husband, Lucian, acquired the artist's Ashfield farm following the death of Elmer's widow in 1927. This pastel may have been acquired at that time, or have been given to them earlier. They had helped the Elmers with chores for a number of years. The Bona Vista club house was built on the shores of Ashfield Pond about 1898 by a group of young men from Shelburne Falls. It is still standing.

47. LAKE WITH SAILBOAT. 1905
Pastel, 7⅞ x 13⅞″ (20 x 35.3 cm.)
Signed and dated lower left: E. R. Elmer/1905
Collection of Joseph Holland and Vincent Newton

Provenance: Estate of the artist's widow; purchased by Mr. and Mrs. Carl Adler, Shelburne Falls, Massachusetts, at the auction of her estate, 1928; to present owners, ca. 1964

It has been suggested that the scene represents Rowe Pond in northern Franklin County, Massachusetts, but it has not been possible to confirm this.

Cat. 47

48. MOUNT TOM, EAST SIDE. 1905
Pastel, 13⅞ x 21¾″ (35.3 x 55.3 cm.)
Signed and dated lower left: E. R. Elmer/1905
Collection of Mr. and Mrs. Douglas Barnes

Provenance: Estate of the artist's widow; purchased by Ernest S. Barnes, Ashfield, Massachusetts, at the auction of her estate, 1928; to his son, Howard C. Barnes, Ashfield, Massachusetts; to his son, the present owner
Exhibitions: Shelburne Falls 1906 (no. 71?); Northampton 1982 (no. 34)

The pastel catalogued at number 71 in the 1906 checklist is called *Mount Tom, East Side,* though its price, $7.00, would suggest that it was not so large a work as this. The *Hampshire Gazette* reported in October 1905 that the artist had been taking views in and around Northampton.

49. RIVER LANDSCAPE. 1905
 84 Pastel, 9⅞ x 19¾″ (25.1 x 50.2 cm.)
 Signed and dated lower right: E. R. Elmer/1905
 Collection of Betty B. Moser

 Provenance: Dean Bray, Amherst, Massachusetts; to his daughter, the present owner
 Exhibitions: Shelburne Falls 1906 (no. 48?); Northampton (no. 36) and Shelburne (no. 24) 1982
 The pastel at number 48 in the 1906 checklist is called *Connecticut River, near Northampton* and is priced at $8.50. The scene does appear to be a view of the Connecticut and the artist did spend a week in Northampton taking views in the fall of 1905.

50. MOUNT HOLYOKE, WITH THE CONNECTICUT RIVER IN THE FOREGROUND. 1905
 Pastel, 13⅞ x 22″ (35.8 x 55.8 cm.)
 Signed and dated lower right: E. R. Elmer/1905
 Collection of Mr. and Mrs. Kenneth L. Beals

 Provenance: Estate of the artist's widow; purchased by Mr. and Mrs. Ernest S. Barnes, Ashfield, Massachusetts, at the auction of her estate, 1928; to their daughter, the present owner

Exhibitions: Shelburne Falls 1906 (no. 14); Northampton and Springfield 1952 (no. 15); Northampton 1982 (no. 33)
The pastel at number 14 in the 1906 exhibition is called *Mt. Holyoke.*

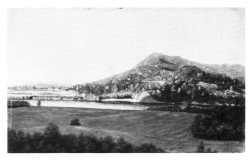
Cat. 50

51. MOUNT HOLYOKE. 1905?
 Sepia pastel, 7⅞ x 13⅞″ (20 x 35.3 cm.)
 Not signed, not dated
 Collection of Mrs. Robert Luce

 Provenance: the artist's widow, to the present owner, her great-niece, 1927
 Exhibitions: Shelburne Falls 1906 (no. 86?)
 The sepia pastel at number 86 in the 1906 checklist is probably this work.

Cat. 51

52. LAKE PONTOOSUC, PITTSFIELD, MASSACHUSETTS. 1905
78
Pastel, 5⅝ x 15⅞″ (14.2 x 40.3 cm.)
Signed and dated lower right: E. R. Elmer/1905
Collection of Ann Holden Salguero

Provenance: Estate of the artist's widow, to her great-niece, Mrs. Robert Luce, 1927–28; to her son, Dean Luce; to present owner, 1982
Exhibitions: Springfield 1952; Northampton 1982 (no. 29)

Mrs. Robert Luce possesses a small tinted photograph (fig. 79) on which this pastel is based. It was not catalogued in the 1952 exhibition at Northampton but was shown in Springfield.

53. ECHO LAKE AND MOAT MOUNTAIN, NEW HAMPSHIRE. 1905
86
Pastel, 13¾ x 21⅞″ (34.9 x 55.6 cm.)
Signed and dated lower left: E. R. Elmer/1905
Collection of Mrs. Robert Luce

Provenance: Estate of the artist's widow, to present owner, her great-niece, 1927–28
Exhibitions: Shelburne Falls 1906 (no. 28); Northampton and Springfield 1952 (no. 16); Northampton (no. 28) and Shelburne (no. 21) 1982

The composition is based directly on a photograph (fig. 87) that appeared in a Boston and Maine Railroad souvenir booklet of photographs entitled *Mountains of New England.*

54. EAGLE CLIFF, MOUNT LAFAYETTE AND ECHO LAKE, NEW HAMPSHIRE. 1905?
Pastel, 13 x 21″ (33 x 53.3 cm.)

Signed lower right: E. R. Elmer; not dated
Collection of Joseph Holland and Vincent Newton

Provenance: Dr. Ernest C. Payne, Shelburne Falls, Massachusetts; Mr. and Mrs. H. Judd Payne, Bernardston, Massachusetts; to present owners, 1963
Exhibitions: Shelburne Falls 1946; Northampton and Springfield 1952 (no. 26); Northampton 1982 (no. 43)

Like catalogue number 53, this pastel is based directly on a photograph (fig. 101) that appears in a small souvenir booklet entitled *Mountains of New England* issued by the Boston and Maine Railroad.

Cat. 54

Fig. 101. "Eagle Cliff, Mount Lafayette and Echo Lake, New Hampshire." Photograph, probably by Henry Greenwood Peabody, in *Mountains of New England,* Boston and Maine Railroad, publisher.

55. A SURE CATCH. 1905
Pastel, 16 x 24" (40.8 x 61 cm.)
Signed and dated lower left: E. R.
Elmer/1905
Collection of Carl Adler

Provenance: Estate of the artist's widow; purchased by Charles Adler, Shelburne Falls, Massachusetts, at the auction of her estate, 1928; to his son, the present owner
Exhibitions: Shelburne Falls 1906 (no. 45)
A pencil inscription on the old backing paper reads "A Sure Catch."

The pastel at number 17 of the 1906 checklist is called simply *Moonlight.*

Cat. 56

Cat. 55

56. MOONLIGHT ON THE RIVER. 1905
Pastel, 12 x 20" (30.5 x 50.8 cm.)
Signed and dated lower right: E. R.
Elmer/1905
Shelburne Museum, Inc., Shelburne, Vermont

Provenance: Estate of the artist's widow; purchased by Mrs. Charles Adler, Shelburne Falls, Massachusetts, at the auction of her estate, 1928; to Richard Gipson, Arlington, Vermont, as agent for the present owner, 1960
Exhibitions: Shelburne Falls 1906 (no. 17?); Northampton (no. 31) and Shelburne (no. 23) 1982
References: Muller, p. 65

57. MOONLIT LANDSCAPE. 1905
Pastel, 12 x 20" (30.5 x 50.8 cm.)
Signed and dated lower right: E. R.
Elmer/1905; inscribed: "from Ch . . ." (illegible)
Collection of Joseph Holland and Vincent Newton

Provenance: Dr. Ernest C. Payne, Shelburne Falls, Massachusetts; Mr. and Mrs. H. Judd Payne, Bernardston, Massachusetts; to present owners, about 1963
Exhibitions: Shelburne Falls 1906 (no. 42 or no. 17?); Shelburne Falls 1946; Springfield 1952; Northampton 1982 (no. 32)
This pastel is freely based on a color reproduction in the possession of the owners (fig. 102) of a painting by an unidentified artist, who may be named in the illegible inscription beneath the signature. The 1906 checklist has pastels entitled *Moonlight* (no. 17) and *Moonlight and Mackerel Sky* (no. 42), one of which may be this work. It did not come to the attention of the organizers of the 1952 show in

time for the Northampton exhibition but was included in the Springfield showing.

Cat. 57

Fig. 102. Color reproduction of painting by unknown artist.

Cat. 58

58. VASE WITH ASTERS. 1905
Pastel, 13⅞ x 7⅞" (35.3 x 20 cm.)
Signed and dated lower right: E. R. E./1905
Collection of Joseph Holland and Vincent Newton

Provenance: Edgar L. Lockhart, Ashfield, Massachusetts, as a gift from the artist; his sister, Mrs. Frank Gillman, Hingham, Massachusetts, her daughter, Mrs. Burrell, Hingham, Massachusetts; to present owners, ca. 1963
Exhibitions: Shelburne Falls 1906 (no. 15)
 Number 15 in the 1906 checklist, a pastel entitled *Asters,* was priced at $4.50, a figure that conforms to the prices of other works of this general size.

59. PEACHES AND GRAPES. 1905
Pastel, 7 x 13" (sight)
Signed and dated lower left: E. R. Elmer/1905
Collection of Howard H. Bristol, Jr.

Provenance: Estate of the artist's widow; purchased by Mr. and Mrs. Harold A. Lesure, Ashfield, Massachusetts, at the auction of her estate, 1928; to Howard C. Barnes, Ashfield, Massachusetts; to present owner, 1971
Exhibitions: Shelburne Falls 1906 (no. 35); Northampton (no. 26) and Shelburne (no. 20) 1982

60. STILL LIFE WITH PEARS AND CLOVER. 1905?
Pastel, 13½ x 21½" (34.3 x 54.6 cm.)
Signed and dated lower right: E. R. Elmer/190? (date illegible)
Collection of Mrs. Robert Luce

90

139

Provenance: Estate of the artist's widow; purchased at the auction of her estate, 1928
Exhibitions: Shelburne Falls 1906 (no. 54); Northampton and Springfield 1952 (no. 12); Northampton (no. 40) and Shelburne (no. 27) 1982

The pastel at number 54 of the 1906 checklist is called *Pears and Clover.*

61. STILL LIFE: FLOWERS AND JAR OF STRAWBERRIES. 1905?
Pastel, 10 x 15⅞″ (25.4 x 40.8 cm.)
Signed and dated lower right: E. R. Elmer/05? (date illegible)
Shelburne Museum, Inc., Shelburne, Vermont

Provenance: Herbert Ashworth, Shelburne Falls, Massachusetts; Richard Gipson, Arlington, Ver-

mont, as agent for the present owner, 1960
Exhibitions: Shelburne Falls 1946?; Northampton and Springfield 1952 (no. 11); Northampton (no. 39) and Shelburne (no. 26) 1982
References: Muller, p. 65

62. OUR VILLAGE CARVER. 1906
95
Oil on canvas, 24 x 20″ (61 x 50.8 cm.)
Signed and dated lower right: E. R. Elmer/1906
Collection of Joseph Holland and Vincent Newton

Provenance: Alethian Lodge, I.O.O.F., Shelburne Falls, Massachusetts; to present owners, ca. 1963
Exhibitions: Shelburne Falls 1906 (no. 2); Northampton and Shelburne 1982 (no. 14)

The subject is Dr. Andrew Everett Willis, a popular figure in Shelburne Falls, who took up the

Cat. 61

carving of violins and low-relief portraits, such as the one seen in the background of this painting, after he retired from his medical practice. He claimed to have made the first portrait of Abraham Lincoln, when he was a young man in Illinois. Charles Eliot Norton and George William Curtis, both summer residents in Ashfield, were subjects of Willis's carved reliefs. The painting was done by May 1906, when it was shown in the local drugstore window.

63. A WEAVING SCENE (GIRL WEAVING RUG). 1906
Pastel, 15⅞ x 23⅝″ (40.3 x 62.5 cm.)
Signed and dated lower right: E. R. Elmer/1906

Shelburne Museum, Inc., Shelburne, Vermont, gift of Mrs. P. H. B. Freylinghuysen, 1960

Provenance: The artist's sister, Emeline Elmer; purchased by Mr. and Mrs. Galen W. Johnson, East Buckland, Massachusetts, at the auction of her estate, April 1940; to Richard Gipson, Arlington, Vermont, 1960; to donor, 1960
Exhibitions: Shelburne Falls 1906 (no. 5); Shelburne Falls 1946; Northampton and Springfield 1952 (no. 27); Northampton (no. 45) and Shelburne (no. 29) 1982
References: Muller, p. 65

The girl at the loom is the artist's niece, Ethel Elmer, daughter of his sister Emeline and her husband, A. Chapin Elmer. Number 5 in the 1906 checklist, *A Weaving Scene,* was priced at $15.00, the most expensive of all the pastels.

Cat. 63

64. THE DOLE CORNER. 1906
Pastel, 7¾ x 13¾″ (19.6 x 35.7 cm.)
Signed and dated lower left: E. R. Elmer/06
Collection of Mr. and Mrs. Douglas Barnes

Provenance: Mr. and Mrs. Howard C. Barnes, Ashfield, Massachusetts, as a wedding gift from the artist, 1915; to their son, the present owner, 1977
Exhibitions: Shelburne Falls 1906 (no. 8?); Northampton 1982 (no. 44)
The "Dole Corner" was the name given to the intersection of Barnes Road and Phillips Road, just north of the artist's Ashfield farm.

Cat. 64

65. VIEW FROM ABOVE HARLOW PHILLIPS' HOUSE, ASHFIELD. 1906
Pastel, 14⅛ x 27″ (35.7 x 68.6 cm.)
Signed and dated lower right: E. R. Elmer/1906
Collection of Priscilla Barnes Bingham

Provenance: Estate of the artist's widow; her nephew, Howard C. Barnes, Ashfield, Massachusetts, 1927; to his daughter, the present owner
Exhibitions: Shelburne Falls 1906 (no. 20?); Northampton 1982 (no. 48)

Number 20 in the 1906 checklist is a pastel entitled *Autumn Scene, Ashfield, Mass.,* and the price, $14.00, suggests that it was a large work such as this one. On a list of works that were hanging in the artist's house at the time of his widow's death is one identified as *Top of Harlow's Hill (deer),* which is probably this pastel.

Cat. 65

66. VIEW ON UPPER PHILLIPS ROAD, ASHFIELD. 1906
Pastel, 12 x 20″ (sight)
Signed and dated lower right: E. R. Elmer/1906
Collection of Philip W. Elmer

Provenance: Sidney P. Elmer, Ashfield, Massachusetts; his son, Roy C. Elmer, Melrose, Massachusetts; his son, the present owner, 1958
Three versions of this composition have so far been located. (See catalogue numbers 67 and 68.)

Cat. 66

142

67. VIEW ON UPPER PHILLIPS ROAD,
ASHFIELD. 1906
Sepia pastel, 9⅞ x 14" (25.1 x
35.6 cm.)
Not signed, not dated
Collection of Steven J. Howe

Provenance: James L. Howe,
Ashfield, Massachusetts, as a gift
of the artist; his son, LeRoy Howe;
his son, the present owner
The artist's niece, Ethel Elmer,
daughter of his sister Emeline and
Chapin Elmer, married James L.
Howe in October 1906, and the
pastel was probably a wedding gift.
Ethel committed suicide three
years later. An inscription, not in
the artist's hand, is on the old back-
ing paper: "To James L. Howe
from E. R. Elmer 1906." (See
catalogue numbers 66 and 68.)

68. VIEW ON UPPER PHILLIPS ROAD,
ASHFIELD. 1906?
Pastel, 14 x 22" (35.5 x 56 cm.)
Not signed, not dated
Collection of Mr. and Mrs. Harold
A. Lesure

Provenance: Artist's wife to present
owners as a wedding gift, 1927
Exhibitions: Northampton 1982
(no. 49)
This picture has also been called
Country Road with Row of Maples,

Cat. 68

but its close similarity to the
preceding two entries confirms its
actual site. All three works were
probably based on a photograph,
perhaps taken by the artist, that
shows Mount Owen in Ashfield in
the distance. Though this work is
not dated, it may have been done at
the same time as catalogue num-
bers 66 and 67.

Cat. 69

69. ASHFIELD FARM WOODLOT. 1906
Sepia pastel, 7⅞ x 11³/₁₆" (20 x
28.4 cm.)
Signed and dated lower right: E. R.
Elmer/1906
Collection of Joseph Holland and
Vincent Newton

Provenance: Mr. and Mrs. Jacob A.
Binder, Shelburne Falls, Mas-
sachusetts; their son, Howard P.
Binder; to present owners, ca. 1963
Exhibitions: Shelburne Falls 1946;
Springfield 1952
The picture was not catalogued or
shown in the Northampton exhibi-
tion of 1952, but was added to the
Springfield showing as *Pasture on
the Artist's Farm.*

70. APPLE PICKING (THE ARTIST'S
ORCHARD, ASHFIELD). 1906
Pastel, 8 x 13¾" (20.3 x 35 cm.)

143

Signed and dated lower right: E. R. Elmer/1906
Buckland Historical Society, Buckland, Massachusetts, gift of Maud Valona Elmer

Provenance: Estate of the artist's widow, to his niece, Maud V. Elmer, 1927
Exhibitions: Shelburne Falls 1906 (no. 46); Northampton and Springfield 1952 (no. 22)

Apple Picking was the title used in the 1906 exhibition. Maud Elmer later identified the scene as her uncle's Ashfield orchard; she believed he was living in Ashfield at this time, but in fact he was still a resident of Shelburne Falls. He did not move to Ashfield until 1907 or 1908 and did not purchase the farm with the apple orchard until 1911.

Cat. 70

71. MOUNT OWEN, ASHFIELD. 1906
Pastel, 9¾ x 25¾" (24.7 x 65.3 cm.)
Signed and dated lower right: E. R. Elmer/1906
Shelburne Museum, Inc., Shelburne, Vermont, gift of Maud Valona Elmer, 1961

Provenance: Estate of the artist's widow to his niece, Maud V. Elmer, 1927
Exhibitions: Shelburne Falls 1906 (no. 38?); Northampton and Springfield 1952 (no. 21)

References: Muller, p. 63, fig. 134
Number 38 in the 1906 checklist is called *Mt. Owen, Ashfield, Mass.,* and is priced at $10.00, which puts it into the general range for a work of this size; however, Mount Owen figures in many of the pastels.

Cat. 71

72. ASHFIELD POND. 1906
Pastel, 9⅞ x 16¾" (24.2 x 39.4 cm.)
Signed and dated lower right: E. R. Elmer/1906
Collection of Joseph Holland and Vincent Newton

Provenance: William L. Hubbard, Sunderland, Massachusetts; to present owners, ca. 1963
Exhibitions: Shelburne Falls 1906 (no. 50?)

If this scene is indeed a view of Ashfield Pond, the pastel may be the one shown in the 1906 exhibition, checklist number 50.

Cat. 72

Cat. 73

73. BY THE CAMPFIRE. 1906
Pastel, 16⅛ x 8″ (41.3 x 20.4 cm.)
Not signed, not dated
Collection of Mr. and Mrs. Harold
A. Lesure

Provenance: Estate of the artist's
widow; purchased at the auction of
her estate, 1928
Exhibitions: Shelburne Falls 1906
(no. 27)

An inscription on the backing
paper states that the pastel was
"painted in 1906," and that the
price at the auction in 1928 was
$9.00, the same price the artist had
asked for it in 1906. The scene is
on Chesterfield Lake (now Damon
Pond) in Goshen, Massachusetts,
where the artist and his friends
often camped in the summertime.
The owners identify the people as
the artist, his wife, and her niece,
Minnie Barnes.

74. TORREY'S WOOD, WILLIAMSTOWN,
MASSACHUSETTS. 1906
Sepia pastel, 11⅞ x 18″ (32 x
45.7 cm.)

Signed and dated lower left: E. R.
Elmer/1906
Collection of Mrs. Robert Luce

Provenance: Estate of the artist's
widow to present owner, her great-
niece, 1927–28
Exhibitions: Shelburne Falls 1906
(no. 76)

The composition is taken directly
from a photograph that appeared in
a small souvenir booklet issued by
the Boston and Maine Railroad enti-
tled *The Charles River to the Hud-
son* (fig. 103). In the 1906
checklist there were two sepia
pastels of this subject, one priced at
$7.00 and the other at $3.00. The
size of this one suggests that it was
number 76, the more expensive of
the two.

Cat. 74

Fig. 103. "Torrey's Wood, Williamstown,
Massachusetts." Photograph, probably by
Henry Greenwood Peabody, in *The Charles
River to the Hudson.* Boston and Maine
Railroad, publisher.

Cat. 75

Images of New England, 1860– 1930 (Susan Mahnke, ed., Dublin, N.H., 1982), the photographer of this view and of many of the little Boston and Maine booklets issued before and after the turn of the century, is identified as Henry Greenwood Peabody (1855– 1951). He may also have taken photographs reproduced in figures 87, 101 and 103.

Maud Elmer was a cousin of the Eldridges.

Fig. 104. Henry Greenwood Peabody. "Noontime, Lancaster, Massachusetts." Photograph in *Picturesque New England/ Historical, Miscellaneous.* Boston and Maine, publisher.

Cat. 76

75. NOONTIME, LANCASTER, MAS-
 SACHUSETTS. 1906?
 Sepia pastel, 7½ x 13½" (sight)
 Not signed, not dated
 Collection of Howard P. Eldridge

 Provenance: Mr. and Mrs. George
 O. Eldridge, Shelburne Falls, Mas-
 sachusetts, as a wedding gift from
 Maud V. Elmer, 1906; to their son,
 the present owner.
 The composition is based on a
 photograph (fig. 104) published in
 a Boston and Maine Railroad
 souvenir booklet entitled *Pictur-
 esque New England/Historical
 Miscellaneous.* In *Looking Back/*

76. LANDSCAPE AT SUNSET. 1906
 Pastel, 10¼ x 14" (26 x 35.4 cm.)
 Signed and dated lower right: E. R.
 Elmer/1906
 Collection of Margaret Phillips
 Taintor

 Provenance: Grace Phillips,
 Ashfield, Massachusetts, to her
 sister, the present owner
 Exhibitions: Northampton 1982
 (no. 46)
 The owner says that this work
 and the following one (cat. no. 76)
 represent imaginary landscapes
 done especially for her and her sis-
 ter, both granddaughters of the art-
 ist's sister, Emeline.

77. LANDSCAPE AT SUNSET. 1906
Pastel, 11 x 14⅜″ (27.8 x 36.5 cm.)
Signed and dated lower right: E. R. Elmer/1906
Collection of Mrs. Wayne Phillips

Provenance: Margaret Phillips Taintor, Bangor, Maine, to her sister-in-law, the present owner
Exhibitions: Northampton 1982 (no. 47)
See note for catalogue number 76.

Cat. 77

78. SUNLIGHT THROUGH THE TREES. 1907
Pastel, 9⅞ x 19⅝″ (25.2 x 49.8 cm.)
Signed and dated lower left: E. R. Elmer/1907
Shelburne Museum, Inc., Shelburne, Vermont

Provenance: Estate of the artist's widow; to his niece, Maud V. Elmer; to Richard Gipson, Arlington, Vermont, as agent for present owner, 1960
Exhibitions: Shelburne Falls 1946?
References: Muller, p. 65

A notation on the back reads "Mt. Owen in Ashfield, Mass., near artist's home." This may be the pastel described in the newspaper account of the 1946 exhibition as a "scene looking east from the Pettibone place," apparently lent by Maud Elmer. The Pettibone farm, near the artist's Ashfield house, commanded a good view of Mt. Owen.

Cat. 78

79. VASE WITH ZINNIAS. 1907
 91 Pastel, 12½ x 6½″ (31.7 x 16.5 cm.)
Signed and dated lower right: E. R. Elmer/1907
Collection of Joseph Holland and Vincent Newton

Provenance: Edgar L. Lockhart, Ashfield, Massachusetts; his sister, Mrs. Frank Gillman, Hingham, Massachusetts; her daughter, Mrs. Burrell, Hingham, Massachusetts; to present owners, ca. 1963
Exhibitions: Northampton 1982 (no. 50)

80. DEERFIELD RIVER FROM THE IRON BRIDGE AT SHELBURNE FALLS. 1908
Sepia pastel, 7⅛ x 18″ (18.2 x 45.7 cm.)
Signed and dated lower left: E. R. Elmer/1908
Collection of Mr. and Mrs. Kenneth L. Beals

147

Provenance: Amherst, Massachusetts tag sale to present owners
Exhibitions: Northampton 1982 (no. 52)

See catalogue number 27.

Cat. 80

81. DEERFIELD RIVER AT THE DUGWAY. 1908?
Pastel, 18 x 12″ (46 x 30.5 cm.)
Signed and dated lower left: E. R. Elmer/190? (date illegible)
Collection of Mr. and Mrs. Harold A. Lesure

Provenance: Estate of the artist's widow; purchased at the auction of her estate, 1928
Exhibitions: Northampton 1982 (no. 51)

The dugway was a section along the Deerfield River north of Shelburne Falls where the bank was cut away for a street railway line. The date, partially illegible, may be 1905.

Cat. 81

82. CLARENCE W. WARD'S CAMP ON THE NORTH RIVER, NEAR GRISWOLDVILLE. 1908?
Sepia pastel, 5⅝ x 9⅞″ (15 x 25.1 cm.)
Signed and dated lower left: E. R. Elmer/190? (date illegible)
Collection of Mr. and Mrs. R. Russell Luce

Provenance: Clarence W. Ward, Shelburne Falls, Massachusetts; to his daughter, Mrs. Hugh F. Ward; to the present owner, 1982

The artist's exhibitions in 1905 and 1906 were held at Clarence Ward's ice-cream parlors on Bridge Street, in Shelburne Falls.

Cat. 82

83. GIRL IN WOODS. 1908
97 Pastel, 9⅞ x 13¾″ (25.2 x 34 cm.)
Signed and dated lower left: E. R. Elmer/1908
Collection of Carrie M. Dige

Provenance: Estate of the artist's widow; purchased by Mr. and Mrs. Anton Dige, Ashfield, Massachusetts, at the auction of her estate, 1928; to their son, Carl J. Dige, Ashfield, Massachusetts, 1947; to his wife, the present owner
Exhibitions: Northampton (no. 53) and Shelburne (no. 30) 1982

Nina Gilbert Barnes, wife of Ernest S. Barnes, who was a nephew of Mary Elmer, is believed to be the girl seen here.

84. THE SIDNEY ELMER BIRTHPLACE,
BAPTIST CORNER, ASHFIELD. 1908
Pastel, 9¹/₁₆ x 15⅜″ (23 x 39 cm.)
Signed and dated lower left: E. R.
Elmer/1908
Collection of Edith M. Jerome

Provenance: Sidney P. Elmer,
Ashfield, Massachusetts; his
daughter, Ethel Elmer Graves,
Ashfield, Massachusetts; to her
daughter, the present owner
Exhibitions: Northampton and
Springfield 1952 (no. 23); North-
ampton 1982 (no. 55)
 Sidney P. Elmer was a first
cousin of the artist.

Cat. 85

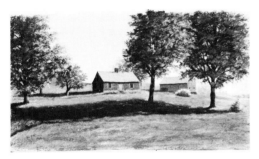

Cat. 84

85. GRAZING SHEEP. 1908
Pastel, 9⅞ x 19⅜″ (25.2 x
49.2 cm.)
Signed and dated lower left: E. R.
Elmer/1908
Collection of William Bull Elmer

Provenance: Charles Bliss Elmer to
his son, the present owner, ca.
1930
Exhibitions: Northampton 1982
(no. 54)
 The first owner, a cousin of the
artist, bought the picture about
1916 when he and his family came
to Ashfield for a family reunion.

86. GRAY'S MEADOW FROM GRAVES'S
 96 HILL, ASHFIELD. 1908
Pastel, 10 x 26″ (25.5 x 65.8 cm.)
Signed and dated lower right: E. R.
Elmer/1908
Collection of Irene Gray Merriam

Provenance: Frank and Elizabeth
Gray, Ashfield, Massachusetts; to
their daughter, the present owner
Exhibitions: Northampton 1982
(no. 20)

87. VIEW OF THE ARTIST'S HOME,
 98 ASHFIELD. ca. 1908? (or 1920?)
Oil on canvas, 12 x 20¹/₁₆″ (35 x
50.9 cm.)
Not signed, not dated
Collection of Mrs. Wayne Phillips

Provenance: The artist's sister,
Emeline Elmer, Ashfield, Mas-
sachusetts; to her grandson, Wayne
Phillips, 1939; to his widow, the
present owner
Exhibitions: Northampton and
Springfield 1952 (no. 24); North-
ampton and Shelburne 1982 (no.
15)
 The artist and his wife moved
from Shelburne Falls to Ashfield in
late 1907 or early 1908 and in 1911
bought the farm near this location
belonging to John H. Elmer. The
picture was dated "ca. 1920" in the
1952 exhibition.

Cat. 88

88. HAY WAGON, ASHFIELD. ca. 1908?
Pastel, 7 x 17¾″ (17.7 x 45.3 cm.)
Signed and dated lower right:
E. R. E./(date illegible)
Collection of Ann Holden Salguero

Provenance: Estate of the artist's
widow; purchased by George W.
Lesure, Ashfield, Massachusetts,
at the auction of her estate, 1928;
to Kathleen Barnes Lesure, Wil-
liamsburg, Massachusetts; to her
daughter, the present owner, 1978

The scene is thought to be one on
the farm of the artist's sister,
Emeline. It may actually be on the
nearby farm of his cousin Sidney
Elmer, who is identified as the man
driving the wagon.

According to the present owner,
the painting was done especially for
his father, Sidney Elmer's son, who
was a cousin of the artist.

90. COPY AFTER "THE MONARCH OF
THE GLEN"
Oil on wood panel, with arched top,
fitted with brass fixtures for use as
a fire screen, 39⅞ x 32⅞″ (101.3 x
83.2 cm.)
Not signed, not dated
Collection of Carrie M. Dige

Provenance: Mr. & Mrs. Anton
Dige, Ashfield, Massachusetts; to
their son, Carl J. Dige by 1947; to
his wife, the present owner

The painting is a free copy after
Edwin Landseer's *The Monarch of
the Glen,* 1851, one of the most
popular images of the nineteenth
and early twentieth centuries. It was
borrowed and adapted to advertise
insurance, beer, cigars, and many
other products.

Cat. 89

89. SIDNEY ELMER'S DAIRY FARM,
ASHFIELD, MOUNT OWEN IN THE
DISTANCE. 1921
Oil on canvas, 15 x 31″ (sight)
Signed and dated lower left: E. R.
Elmer/1921
Collection of Philip W. Elmer

Provenance: Roy C. Elmer, Mel-
rose, Massachusetts; to his son,
the present owner, 1958

Cat. 90

APPENDICES

A: Documents, Inventions, Memorabilia

On The Road to Fame and Fortune

<div align="right">
New York City

Nov. 20, '99
</div>

Editor of Echo:

As I promised, I will let you know how I am getting on in the city. I wrote you in my last letter that I was receiving private instruction from the emminent [sic] artist, Mr. Walter Satterlee, A.N.A. and have just received the unexpected compliment of being commissioned to make reproductions in colors from his original paintings for the holiday trade at a good price, which with my portraits that I have to make will be all I can possibly do this winter outside my studies.

Mr. Satterlee is one of the recognized leaders in Art in New York City, having studied in Paris and Rome and exhibited his works at the Royal Academy in London.

He has been a member of the National Academy of Designs [sic] and the American Water Color Society for many years, and among his many patrons are included such prominent men as Cornelious [sic] Vanderbilt, John Jacob Astor and others.

I have also recently had the honor of being admitted to the National Academy of Designs [sic] of New York City, being one of a few selected by the committee after one weeks competition with over 300 art students.

Am in the painting class from 1 to 4 p.m., sketch class from 4:30 to 5:30 p.m., and the "Antique" from 7 to 10 p.m. With the single exception of the "Life" these are the highest classes in the Academy and I hope to be advanced to that class in February.

The standard of excellence is unusually high this season, the officials having patterned after the "Beaux Arts" of Paris, admitting no one but artists of recognized merit, and many of these are placed on probation. I am permanently admitted for the season, and expect to remain to the end which is about May 1st, although I may possibly return to Shelburne Falls somewhat sooner.

<div align="right">
Your friend, E. R. Elmer
</div>

Letter published in the *Deerfield Valley Echo,* Shelburne Falls, Massachusetts, November 29, 1899.

Nov. 23. Art Exhibit by E.R. Elmer. Local people have enjoyed a treat the past week in the free art exhibition of the work of E.R. Elmer of this town. Mr. Elmer is an artist of 15 years experience, having been a pupil of Walter Satterlee, A.N.A., and a student at the National Academy of Design of New York City for one year. The exhibition was in a large room over the savings bank and in the four afternoons during which the exhibition was open but a short time, over 500 visitors were present. The exhibition was a great pleasure and a surprise to the artist's friends in this vicinity. Mr. Elmer's work was composed of oil paintings, pastels, crayons and charcoals, sepias and charcoals from the antique. There were many bits of local scenery in the exhibition and these gave critics a chance to observe the artist's faithful reproductions. Mr. Elmer makes a specialty of enlarging photographs for which he took many orders.

The favorites of the exhibition were Arms Academy, Violin and Music, Views of the Birthplace of Mary Lyon, scenes on the Deerfield River, and moonlight and sunlight effects. Mr. Elmer lived on the Mary Lyon homestead for 13 years and drew the house from memory, the house being destroyed 40 years ago. His best work was a subject entitled "Apples and Cider" in which the coloring and shadows were well brought out. About half the number of exhibits were sold during the show, and Mr. Elmer hopes to make the free exhibition an annual one.

Notice published in the *Greenfield Recorder,* Greenfield, Massachusetts, November 23, 1904.

Fig. 105. Business invoice, after 1902. Collection of Mrs. Robert Luce.

No.		Price
66.	Shattuckville Bridge	$2 00
67.	Glimpse on Frankton Pond	2 00
68.	Mulberry Blossoms	2 00
69.	A Hazy Morning	4 00
70.	View west from Cemetery	6 50
71.	Mt. Tom, east side	7 00
72.	Reservoir Falls	5 50

Sepia Pastels

No.		Price
73.	Squam River, Ashland, N. H.	4 50
74.	Nashua River, Lancaster, Mass.	4 50
75.	View near North River Bridge	6 50
76.	Torrey Road, Williamstown, Mass.	7 00
77.	Partridge on Drumming Log	3 00
78.	Torrey Road	3 00
79.	Oak Woods	3 50
80.	Deerfield River, above Tunnel	3 00
81.	New Reservoir	3 00
82.	A Shady Drive	3 50
83.	After the Storm	6 00
84.	Birthplace of Mary Lyon, west side	6 50
85.	Birthplace of Mary Lyon, east side	6 50
86.	Mt. Holyoke	6 00
87.	Nashua River, near Clinton, Mass.	4 60
88.	The Davenport Homestead	4 60
89.	Old Oaken Bucket	4 60

Charcoals and Crayons

No.		Price
90.	View near Dugway	4 50
91.	Deerfield River, above Tunnel	4 50
92.	View near St. Johns, Newfoundland	5 00
93.	View near St. Johns, Newfoundland	5 00

THIRD ANNUAL

Free Art Exhibition

At C. W. Ward's Ice Cream Parlors, No. 10 Bridge Street.

FROM THE STUDIO OF

E. R. ELMER,

Pupil of Walter Satterlee, A. N. A., and of the National Academy of Designs of New York City.

Open to the Public

Thursday, Friday and Saturday,

Dec. 13th, 14th and 15th, 1906.

FROM 2 to 5 and 7 to 9 p. m.

ALL WELCOME.

Oil Paintings

No.		PRICE
1.	A Good Point	$25 00
2.	Our Village Carver	30 00
3.	An Interesting Story	25 00
4.	Deerfield River, near Dugway	20 00

Pastel Paintings

No.		Price
5.	A Weaving Scene	15 00
6.	Sheep Drinking	8 50
7.	Watermelon	10 00
8.	Parting of the Ways	6 00
9.	Ashfield Pond and Club House	6 50
10.	Nonotuck Mountain, near Northampton	7 00
11.	View on Frankton Pond	4 00
12.	Mt Tom, west side	11 00
13.	A Country Road	7 00
14.	Mt. Holyoke	10 00
15.	Asters	4 50
16.	View from Shattuckville Bridge	3 25
17.	Moonlight	8 75
18.	Sheep in Pasture	11 00
19.	Scotts Bridge	9 50
20.	Autumn Scene, Ashfield, Mass.	14 00
21.	View near Buckland Station, west	7 50
22.	View near Buckland Station, east	7 50
23.	Apples and Cider	8 50
24.	Deerfield Valley, from near Dr. Canedy's	7 50
25.	Fish Pond, near North Adams	6 00
26.	A Shady Drive, Ashfield, Mass.	10 00
27.	By the Camp Fire	9 00
28	Echo Lake and Moat Mountain, N. H.	10 00
29.	Old Saw Mill	5 00
30.	Gardner Falls Reservoir	9 00
31.	View on Paradise Pond, Northampton	$ 5 00
32.	View on Deerfield River, near North River	5 00
33.	View north on Frankton Pond	5 00
34.	The Cutlery Works and Falls	5 00
35	Peaches and Grapes	5 00
36.	Lake Winnipesaukee, N. H.	5 00
37.	Lamson & Goodnow Cutlery Works	9 00
38.	Mt. Owen, Ashfield, Mass.	10 00
39.	Sheep and Shepherdess	9 00
40.	Early Morning	6 50
41.	Autumn on the Reservoir	5 50
42.	Moonlight and Mackerel Sky	4 50
43.	The Pipe as a Last Resort	5 00
44.	Solitude	8 75
45.	A Sure Catch	10 00
46.	Apple Picking	5 00
47.	Shattuckville Pond	5 00
48.	Connecticut River, near Northampton	8 50
49.	Oak Woods, Ashfield, Mass.	10 00
50.	Ashfield Pond	7 00
51.	Glimpse on Reservoir	5 00
52.	Main Street, Shelburne Falls	8 00
53.	Tiger Lilies	5 00
54.	Pears and Clover	7 00
55.	View on Deerfield River, near Manning's	7 00
56.	Frankton Pond and Power House	3 50
57.	Glimpse on Deerfield River	3 00
58.	Frankton Pond, looking south near North End	3 00
59.	Upper end of Frankton Pond	3 00
60.	Frankton Pond and Shattuckville Bridge	3 00
61.	A Glimpse of Paradise, Northampton	3 50
62.	Deerfield River, below Maxwell's	3 00
63.	Sunset	3 25
64.	Birthplace of Mary Lyon, east side	7 00
65.	Birthplace of Mary Lyon, west side	7 00

Figs. 106 & 107. Checklist of the 1906 exhibition. Smith College Museum of Art, Gift of Mrs. Hugh Ward.

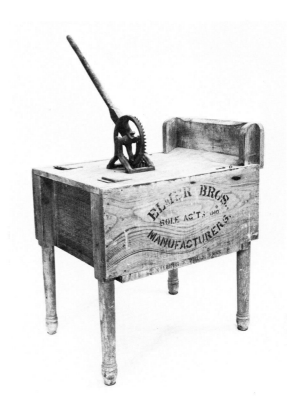

Fig. 108. "Centennial" washing machine. Patented 1876 by Sylvester J. Taylor. Manufactured by the Elmer Brothers. Shelburne Historical Society, Shelburne Falls, Massachusetts.

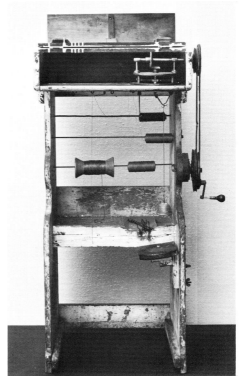

Fig. 109. Whipsnap machine, ca. 1887. Wood and metal, 49″ high. Invented and manufactured by the artist. Edwin Smith Historical Museum, West Athenaeum, Westfield, Massachusetts, Gift of Mrs. George W. Kingsley.

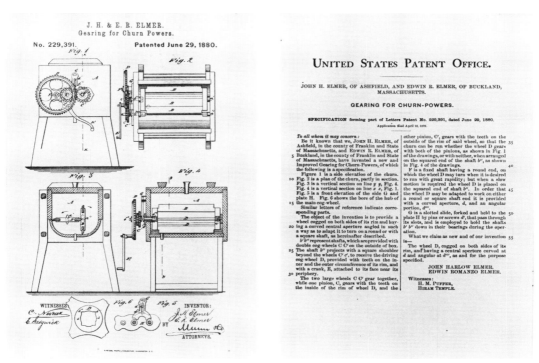

J. H. & E. R. ELMER.
Gearing for Churn Powers.

No. 229,391. Patented June 29, 1880.

Fig. 1
Fig. 2
Fig. 3
Fig. 4
Fig. 6
Fig. 5

WITNESSES
C. Nurra
E. Sequrix

INVENTOR:
J. H. Elmer
E. R. Elmer
BY
Munn & Co
ATTORNEYS.

UNITED STATES PATENT OFFICE.

JOHN H. ELMER, OF ASHFIELD, AND EDWIN R. ELMER, OF BUCKLAND, MASSACHUSETTS.

GEARING FOR CHURN-POWERS.

SPECIFICATION forming part of Letters Patent No. 229,391, dated June 29, 1880.

Application filed April 19, 1879.

To all whom it may concern:

Be it known that we, JOHN H. ELMER, of Ashfield, in the county of Franklin and State of Massachusetts, and EDWIN R. ELMER, of Buckland, in the county of Franklin and State of Massachusetts, have invented a new and Improved Gearing for Churn-Powers, of which the following is a specification.

Figure 1 is a side elevation of the churn. Fig. 2 is a plan of the churn, partly in section. Fig. 3 is a vertical section on line y y, Fig. 4. Fig. 4 is a vertical section on line x x, Fig. 1. Fig. 5 is a front elevation of the side G and plate H. Fig. 6 shows the bore of the hub of the main cog-wheel.

Similar letters of reference indicate corresponding parts.

The object of the invention is to provide a wheel cogged on both sides of its rim and having a curved central aperture angled in such a way as to adapt it to turn on a round or with a square shaft, as hereinafter described.

b' b'' represent shafts, which are provided with double cog-wheels C C' on the outside of box. The shaft b'' projects with a square shoulder beyond the wheels C' c', to receive the driving cog-wheel D, provided with teeth on the inner and the outer circumference of its rim, and with a crank, E, attached to its face near its periphery.

The two large wheels C C' gear together, while one pinion, C, gears with the teeth on the inside of the rim of wheel D, and the other pinion, C', gears with the teeth on the outside of the rim of said wheel, so that the churn can be run whether the wheel D gears with both of the pinions, as shown in Fig 1 of the drawings, or with neither, when arranged on the squared end of the shaft b'', as shown in Fig. 4 of the drawings.

F is a fixed shaft having a round end, on which the wheel D may turn when it is desired to run with great rapidity; but when a slow motion is required the wheel D is placed on the squared end of shaft b''. In order that the wheel D may be adapted to work on either a round or square shaft end it is provided with a curved aperture, d, and an angular portion, d'''.

G is a slotted slide, forked and held to the plate H by pins or screws d', that pass through its slots, and is employed to hold the shafts b' b'' down in their bearings during the operation.

What we claim as new and of our invention is—

The wheel D, cogged on both sides of its rim, and having a central aperture curved at d and angular at d''', as and for the purpose specified.

JOHN HARLOW ELMER.
EDWIN ROMANZO ELMER.

Witnesses:
H. M. PUFFER,
HIRAM TEMPLE.

Figs. 110 & 111. Patent for churn. 1880.

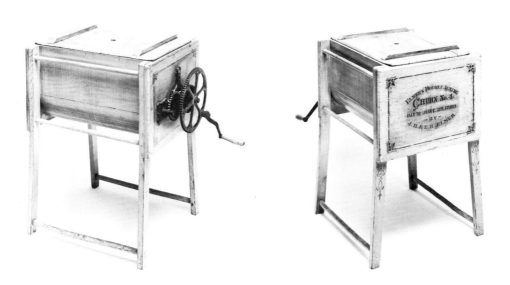

Figs. 112 & 113. Elmer's Double-Acting Churn No. 4, 1880. Wood and metal, 35¾″ high. Collection of Mr. and Mrs. Douglas Luce.

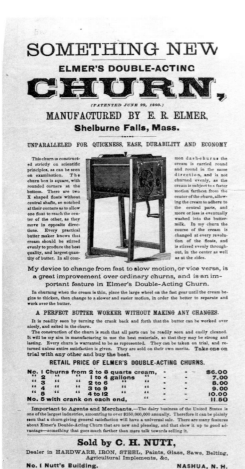
Fig. 114. recto & verso. Handbill for churn, ca. April 1881.

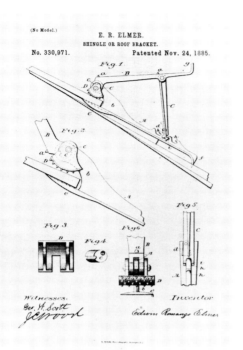

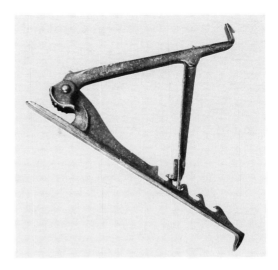

Fig. 115, above left. Patent for shingle or roof bracket, 1885.

Fig. 116, above right. Shingle or roof bracket, 1885. Cast iron, 10⅛″ long. Collection of Thomas McDonald.

Fig. 117. Japanese print owned by the artist. 3⅜″ x 5½″. Collection of Mrs. Robert Luce.

Fig. 118. Lace collar worn by the artist's daughter in *Mourning Picture* (fig. 55). Smith College Museum of Art, Gift of Mrs. Robert Luce.

Fig. 119. Magnifying glass and sugar bowl seen in *Magic Glasses* (fig. 64). Collection of Mrs. Robert Luce.

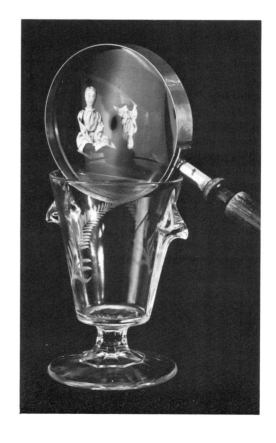

B: Genealogy

Samuel ELMER — Chloe CHAPIN
1766–1828 d. 1848

Ansel
1795–1865

m. Rachel Phillips
1804–1874

Louisa Jane
b. & d. 1831

Ansel Chapin ___ m. Emeline Elmer ___
1834–1919 1844–1939

Ellsworth

Amy m. Wayne Phillips

Herbert Fitch

Ethel m. James L. Howe

John Harlow ___ m. Jane P. (Ware)
1838–1917 1836–1909

Erastus
1797–1890

m. Susan Smith
1807–1878

Clarissa ___ m. Harvey Totman ___
1826–1859

Sylvester

Mary

Delilah ___ m. John Quigley
1828–1912

Ansel ___ m. (1) Helen Hickok ___
1830–1926

George

Edwin

m. (2) Mary Jane Spears ___ Clara

Darwin
1833–1859

Edwin
1835–1843

Nathan
1800–1863

m. Julia Smith

Margaret
1837–1845

Sylvester
1839–1845

Alfred
1803–1868

Israel
1841–1842

Mary
1805–

m. Horace Flower

Emeline ___ m. Ansel Chapin Elmer
1844–1939 1834–1919

Clarissa
1808–1884

Angeline
b. & d. 1846

m. Joseph Wight

Samuel ___ m. (1) Alma Whiting ___
1849–1902

Maud Valona
1879–1963

Wilson
1810–1885

m. (2) Alice K. Davis ___

Blaine Everitt
1894–1951

m. (1) Julia Wood
 (2) Amanda Richmond

Edwin Romanzo ___ m. Mary Jane Ware ___
1850–1923 1860–1927

Effie Lillian
1880–1890

Watson
1810–1882

m. Julia Phillips

Irving

Sidney

Nellie

Consider
1815–1841

Isabel

Levi SMITH — Phebe ?
both died before 1807

Israel
1786–after 1865
 m. (1) Esther Cook Susan m. Erastus Elmer
 1807–1878 1797–1890
 m. (2) Elizabeth Phillips
 m. (3) Anna Smith Edwin

Betsey m. Abijah Totman
1797–

Samuel WARE — Jane PAYNE m. (2) John H. Elmer
 –1864 1836–1909

Lucy m. Freeman Barnes
1857–1926

Minnie m. (1) Edward Charter Doris m. Robert Luce
 (2) George A. Reniff

Albert

Ernest m. Nina Gilbert Kathleen m. Harold A. Lesure
 Bernard
 Phyllis m. Kenneth L. Beals

Howard m. Esther Giles Douglas
 Priscilla m. Charles T. Bingham

Mary Jane m. Edwin Romanzo Elmer
1860–1927

160

SELECTED BIBLIOGRAPHY

No study of the life and art of Edwin R. Elmer could be undertaken without consultation of the short memoir written about 1960 by his niece, Maud Valona Elmer (1879–1963), "Edwin Romanzo Elmer as I Knew Him." Quotes from the references to it are so frequent in the text that I have not footnoted each one, but have in every case named her as the source. Maud Elmer, an artist herself, had been supervisor of art for the public schools of Seattle, Washington, where she went in 1908 and where she died. Many letters from her in the Museum's files and in the possession of Florence Haeberle have also proved very useful. An interview with the artist's sister, Emeline, conducted by Mary Elisabeth Hyde and Faith Sanborn Brainard for the *Mount Holyoke Alumnae Quarterly* is the only record of the recollections of a member of the artist's own generation.

Much information in the biographical section is based on gleanings from census records, deeds, wills, court proceedings, vital statistics, church records and newspapers in towns and counties in Massachusetts, Vermont, Connecticut, New York, Ohio, and Washington.

Many libraries and historical societies have yielded helpful data, particularly the Milo Belding Library and the Ashfield Historical Society, Ashfield, Massachusetts; the Arms Library and the Shelburne Historical Society, Shelburne Falls, Massachusetts; the Buckland Public Library and the Buckland Historical Society, Buckland, Massachusetts; the Forbes Library and the Northampton Historical Society, Northampton, Massachusetts; the Pocumtuck Valley Memorial Association Library, Deerfield, Massachusetts; the Greenfield Public Library, Greenfield, Massachusetts; the Mount Holyoke College History Archives, South Hadley, Massachusetts; the Houghton Library, Harvard University, Cambridge, Massachusetts; the New England Historical and Genealogical Society, Boston, Massachusetts; the Connecticut Historical Society, Hartford, Connecticut; the Cleveland Public Library and the Western Reserve Historical Society Library, Cleveland, Ohio; the New York Public Library and the New-York Historical Society Library, New York, New York, and the Archives of American Art, an invaluable resource which I have consulted at its branches in New York, Boston and San Francisco.

Books and Articles

"American Luminism." *The Art Digest,* vol. 25, no. 7, January 1, 1951, pp. 11 and 31.

Barhydt, J. A. *Crayon Portraiture.* New York, 1892.

Baur, John I. H. "Trends in American Painting, 1815 to 1865." In *M. and M. Karolik Collection of American Paintings, 1815 to 1865.* Cambridge, 1949.

Baur, John I.H. *American Painting in the Nineteenth Century, Main Trends and Movements.* New York, 1953.

Baur, John I.H. "American Luminism, A Neglected Aspect of the Realist Movement in Nineteenth-Century American Painting." *Perspectives USA, 9,* Autumn 1954, pp. 90–98.

Black, Mary. "Rediscovery: Erastus Salisbury Field." *Art in America,* vol. 54, no. 1, January–February, 1966, pp. 49–56.

Burns, Sarah. "A Study of the Life and Poetic Vision of George Fuller (1822–1884)." *The American Art Journal,* Autumn 1981, pp. 11–37.

Cary, Edward. "Some American Pre-Raphaelites: A Reminiscence." *The Scrip,* vol. II, no. 1, October 1906, pp. 1–7.

Cary, Elisabeth Luther. *The Rossettis, Dante Gabriel and Christina.* New York and London, 1900.

Catalogue of the Gallery of Art of the New-York Historical Society. New York, 1915.

Chapman, Edmund H. *Cleveland: Village to Metropolis. A Case Study of Problems of Urban Development in Nineteenth-Century America.* Cleveland, 1964.

Coke, Van Deren. *The Painter and the Photograph.* Albuquerque, 1964.

Coke, Van Deren. *The Painter and the Photograph from Delacroix to Warhol.* Albuquerque, 1972.

Cowdrey, Mary Bartlett. *National Academy of Design Exhibition Record, 1826–1860.* New York, 1943.

Cranch, Christopher Pearse. "Art-Criticism Reviewed." *The Galaxy,* vol. IV, May 1867, pp. 77–81.

Cutter, William Richard. *Genealogical and Family History of Western New York.* 3 vols. New York, 1912.

Dickason, David H. "The American Pre-Raphaelites." *Art in America,* vol. 30, no. 3, July 1942, pp. 157–65.

Dickason, David H. "Clarence King—Scientist and Art Amateur." *Art in America,* vol. 32, no. 1, January 1944, pp. 41–51.

Dickason, David H. *The Daring Young Men. The Story of the American Pre-Raphaelites.* Bloomington, Indiana, 1953.

Dilley, Butler F., ed. *Biographical Cyclopedia of Chautauqua County.* Philadelphia, 1891.

Dods, Agnes M. "Connecticut Valley Painters." *Antiques,* October 1944, pp. 207–209.

Downs, John Phillip and Hedley, Fenwick I., eds. *History of Chautauqua County, New York and Its People.* 3 vols. Boston and New York, 1921.

Edson, Obed. *History of Chautauqua County.* 2 vols. Boston, 1894.

Ellis, E. R. *Biographical Sketches of Richard Ellis, First Settler of Ashfield, Mass., and His Descendants.* Detroit, 1888.

M. V. ELMER. Elmer, Maud Valona. "Edwin Romanzo Elmer as I Knew Him." *Massachusetts Review,* vol. VI, no. 1, Autumn-Winter 1964–65, unpaginated [pp. 120–45].

Flexner, James Thomas. *Nineteenth Century American Painting.* New York, 1970.

FRANKENSTEIN. Frankenstein, Alfred. "Edwin Romanzo Elmer." *Magazine of Art,* vol. 45, no. 6, October 1952, pp. 270–72.

Frankenstein, Alfred. *After the Hunt: William Harnett and Other American Still Life Painters 1870–1900.* Berkeley, 1953.

Gerdts, William H. "The Influence of Ruskin and Pre-Raphaelitism on American Still-Life Painting." *The American Art Journal,* vol. 1, no. 2, Fall 1969, pp. 80–97.

Gerdts, William H. *Painters of the Humble Truth, Masterpieces of American Still Life 1801–1939.* Columbia, Missouri, 1981.

Gerdts, William H. and Burke, Russell. *American Still Life Painting.* New York, 1971.

Green, Elizabeth Alden. *Mary Lyon and Mount Holyoke, Opening the Gates.* Hanover, New Hampshire, 1979.

GREENE AND WHEELING. Greene, Richard Lawrence and Wheeling, Kenneth Edward. *A Pictorial History of the Shelburne Museum.* Shelburne, Vermont, 1972.

Guilford, L. T. *The Story of a Cleveland School, From 1848 to 1881.* Cambridge, 1890.

A History of the Town of Ashfield, Franklin County, Massachusetts. Vol. 2, *1910–1960.* Ashfield, 1965.

Hitchcock, Edward (compiler). *The Power of Christian Benevolence Illustrated in the Life and Labors of Mary Lyon.* Northampton, 1851.

Howes, Frederick G. *History of the Town of Ashfield, Franklin County, Massachusetts from its Settlement in 1742 to 1910.* 1910. Reprint, Moscow, Idaho, 1974.

Howat, John K. *The Hudson River and Its Painters.* New York, 1972.

Hughes, Dudley Darwin and Hughes, W. H. *Hughes and Allied Families.* 1879. Reprint, Charleston, S.C., 1968.

Hyde, Mary Elisabeth and Brainard, Faith Sanborn. "Mrs. Elmer and The Mary Lyon Birthplace in Buckland." *Mount Holyoke College Alumnae Quarterly,* November 1937, pp. 202–203.

Ironside, Robin and Gere, John A. *Pre-Raphaelite Painters.* New York, 1948.

James, Henry. *Notes of a Son and Brother.* New York, 1914.

James Henry. *A Landscape Painter.* New York, 1919.

Johnson, William W. *Elmer-Elmore Genealogy. Records of the Descendants of Edward Elmer, of Braintree, Eng., and Hartford, Conn., through his son Edward. 1632–1899.* North Greenfield, Wisconsin, 1899.

JONES. Jones, Betsy Burns. "Edwin Romanzo Elmer in the Collection of the Smith College Museum of Art." *Smith Alumnae Quarterly,* vol. LXX, no. 3, April 1979, pp. 14–17.

Kendrick, Fannie S. *The History of Buckland, 1779–1935, with Genealogies by Lucy Cutler Kellogg.* Buckland, Massachusetts, 1937.

Large, Moina W. *History of Ashtabula County, Ohio.* 2 vols. Topeka and Indianapolis, 1924.

Lillie, Mrs. L. C. "Two Phases of American Art." *Harper's New Monthly Magazine,* vol. LXXX, no. 476, January 1890, pp. 206–216.

Lindquist-Cock, Elizabeth. *The Influence of Photography on American Landscape Painting, 1839–1880.* New York, 1977.

Lindquist-Cock, Elizabeth. "Stillman, Ruskin & Rossetti: The Struggle Between Nature and Art." *History of Photography,* vol. 3, no. 1, January 1979, pp. 1–14.

Lipman, Jean and Franc, Helen M. *Bright Stars: American Painting and Sculpture Since 1776.* New York, 1976.

Maas, Jeremy. *Victorian Painters.* New York, 1969.

Marlor, Clark S., ed. *A History of the Brooklyn Art Association.* New York, 1970.

Mather, Frank Jewett, Jr. *Charles Herbert Moore, Landscape Painter.* Princeton, 1957.

Milne, Gordon. *George William Curtis and the Genteel Tradition.* Bloomington, Indiana, 1956.

MULLER. Muller, Nancy. C. *Paintings and Drawings at the Shelburne Museum.* Shelburne, Vermont, 1976.

Naylor, Maria, ed. *The National Academy of Design Exhibition Record, 1861–1900.* 2 vols. New York, 1973.

The New Path, vol. I, no. 1, May 1863–vol. II, no. 12, December 1865.

Newman, Alan B., ed. *New England Reflections, 1882–1907, Photographs by the Howes Brothers.* New York, 1981.

Nichol, Francis D. *The Midnight Cry.* Washington, D.C., 1944.

Norton, Charles Eliot. "The New Path." Review in *The North American Review,* vol. 98, no. 202, January 1864, pp. 303–304.

Norton, Charles Eliot, ed. *Letters of John Ruskin to Charles Eliot Norton.* 2 vols. Boston and New York, 1905.

Norton, Sara and Howe, M. A. DeWolfe, eds. *Letters of Charles Eliot Norton, with Biographical Comment.* 2 vols. Boston, 1913.

Novak, Barbara. *American Painting of the Nineteenth Century.* New York, 1969.

Novak, Barbara. *Nature and Culture.* New York, 1980.

Ovenden, Graham. *Pre-Raphaelite Photography.* London, 1972.

Patrie, Lois McClellan. *A History of Colrain, Massachusetts.* Troy, New York, 1974.

Pilgrim, Dianne H. "The Revival of Pastels in Nineteenth-Century America: The Society of Painters in Pastel." *The American Art Journal,* November 1978, pp. 43–62.

Reynolds, Graham. "The Pre-Raphaelites and their Circle." *Apollo,* vol. XCIII, no. 112, June 1971, pp. 494–501.

Richards, T. Addison. "The Valley of the Connecticut." *Harper's New Monthly Magazine,* vol. XIII, no. LXXV, August 1856, pp. 289–302.

Richardson, Edgar Preston. *American Romantic Painting.* New York, 1944.

Richardson, Edgar Preston. "Art Aspects of American Processional." *The Corcoran Gallery of Art Bulletin,* vol. 4, no. 4, September 1951, unpaginated.

Richardson, Edgar Preston. *Painting in America.* New York, 1956.

Richardson, Edgar Preston. *A Short History of Painting in America.* New York, 1963.

The Round Table, vols. 1–10, December 19, 1863–July 3, 1869.

Ruskin, John. *Modern Painters.* 5 vols. London, 1856.

Ryder, James F. *Voigtländer and I: In Pursuit of Shadow Catching.* 1902. Reprint, New York, 1973.

Scharf, Aaron. *Art and Photography.* London, 1978.

Schwarz, Heinrich. "Art and Photography: Forerunners and Influences." *Magazine of Art,* November 1949, pp. 252–67.

Snow, Julia D. Sophronia. "King versus Ellsworth." *Antiques,* vol. XXI, no. 3, March 1932, pp. 118–21.

Staley, Allen. *The Pre-Raphaelite Landscape.* Oxford, 1973.

Stebbins, Theodore E., Jr. *The Life and Works of Martin Johnson Heade.* New Haven, 1975.

Stebbins, Theodore E., Jr. *American Master Drawings and Watercolors. A History of Works on Paper from Colonial Times to the Present.* New York, 1976.

Stein, Roger B. *John Ruskin and Aesthetic Thought in America, 1840–1900.* Cambridge, Massachusetts, 1967.

Taylor, Joshua C. *America as Art.* Washington, D.C., 1976.

Vanderbilt, Kermit. *Charles Eliot Norton, Apostle of Culture in a Democracy.* Cambridge, Massachusetts, 1959.

Warner, Charles F., ed. *Picturesque Franklin.* Northampton, 1891.

Wells, Harriette Hyde. *Several Ancestral Lines of Josiah Edson and His Wife, Sarah Pinney.* Albany, 1901.

Wight, Peter B. "The Development of New Phases of the Fine Arts in America." *The Inland Architect and Builder,* November 1884, pp. 51–53; December 1884, pp. 63–65.

Williams, Hermann Warner, Jr. *Mirror to the American Past, A Survey of American Genre Painting: 1750–1900.* Greenwich, Connecticut, 1973.

Williams, William W. *History of Ashtabula County, Ohio.* Philadelphia, 1876.

Young, Andrew W. *History of Chautauqua County.* Buffalo, 1875.

Exhibition Catalogues

Brooklyn, New York, The Brooklyn Museum. *William Trost Richards, American Landscape and Marine Painter, 1833–1905,* June 20–July 29, 1973. Text by Linda S. Ferber.

Cambridge, Massachusetts, Fogg Art Museum. *Paintings and Drawings of the Pre-Raphaelites and Their Circle,* April 8–June 1, 1946. Text by Agnes Mongan.

Chicago, The Art Institute. *P. B. Wight: Architect, Contractor, and Critic, 1838–1925,* January 22–July 1, 1981. Text by Sarah Bradford Landau.

Deerfield, Massachusetts, Deerfield Academy. *James Wells Champney, 1843–1903,* April 30–June 5, 1965. Texts by members of the American Studies Group.

Indianapolis, Herron Museum of Art. *The Pre-Raphaelites,* February 16–March 22, 1964. Text by Curtis G. Coley.

New York, Washburn Gallery. *John William Hill, John Henry Hill, Drawings and Watercolors,* November 3–27, 1976.

New York, Coe Kerr Gallery. *American Luminism,* October 25–November 25, 1978. Text by William H. Gerdts.

Springfield, Massachusetts, George Walter Vincent Smith Art Museum. *Of Town and River: Art of Springfield's First Golden Era,* September 9, 1979–October 19, 1979. Texts by Pamela McCarron Ellison and Jane Connell.

Springfield, Massachusetts, George Walter Vincent Smith Art Museum. *Arcadian Vales: Views of the Connecticut River Valley,* November 22, 1981–February 7, 1982. Texts by Martha Hoppin, Gloria Russell, Jill A. Hodnicki and Sheree Jaros.

Washington, D.C., The Corcoran Gallery of Art. *American Processional, 1492–1900,* July 8–December 17, 1950. Texts by Hermann Warner Williams, Jr., and Elizabeth McCausland.

Washington, D.C., National Collection of Fine Art. *Academy: The Academic Tradition in American Art,* June 6–September 1, 1975. Texts by Lois Marie Fink and Joshua C. Taylor.

Washington, D.C., The National Gallery of Art. *The Reality of Appearance: The Trompe L'Oeil Tradition in American Painting,* March 21–May 3, 1970. Text by Alfred Frankenstein.

Washington, D.C., The National Gallery of Art. *American Light, The Luminist Movement, 1850–1875,* February 10–June 15, 1980. Texts by John Wilmerding, Lisa Fellows Andrus, Linda S. Ferber, Albert Gelpi, David C. Huntington, Weston Naef, Barbara Novak, Earl A. Powell and Theodore E. Stebbins, Jr.

Washington, D.C., The National Gallery of Art. *An American Perspective: Nineteenth-Century Art from the Collection of Jo Ann and Julian Ganz, Jr.,* October 4, 1981–January 31, 1982. Texts by John Wilmerding, Earl A. Powell and Lynda Ayres.

INDEX